THE CABIN IN THE WOODS
THE OFFICIAL VISUAL COMPANION

ISBN: 9781848565241

Published by
Titan Books
A division of
Titan Publishing Group Ltd
144 Southwark St
London
SE1 0UP

First edition April 2012
1 2 3 4 5 6 7 8 9 10

Did you enjoy this book? We love to hear from our readers.
Please e-mail us at: readerfeedback@titanemail.com or
write to Reader Feedback at the above address.

ACKNOWLEDGEMENTS
Titan Books would like to thank everyone who helped with this project:
the entire cast and crew of *The Cabin in the Woods*, especially Joss
Whedon, Drew Goddard, Martin Whist, David LeRoy Anderson and
Heather Langenkamp Anderson. Thanks also to Karol Mora and Jon
Rosenberg at MGM. and all at Lionsgate, including Yon Elvira,
Amanda Maes and Tanya Wolkoff.

Titan Books would also like to thank the many talented artists, including
Brent Boates, Michael Broom, Michael Corrado, Kirsten Franson, Trevor
Goring, Ray Lai, Anthony Leonardi, Joe Pepe, Jordu Schell, Constantine
Sekeris, Peter Stratford, Michael Toby, Scott Wheeler and Simeon Wilkins,
who worked on pre-production art for *The Cabin in the Woods*, a selection
of which is showcased in this book.

Book design by Amazing15

THE CABIN IN THE WOODS

THE OFFICIAL VISUAL COMPANION

FOREWORD BY
DREW GODDARD

AFTERWORD BY
JOSS WHEDON

SCREENPLAY
WRITTEN BY JOSS WHEDON & DREW GODDARD

INTERVIEWS BY ABBIE BERNSTEIN

TITAN BOOKS

CONTENTS

FOREWORD BY
DREW GODDARD

"How the hell are they letting us make this movie?"

These are the ten words that went through my head every single day while making *The Cabin in the Woods*. And you know what? I still don't really have an answer to that question. Let's be honest — when trying to gauge the wants and desires of the American public, the first thing that springs to mind is not necessarily, "More blood from the merman's blowhole."

And yet, here we are.

This was the dream. I'd look at the schedule every day and see things like *Unicorn Meeting* and *Werewolf Wardrobe Fitting* and *Elevator Slaughter Rehearsal* and wonder if I had somehow died and gone to a heaven-like place. I remember there was one point during prep where we were rehearsing the Japanese girls singing their song of joy in the same rehearsal space with the Buckners while they were working on the proper way for pain worshipping zombies to carve up a still-living victim. And so I actually had a moment where I said, "I think when Saki holds up the frog, two of you girls should clap and hug" and then immediately turned around and said, "Judah's too hurried — he would *take his time* sawing her head off!"

This was my job.

This was a job I should not have had for many reasons, not the least of which is that apparently I'm the type of person who doesn't think to separate the eight-year-old children from the zombie slaughter rehearsal. (My thinking? These kids gotta learn about zombie slaughter sometime. Believe me, they'll be thanking me when the torture tools start flying and they know to *always keep moving, Yumi. As soon as you stop, that's your ass.*)

My point is, I'm a lucky man.

I'm lucky because I got to work with the hundreds of talented artists who made *Cabin* happen (some of whose work you'll see in this book you now hold in your hot little hands.) I'm lucky because every day I got to watch my favorite actors in the world elevate our silly little dialogue, at which point I'd then get to throw viscera at them. (The actors are mentioned in this book too. They even tell anecdotes. Some of which might make it sound like I don't know what I'm doing. When you read such things, please remember: they're actors. They get paid to lie.) And I'm lucky because I got to work with Joss, whose skin is so white it makes people think I'm Latino when I stand next to him.

Mostly, I'm lucky because I got to work on a true labor of love. *Cabin* started with two guys in a hotel room trying to make each other laugh, and ended in a bloodbath of mermen, drugs, unicorns, tentacles, angry prairie folk, and Lovecraftian apocalypse. I have no fucking idea how they let us make this movie, but I know I loved every second of it.

Hopefully some of that love comes through in the following pages.

DREW GODDARD
November, 2011

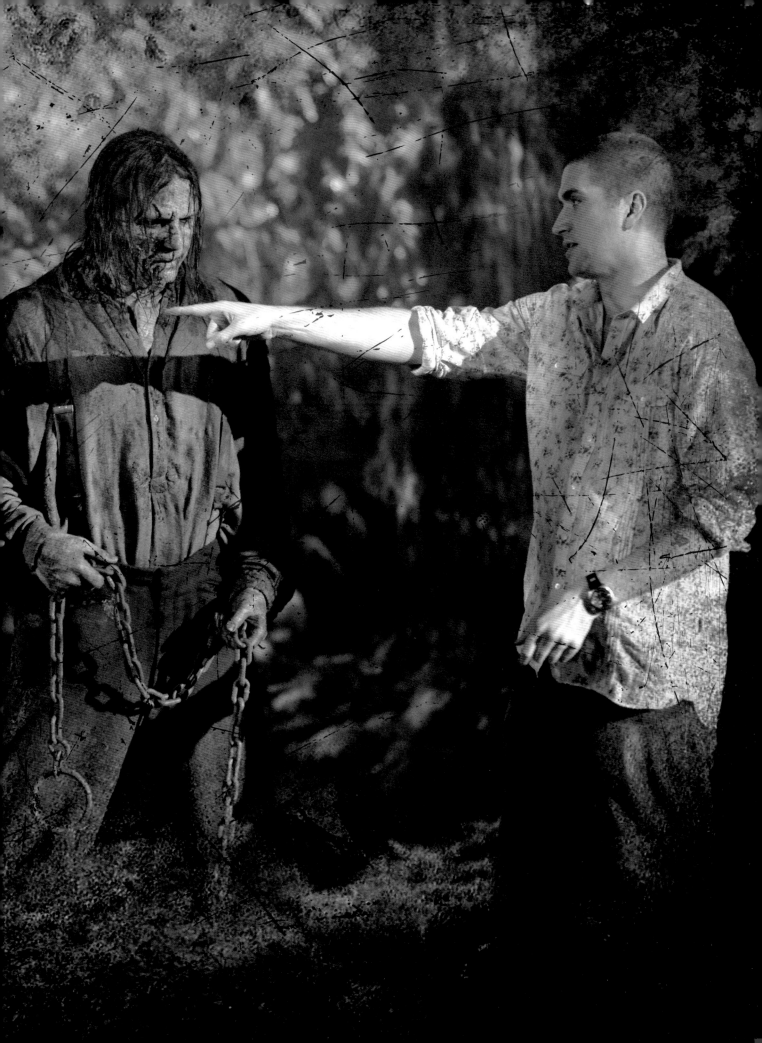

INTO THE WOODS

JOSS WHEDON AND DREW GODDARD ON THE MAKING OF THE FILM

Above: Co-writer and producer Joss Whedon.

DID you always want to be a writer?

DREW GODDARD: Absolutely.

What brought you to Los Angeles?

GODDARD: I just wanted to work, I suppose. That's where the work was. I didn't know anyone in New Mexico making movies, so I had to make my way out here.

How did you become professionally involved with each other?

GODDARD: I wrote some scripts — in TV, you write what are called 'spec' scripts and send them out. I started as a production assistant,

just met writers and producers that way, and I gave a producer friend of mine my scripts. She passed them on to Marti Noxon over at *Buffy*, and they read them and liked them and asked me to come work for them.

JOSS WHEDON: Drew was actually in contention for both *Buffy* and *Angel*. Both shows wanted him. And so he ended up on both shows, one after the other. It was in the last year of both, so I like to refer to him as 'the show killer.'

Have you always been a horror fan?

GODDARD: No. That's sort of the irony of it. I was a very scared child. I couldn't watch them. I was too terrified. I would cry and they

would give me nightmares. It wasn't until I hit the teenage years that I was finally man enough to be able to watch these things [laughs].

WHEDON: I have. I have. I've loved all of the great horror films. I watched *Nosferatu* many times — the original — as a child, so from the very start, and then the Universals and Jacques Tourneur [*Cat People, I Walked With a Zombie, Night of the Demon*] and Val Lewton [*The Body Snatcher, Curse of the Cat People*] in the Forties and the giant monsters of the Fifties. I watched everything. And of course, the really disturbing films of the Seventies and early Eighties — all the greats of my youth, *Halloween, A Nightmare on Elm Street*, all that stuff. Then I started to not like horror right around the torture porn era. But even during that, there have been great flicks like *The Descent* that have restored my faith. That's a classic horror movie.

Can you define what you like about horror?

WHEDON: You know, that's one of those things they're always asking and I've seen Stephen King trying to explain it a hundred thousand times — why do we like being terrified? I've never heard a perfect answer, but I do think it's ultimately a thrill ride, because it's basically where we get to inoculate ourselves against real fear. You ask me about those home invasion scary movies or movies where people just get beat upon or manipulated or other people treat them horribly — I can't even watch them, your *Funny Games*

or *The Vanishing*. Even *Grey Gardens* makes me frightened and disturbed, this feeling of wishing that I hadn't seen that part of humanity. But you take it just one step away from that, like to *The Strangers*, and I'm just delighted to be completely terrified.

And have you always been an apocalypse fan?

GODDARD: Sure [laughs]. I don't recall ever being not a fan of it, so I'll say yes.

Did you consciously decide to jump from TV to film?

GODDARD: It wasn't a conscious decision. It was pretty organic. There are a lot of people who think there's a progression from TV to movies and I'm not one of them. I feel like, if anything, TV has more cred and is harder to do. I have tremendous respect for TV. I just sort of go with what sounds exciting. And so I was working at *Lost* when J.J. [Abrams] asked if I wanted to write *Cloverfield* and I said, 'That sounds fun, so I'll try that,' and then Joss and I wrote *Cabin* and I got a chance to direct it and I said, 'That sounds fun, I'll do that.' But there's no real master plan. I love TV, I love movies — I love doing both.

When did you decide you wanted to direct?

GODDARD: It was sort of in the process of writing — I mean, I've

Above: Co-writer and director Drew Goddard.

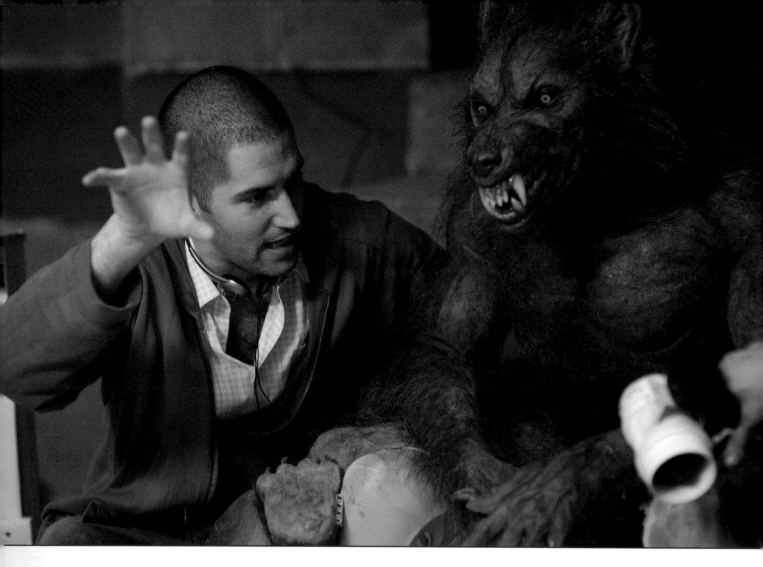

always known I want to direct, but it didn't seem like a reality until the process of writing *Cabin* that we thought, 'Oh! This would be the perfect thing to direct.'

How did *Cabin* come about?

WHEDON: It had been sort of cooking in my head for a while, and I knew it had a third act, and I knew it was the perfect thing for the two of us to go and work on and realize our dream of writing something in a weekend.

GODDARD: Joss and I had worked together for so long on *Buffy* and *Angel* and I loved working with him — and we always talked about writing something together. Then I went to work on other shows and — it sounds sappy, but I think we simply missed each other [laughs] and we talked about, 'It would be fun to write something, just for the sake of writing it,' if that makes sense. We were like, 'We should challenge ourselves to write something in a weekend, if we could do it.' Because we would do *Buffy* scripts like that all the time, where we would be behind, against deadline, and we would just write something and strangely, not always but sometimes, you come up with your best stuff when you're forced to work inside a creative box. And we just kept saying, 'It would be fun if we could go to a hotel and lock ourselves in the hotel for the weekend, and come out with a script.' So that idea was kicking around for about a year, the idea of that process as being something

that would be fun, and then one day Joss said, 'I think I've got an idea for a script that we could do like that.' Because certain scripts you could not do in a short time period. You couldn't do an involved mystery — it would take too long to figure out what to do. *The Usual Suspects* — it's going to take you a long time to figure out. And we spent a long time talking about the story, but the actual writing of it I think we did in four days. And then of course we did rewriting.

What was the original idea at its core?

WHEDON: The original idea was exactly what the movie is, which is, you play your normal horror movie — five kids go to a cabin in the woods — and you find out that everything they're doing is being manipulated from downstairs, and eventually they get downstairs and fuck shit up. And ultimately, it was a way to pay homage to the movies that I adore, in particular, *The Evil Dead*, the ultimate experience in movie horror, but at the same time, ask the question, not only why do we like to see this, but why do we like to see this *exactly*? Why do we keep coming back to this formula? You look at something as ugly, stupid and morally bankrupt as the remake of *Texas Chainsaw* and you go, 'Not only do we keep performing this ritual, but it's clearly degenerating.' So why do we keep doing it? Why do we keep returning to it? I'm as fascinated and appalled by it as I am delighted, and so welcome to both.

In watching the movies that partially inspired *Cabin*, did either of you think, 'Is somebody pumping stupidity gas at the characters?'

GODDARD: Yes! I mean, haven't we all? I think everyone watches a horror movie and goes, 'I would never do that. I would never behave the way these people behave.' It's just sort of a convention — it's an audience convention as well, to look at them and go, 'Why are these kids acting so stupid?'

WHEDON: Don't you just have to think that? How many times do they have to drop the knife? How many times do they have to split up? How many times do they have to start acting like assholes or just *be* assholes? You look at movies like *Halloween* and *Nightmare on Elm Street* and there are two ways to go. Something like *Texas Chainsaw Massacre*, the characters are a little unlikable in the original, but they're people. There's a sort of documentary feel to it that's very disturbing. But you look at the other classics and they're good people — they're friends, they care about each other. And the more they do that, the more charming and the more they care, the more you care about them, the scarier it is. Now [in most current horror films] they are just fodder — now it's always about the villain, what inventive villain can we make, because that's the action figure, and then we'll throw some expendable teenagers at them, and they get more and more expendable and more love is put into the instruments of torture and no love at all is put into the dialogue polish. But even when they were fun, interesting people in movies like *Night of the Comet*, *Night of the Creeps*, or just mixing horror and humor and being delightful, they were still all doing really stupid things.

Do you enjoy horror movies where the plot turns on stupidity or impossible stuff, or are you commenting on them, or do you enjoy it *and* you're commenting on it?

GODDARD: It's both. I love horror films. And some of my favorite horror films, people do stupid things. So it happens. But I don't hate it the way other people hate it. But I did feel like, 'We need to comment on it.' I think that is the sort of base element of *Cabin* — how do kids do this, what if someone was making them behave that way, and then just go from there.

"I'VE ALWAYS KNOWN I WANT TO DIRECT."
– DREW

WHEDON: I can't stand it. I enjoy horror movies where people don't necessarily trust each other, because that frightens me a great deal, but I absolutely can't stand movies where people don't do what any sane person would do. That doesn't mean panic. Panic is fine; people panic. But when they make obviously idiotic decisions, then it makes me not only crazy but angry, because I lose my identification with the person and then all of a sudden, I'm in the position of saying, 'Well, you deserve it. Thin the herd.'

How did you decide to collaborate with one another on *Cabin*?

WHEDON: Drew and I have wanted to do something like this for a long time. Drew absolutely gets this concept and this world, he has the love for it that I do. He also has the love of fantasy and the bizarre and he's cruel enough to be the director of this film and loving enough to do it really well. And that's the combination I'm looking for. And quite frankly, it was his infamous t-shirt of the werewolf and the unicorn rearing up at each other with the line 'It's on now' that he got at Comic-Con that made me say, 'God damn it, we've got to do it, we've got to write that movie.'

What else was going on professionally with you at that time?

WHEDON: It was written before the (2007-8 writers') strike, so not much [laughs]. I was writing movies that people weren't making. That's how I was able to find three days to myself.

From the basic idea, what was the evolution of the story? I mean, did you know about the dark gods under the control room?

WHEDON: It was always where we were heading. Like I said, we knew what we thought the end of this movie was. One of the advantages going in was knowing exactly what we wanted to get out of it and where we wanted it to go, so it chopped itself up neatly into exactly three acts. And the evolution was almost entirely a straight line. Apart from it becoming a little more absurd in some places than we expected it to, like with the speakerphone and unicorns, stuff like that, we really had the

mission statement from the start, which is how we were able to write so much so fast.

How long was it between the original idea and writing the first draft?

GODDARD: It could have been as long as a year in terms of us talking about, 'Hey, we should write a movie together!' 'Hey, what if we did a horror movie?' 'Yeah, that'd be fun.' My memory is kind of hazy. I was writing *Lost*. We were just working on other stuff, and we'd trade emails and phone calls.

WHEDON: It was a while. It was a long time before we had the opportunity. I had the idea for a couple of years.

GODDARD: There was like a month-long period where we really got serious, talking about the story every day. 'Okay, what would the story be?' 'What are our character names?' and all of those things.

WHEDON: We had a lot of meetings and sat down to dinner a lot of times to make sure that we were ready, and I wrote out a cast list and an outline and the first ten pages.

GODDARD: And then after that, we made the hotel reservations. I think we checked in on a Thursday night, but we didn't write anything Thursday night. We checked in on Thursday night and then checked out on Monday morning.

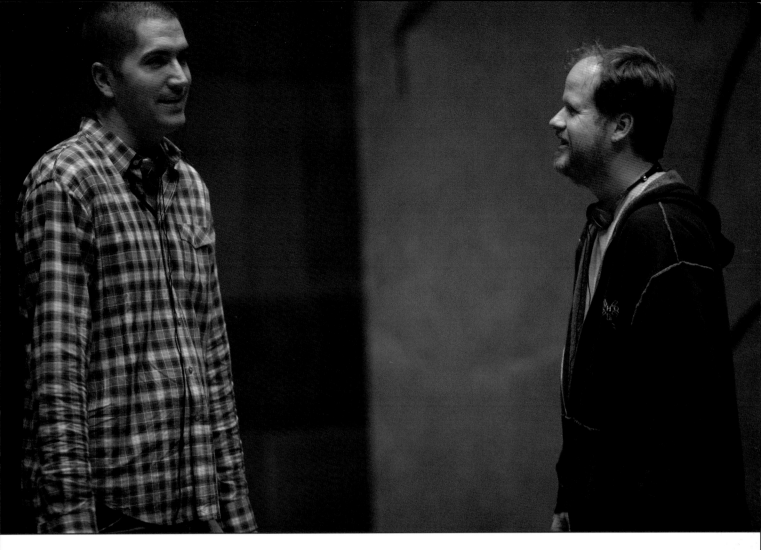

You actually checked yourselves into a hotel together to write this?

GODDARD: Yes. It's in Santa Monica somewhere. And it was great — we had a bungalow with an upstairs and a downstairs. So I would just sit upstairs and Joss would write downstairs and I remember, we would get up at seven a.m. and have breakfast and figure out the stories that we wanted to deal with that day, and then he would write downstairs and I would write upstairs and we'd pass pages back and forth and we'd finish about one a.m. and we'd go to bed and then do the same thing the next day. It was very intense, but it couldn't have been more fun. Joss and I both work very well around our wives. It's not that. But when you're at a hotel, everything can be taken care of. You don't have to think about, 'Where am I going to get food?' [laughs] Or 'When do I have to drive to the office?' We knew we wanted to be near each other, because in order to write like this, if we had a problem, we had to be in close communication all the time. We wanted to take all the problems out of it, sort of go in a bubble, so that all you have to worry about is writing.

WHEDON: You know, the dream, the fantasy — and I've had this fantasy before, as have other writers — is that you lock yourself in a hotel, partially because it is more exciting to say, partially because I have children, and partially because your focus is absolute. Based on the fact that we had ten pages written, we knew we each had an obligation to turn out no less than fifteen pages every day for three days in a row. And that can't be done if you have anything else to do. So when we got to the little bungalow,

and he took the upstairs and I took the downstairs, we basically would talk in the morning about the acts, break it, divide it, and then go down. In a writers' room, there are hours of gossip and chatting and personal stories, and there was none of that. For three days, we never talked about anything except the story. When we'd eat, if we decided to have dinner at the restaurant of the hotel, we'd only talk about the story. We had real focus. And you remove yourself from your life to get that kind of focus.

Is that a way you would like to write more often?

WHEDON: Would I like to be able to write all my screenplays in three days [laughs]? Yeah, that'd be great. That doesn't happen. This was a very particular thing, because there was so much structure in this outline that we knew exactly what we needed to accomplish from scene to scene. The kids were being controlled, which meant that we took them from A to B to C to D, so there was never a question of, 'Well, should he find out about …?' 'Should they kiss in this scene?' It was laid out. It was laid out by Hadley and Sitterson. Anybody who thinks that Drew and I are not Hadley and Sitterson clearly never met us.

Which of you is Hadley and who's Sitterson?

WHEDON: I don't know. I always imagined that he was Hadley, sort of the hotshot, and Sitterson's older. But I don't know — he might want to be Sitterson. He might want to be Ronald the Intern.

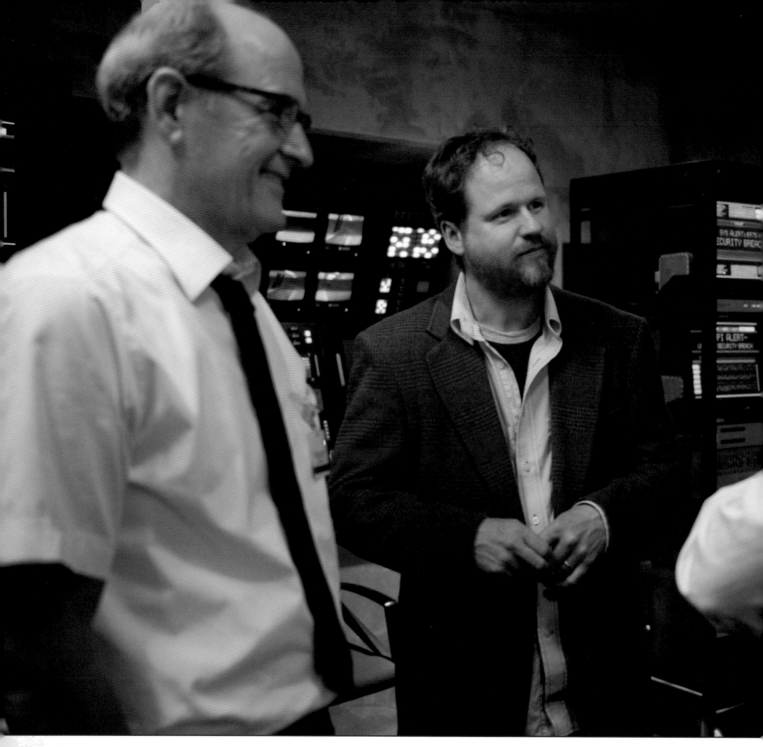

Above: Whedon on the control room set with Richard Jenkins (left) and Bradley Whitford.

How did you divide up the writing on the first draft?

GODDARD: Both of us wanted the chance to do everything, because there's a sort of clear delineation between upstairs and downstairs. There's the cabin stuff and then there's the control room stuff. Both of us wanted to get to do both. So if the movie's in three acts, we would start with Act One and say, 'Okay, I'll do these scenes in Act One and you'll do the other ones.' We'd both have scenes we'd want to write, so we'd start there. We didn't disagree too often. The good news is, all of the scenes in the film are fun, so there weren't a lot of scenes from a writing point of view where anyone went, 'Auggh, don't make me do that one.' Because sometimes scenes are just not fun to write. But all of this was like, 'Oh, that sounds fun, I'll do that.'

Would you say the act breaks are end of Act One is where the Buckners show up and end of Act Two is where Dana and Marty find the elevator?

GODDARD: It's rough. The end of Act One could also be when the cellar door blows open. It just depends on what you want to call it. But I think monsters/reading of the diary to raise monsters is sort of the same thing. And end of Act Two is definitely when they go down into the control room. Because it was so clearly delineated, I have to say, that's why it was so easy to write. We worked really hard on getting the structure ahead of time. So it wasn't like we showed up and it just happened. Joss is very good with structure and he knew those act breaks inherently and it just made everything easy.

How did the scene where Jules makes out with the wolf's head come about?

GODDARD: [laughs] You know, that's one that I don't know that I want to answer. That's one that if I explain, it makes it less interesting, no matter what the explanation is. It felt right. That's all I really want to say about it.

WHEDON: You know what? There are some things better left unsaid, particularly about this. We all have our obsessions and for me, writing a good Marty rant always made me happy, because he more than anyone is the voice of reason, and that's because he's baked.

'The womb of reefer.'

WHEDON: Yes. I wish I could take credit for that line, but that was Drew.

Was the betting in the control room on which monsters would be summoned written because it was funny, or because it gives us an indication of how many monsters there are?

GODDARD: I think it was written more because we wanted it to feel like an office, and that's just something that felt like an office. It was important that these people never felt like they're weird villains. I wanted it to feel like you're in an office, and this could be your office, and stuff like that just happens in offices. There's usually some sort of gambling or betting pool that occurs. We wanted it to feel familiar. I bet on everything. I'm a gambler. There's always a football pool or a lot of sports betting, or Academy Awards or the Emmys that happens in my offices, people will send around a ballot to make a chart.

Can you talk about some of the changes that occurred in the script's evolution?

WHEDON: Honestly, there were not many major changes. We did a lot of polishing and once Drew got up in the storyboards, he brought a lot of new stuff, like the second elevator ding gag, and he really fleshed out the party scene. We fleshed out what was there, polished it, but what we sold, what we thought up originally, is what we filmed. I don't think I've ever seen a straighter course from vision to execution.

GODDARD: Interestingly enough, I think it's changed the least of anything I've ever worked on. Even in its roughest terms — we had a very rough, two-page structure beat sheet before we went in, and it's all very similar. At one point, we talked about maybe making Holden in on it, but we went away from that. That was before we started writing, though — because he was the new guy, maybe he was part of the conspiracy. That was probably the biggest change I can remember, because everything else is pretty straightforward. When we started rewriting, it was really just clarifying. We refined the parts that were a little confusing, which mostly dealt with the mythology, so we just found little places where we could clarify it, so at the end, when they talk about evil gods, it doesn't just come out of nowhere.

So sort seeding in lines like, 'If you want to see your family again...'

Were there any parts that you were particularly passionate about writing?

WHEDON: Oh, yeah. Whenever we'd divvy up an act, we were in pretty close agreement about which parts we wanted to take. He I think had more with Hadley and Sitterson, he really loved those guys. I loved them, too, and we both did everybody. It's not like he wrote one part and I wrote another. We worked on each other's. But there were things like a lot of the control room stuff and party stuff, the wolf making-out with — he was very excited to have a girl make out with the head of a wolf. It's something you should probably discuss with him, at great length.

Right: Whedon with Kristen Connolly.

Below: Goddard directs (left) Connolly and Jesse Williams, and (right) Connolly and Fran Kranz.

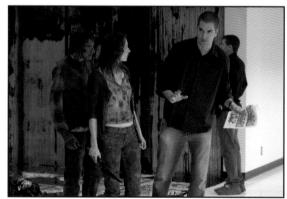

GODDARD: Exactly. Making it so they're mentioning that all along. That was the biggest rewrite note we had for ourselves.

So the control room universe was always pretty much what we see in the final film?

WHEDON: Oh, absolutely. Down to the fact that it all sort of looks like outdated tech. We wanted to give it a real NASA, Houston Seventies sort of vibe.

Was it always five kids as protagonists?

GODDARD: Yeah, it was. Because there are five very clear archetypes in the horror genre, and so we just wanted to use those archetypes.

How did the Buckner family come about? Did one of you say, 'Let's cross zombies with *Texas Chainsaw Massacre*'?

GODDARD: That's about right. I don't know who said that, but

I know we wanted zombies and we liked the *Evil Dead* type of zombies, where they have character, and we wanted to give a very Old World feel. I know Joss has always been weirdly obsessed with prairie folk, so I think he wanted to get those in there.

WHEDON: I don't think it was that blatant, but I don't think you're wrong. I mean, we weren't saying, 'How do we mix those two?' but they were both very much precursors, particularly *Evil Dead*, and we felt like *Evil Dead* was what we wanted to do with these kids, and you get the sense of, you don't exactly explain what it is, it's just sort of terrible and it moves slowly and it looks scary and you want to get away and you can't, *Night of the Living Dead* of course being the ur-movie of those being trapped. Then we got more specific about the idea of, well, it's a family and there's a diary, and they all have their own weapons. And then it started to get really fun — writing Patience's diary and revealing the history of the characters' worshipping pain and all that stuff — those were good times.

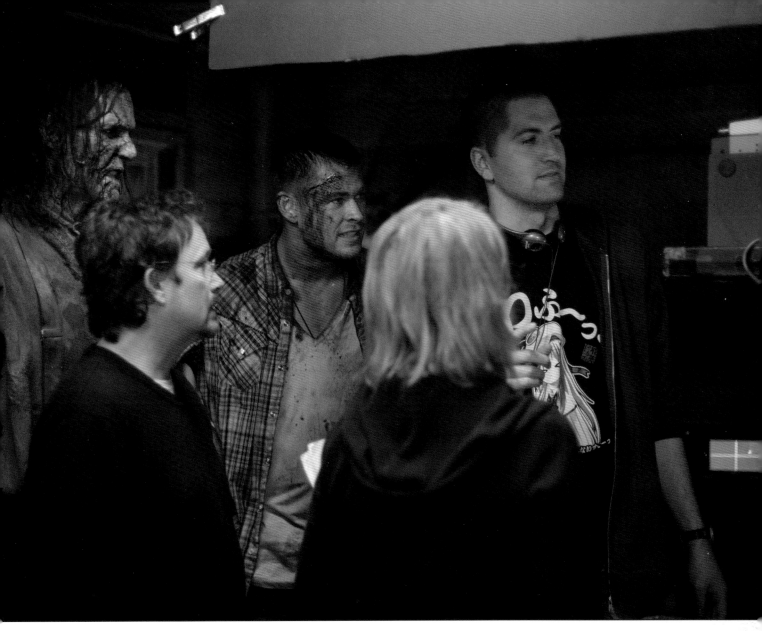

GODDARD: I remember one day, I was working on the cellar scene, but I knew that when Dana came to reading the diary itself, like I said, Joss loves prairie folk, and I thought, 'I bet he's going to want to write this,' so I yelled downstairs, 'Hey, do you want to write the diary?' And he goes, 'Yeah, I do,' and then — I'm not kidding you — six minutes later, he ran upstairs with it, this full page, this beautifully written horror diary of a prairie girl. I was like, 'How did you write that that fast?' And he's just like, 'Some things I was born to do.' [laughs] He cranked that diary out faster than I've ever seen anyone write anything. I couldn't write my own name repeatedly as fast as he wrote that diary. It was amazing.

WHEDON: The logic of the pain-worshipping makes perfect sense to me, I'm very sorry to say. And I love to write the voice of a fourteen-year-old girl who's not that educated at the turn of the century. That's a joy. We loved little Patience and Jodelle [Ferland, who plays the character] just made her even sweeter.

Japan has some of the most downbeat horror movies on Earth. Was it a challenge figuring out how one of those scenarios could end happily?

> # "EVIL DEAD WAS WHAT WE WANTED TO DO WITH THESE KIDS."
> — JOSS

GODDARD: Not really, because when we were conceiving this, I think I was over in Japan promoting *Cloverfield*. It's such a strange culture, because they have such downbeat horror — but then they also have this crazy optimistic kid world that you see, the anime side, and the bright colors and bright light and singing and weirdness, that is also part of the culture. So we thought, 'Okay, we'll do both. We'll do half of one and half of the other.' *Cabin* is very much an American side of that. You've got two sides. You've got the corporate industrial side and you've got the youth having fun. Youth having fun is so prevalent in our culture and corporate

Above: Goddard on set with Chris Hemsworth (center).

Above: Filming the Japanese schoolroom scene.

WHEDON: I seldom operate that way. You want them to come from the characters. So I would say besides the plot itself, there really weren't any that were like, 'Oh, finally, a place to insert this.' Otherwise, I think you can tell. You feel like you've stepped out of it for a moment.

Were there any jokes that you loved that couldn't stay, either because they changed the tone too much or they took too long?

WHEDON: There's always a few, but again, our whole editing process has just been tightening what we had, not dumping entire scenes or restructuring madly or anything like that. So I feel very little sense of regret. In fact, I don't really remember any, 'I loved that so well and now it has to go.' Most of the things that we love the most hit really well and they stayed in.

What was your favorite scene to write?

GODDARD: The Harbinger speakerphone. That was definitely one that I was just like, 'Oh, that's going to be fun.' And it was.

WHEDON: The last scene was fun. I had a favorite moment of writing, which was when I was writing the last scene and Drew was working on another scene, and I came upstairs and I went, 'Drew, they have a gun without silver bullets. Can the werewolf just run away?' And Drew, without looking back, just said, 'I was worried about that, too.' That was the moment I went, 'I love my life.'

institutionalism is also so prevalent. We try to get both of those things in. The question I always have is, 'What are they doing in Stockholm?'

Were there any jokes that pre-existed the script, something where you thought, 'I've wanted to work this gag into something, and this seems like the good context for it'?

GODDARD: No, not really. I don't think there was anything we were trying to wedge in. Everything was very organic to the process.

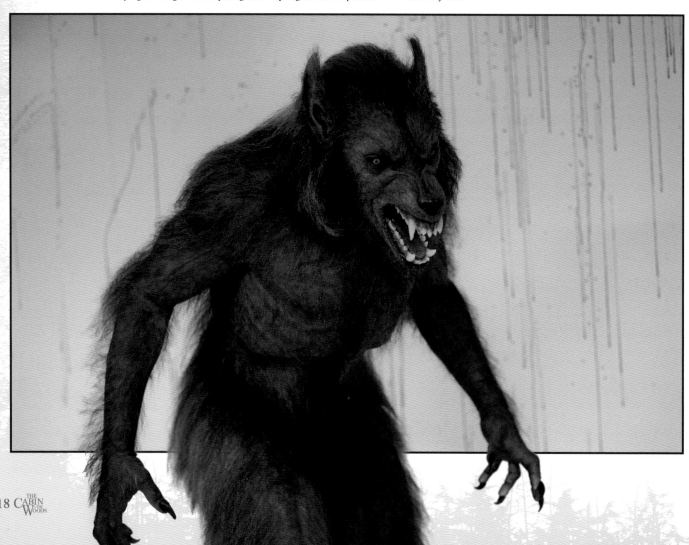

Were there ever other titles than *The Cabin in the Woods*?

WHEDON: No. That was always the title. If we had come up with something dazzling, we might have considered it. Even though it's an odd title in a way, we wanted more than anything to evoke a classical sort of horror.

Do you feel there are thematic links between *Cabin* and *Dollhouse*, because they're both in a way about people being manipulated, that ultimately wind up in the apocalypse?

WHEDON: Yeah, there are absolutely thematic links. Somebody quizzed me about that at a panel — 'Why do you always have people experimented on?' — not knowing the premise of *Cabin*, and I honestly was like, 'Well, you know what? I hadn't really realized that I do that.' [laughs] But I think for me, ultimately, so much of our behavior is socialized and programmed and so much of it is self-destructive and useless and cruel, and so much of our society is more and more in the hands of a few very rich, very corrupt people, or very well-meaning people who have no business controlling the lives of others. It doesn't matter if they're corrupt or well-intentioned — the point is, we are all controlled, we are all experimented upon, and we are all dying from it. And we are all completely unaware of it. We are taught not to be kind. We are taught not to be forward-thinking. We are taught not to be as much as we can be. We are taught to be insecure. We are taught to be subservient. We are taught to be aggressive. And we are taught to buy, buy, buy [laughs]. And these are things that are going on every day, all the time, in everybody's life. So the person is who experimented upon is me, it's everyone, and it's constant. So I guess it's a bit of an obsession.

Because I'm thinking by the time you wrote *Cabin* and the time you wrote *Dollhouse*, you have had a lot of experience with being a producer — that is, controlling certain things — is this in any way a case of writing what you know?

WHEDON: I don't think it's because I'm a producer, because I put on shows, that I'm doing these things. I mean, everybody who puts on a show puts on a show, and not everybody is talking about this. Not everybody is fascinated by the control or loss of control, by the manipulation. I think that's just a personal thing. I don't think it's not a factor at all, but considering if I could only write about what I was in such a specific way, I'd be the dullest man alive. You would not believe how staid my life is.

If you had written *Cabin* all by yourself — and this may be an unanswerable question, because you didn't — do you have ideas of ways in which it might be different?

GODDARD: It just wouldn't be as good [laughs]. At the end of the day, Joss is the best writer I have ever not just met, but ever read or seen. He is my favorite writer of all time. It's just a pleasure to write with him and see what he's going to come up with. There's stuff that he came up with that I could never really come up with, and jokes, lines, all my favorite stuff is stuff he did. I'm good, but I'm not as good as him.

WHEDON: I never thought about writing it by myself. I thought,

'This is something I want to do with Drew.' Drew, since he has been working for me, has been a dear friend and one of my greatest collaborators. And so *Cabin* was never meant to be anything other than a collaboration. And Une Film de Drew Goddard.

How did you decide which of you would direct it?

GODDARD: It's funny. When we were writing it, I remember this very specifically — when we went into it, Joss was like, 'I want to produce it and Drew, you should direct it.' And I said, 'Okay, great.' And I know Joss very well, so I was not surprised when this happened, because in the middle of when we were writing it, he walks up the stairs, he goes, 'I kind of feel like I want to direct this now,' and I started laughing, because I felt like I saw that coming. So part of me was like, 'Aw, I'm disappointed because I want to direct it, but on the other hand, if I'm not going to direct something, I couldn't ask for a better director than Joss Whedon.' That's your dream director if you're a writer. So I was fine with it. But then after he finished it, he decided that he wanted me to direct it again — I'm not really sure why [laughs].

WHEDON: I felt that this movie was very tough. If you look at *Buffy*, it's the least frightening horror show in the history of time and space. I have a problem with dismembering people. And it felt to me a little bit like a step back if I was going to do this, so I felt like, Drew is poised [to direct] and this feels like a good template for him to start with, and I had other things on my plate and it felt like a movie that I wanted to produce. Then I found out that producing a movie is kind of like ordering celery while your date has steak. You're sitting there the whole time, but you don't get the steak. Sometimes it was like, 'I might have made a mistake with this producing thing.' But Drew was ready to commit to it in a way that I wasn't, and was ready to buy the most amount of blood you can purchase in Canada. Drew is a horror aficionado in a way that I am not. He will spend a day watching different blood splatters to find the right one. He is that guy. I thought we might have trouble selling him as the director, because he had no track record. I expected to arm-wrestle in a lot of places where no arm-wrestling occurred at all, but that has a lot to do with my relationship with Mary Parent. When she took over MGM, I was as happy as I could

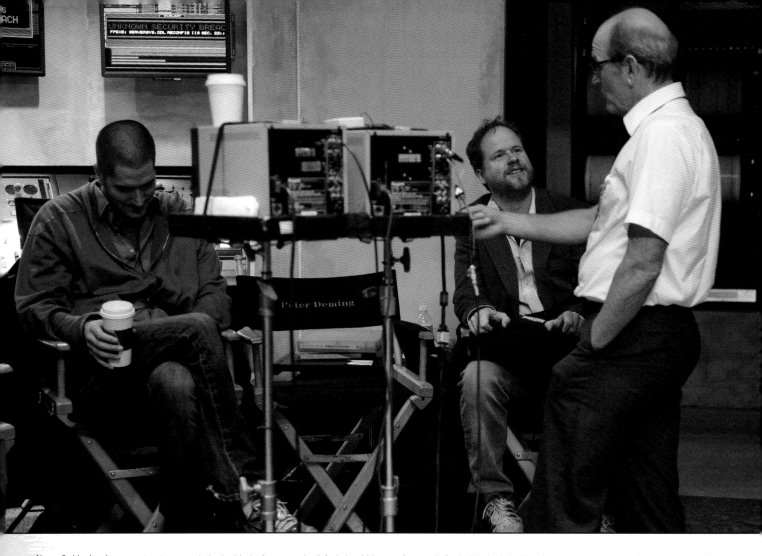

Above: Goddard and Whedon between takes with Richard Jenkins.

be, because she's the kind of person who I feel should be running a studio. She's very passionate and very decisive. She says, 'First-time directors do not scare me.' And she's like, 'I get this script and I want you to shoot this script, I don't want to develop this, I want you to shoot it.' She's got that attitude. She will look out for the problems that a first-time director might incur, she will not doing anything ill-advised or frivolous, but at the same time, when she makes a decision, that's it. She stands by it, she prepares for it.

How would it be different if you decided differently about who would direct?

WHEDON: I don't really think about that much. I think I have a slightly different visual style; I have a slightly different way of working. I think I would have compromised on some things [laughs] and they would have come out a lot cheesier. I think I also would have done some cool stuff, because we all have different visual ideas. But Drew really took command of the set and of the production and was bringing ideas the whole time. There wasn't a time when I was like, 'Wow, I could have done blah-blah-blah.' It was more just, 'How do I facilitate this?'

When did you start showing the script to other people?

GODDARD: Our goal was to finish it so we could show it to our wives [laughs], and that went well. I think a couple weeks went by when we just didn't look at it and then sat with it awhile to read

it fresh. We both had work, so we went and worked on other stuff and started rewriting it. And around then is when the writers' strike happened. So then it just became, 'OK, we've got to put it in a drawer until the strike is over.' And so we didn't really show it to anyone before the strike but then as soon as the strike got resolved, we started talking about it, and that's when we started showing it to our agents and figuring out our plan of attack and how we wanted to go out and sell this thing.

How did you find your cast?

GODDARD: We have great casting agents in Amy Britt and Anya Coloff, who did a lot of Joss's shows — they worked on *Buffy* and *Angel* — and they started scouring and then putting people in front of us. We wanted to have some fresh faces in there, just so it would make the experience better, but we didn't limit ourselves — we looked at everyone. It's weird. It's like alchemy. You have to roll your sleeves up and just start auditioning people and start mixing people together and see who's going to fit and who's not.

WHEDON: It was enormously painstaking. We went not only through dozens and hundreds of kids, but we also went through an entire casting director. We hired someone with no simpatico at all and we had to bring in Amy Britt and Anya Coloff, who've worked so well with me on so many things. So for a long while, we were panicking. Because Drew and I are both very strong believers in finding the people who can do the job right, who not only pop

off the screen but can really just bring the work and the craft and the ridiculous, as well as being charismatic. Drew saw Kristen [Connolly] before I did. The moment I saw Kristen, I lost it: 'This is absolutely the girl.' She had the courage. I was really happy that everybody else agreed with me, because I got that sick feeling you get when you just feel something so strongly and you're like, 'Now I have to get a lot of other people to approve, including my collaborator.' But nobody didn't see it. Fran [Kranz] was probably the first that we had in our pocket that we both agreed was the guy. You also are looking for an ensemble, so you don't want to cast one until you have enough of the others together. Plus, for the auditions, we had written scenes for movies that didn't exist for all of them. We had someone actually turn down the role of Truman when he finally saw the script, because he had thought it was a different movie, because he thought he was reading a different script. There isn't a fake script; there are only fake sides [audition scenes]. We wrote fake sides for all of the principals. In Curt's case, it was a pterodactyl movie; in Holden and Jules' scene, about tentacles in a Jacuzzi; Marty had a monologue about something made entirely of claws. So basically, it was take the exact character that you're looking for and then put them in a different movie. This was to keep it secret so the script didn't go out to every casting agent and person — you know, trying to keep it under wraps, but still seeing what there was to see from the actors.

Is there something about Fran Kranz that makes you think he's one of the Four Horsemen? He brings about the apocalypse in both *Cabin* and *Dollhouse*.

WHEDON: Good old Fran. He's nothing but trouble. What he came in bringing was ridiculous chops and I was saying to Drew, 'I think I might be working with Marty right now on *Dollhouse*,' before Drew even met the man. Fran came in to audition and there was nothing resembling a second choice.

Do you feel that there might be any overlap in people's minds of, 'Well, he's causing the apocalypse here and he's causing the apocalypse there'?

WHEDON: An apocalypse here, an apocalypse there… You know, I was at first reluctant to use the same actor in two projects at the same time, but when somebody's right, they're right. And we hadn't written 'Epitaph One' [the *Dollhouse* episode where it is revealed that Kranz's character has inadvertently helped civilization to collapse] or even come up with *Dollhouse* when we wrote *Cabin in the Woods*. And the idea in 'Epitaph' that he's gone bonkers with the responsibility of what he's done again came late in the game. It might have come from Jed [Whedon] and Maurissa [Tancharoen, who wrote 'Epitaph One']. These things happen. There's certainly a lot of overlap in my stuff. I'm well aware of it. I'm not proud, but there it is [laughs]. There are certain things that I will return to all the time.

Speaking of actors who you return to, were Amy Acker's and Tom Lenk's roles, Wendy Lin and Ronald, written specifically for them?

GODDARD: They weren't at all, but they should've been. You know what? They might've been subconsciously, because the second we thought, 'Hey, we should just cast them,' we were like, 'Of course

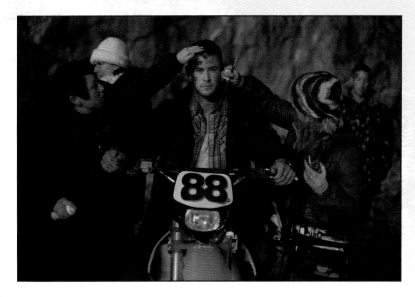

Above: Preparing to film Curt's motorcycle leap.

we should,' because we love them so much. We didn't really write with anyone specifically in mind. It's really after the writing is done that you start thinking about who would play who — but we may have written for Bradley Whitford and Richard Jenkins, because they were so great [laughs].

WHEDON: Drew insisted on trying to track down Tom — he's our good luck charm. And then Amy was a last-minute call-in, because we hadn't found the person for the part and eventually, we got into production, we hadn't found somebody that Drew felt completely confident about, and he was like, 'I feel completely confident about Amy Acker at all times, so let's just make this simple.' So we pulled that trigger. She auditioned and it was extraordinary.

Had you been big fans of Bradley Whitford and Richard Jenkins?

GODDARD: Oh, my God, yes. It wasn't ever said, but I don't remember ever thinking of anyone other than Bradley Whitford. And I think I thought of Richard after the fact, but the second I thought of him, it was like, 'Oh, yeah, that's Sitterson.' I just love him so much. I'm trying to think what I first saw him in. It's sort of like a one-two punch of *Six Feet Under* and whatever Farrelly Brothers movies he was doing at the time, where you just saw his range. The thing I admire most about Richard is, he is unafraid to play anything. He will try anything. And he just goes for it. So definitely, I've just been the biggest fan of his for so long. It's really been my dream and I'm still amazed that we got the cast that we did.

WHEDON: Bradley Whitford was actually the first person that I had thought of for Hadley, literally. Richard Jenkins — and here's an example of me really showing what a great producer I am — I told Drew, 'Don't even try, it's not worth it. He's about to get nominated for an Oscar. We don't have a chance.' [laughs] Good call, pretty proud of that — but I did other good things. I really just thought, 'There's no way.' [Jenkins] told me, 'You can thank my agent, because she put it in my hands and said, "You have to read this."' So they were both our wildest dreams and they were the first people in it. We were like, 'How is this even happening? What's going on? We're confused.'

GODDARD: It was so great. No one had been cast yet and I remember when we'd sit around the table with all the casting people, we'd just talk about our dream cast and Bradley Whitford and Richard Jenkins were our dream two. At the time, everyone was like, 'Well, you might be able to get Bradley,' because Joss knew him, we thought there was a chance, but everyone — including Joss — said, 'There's no way we're going to get Richard.' He had just done *The Visitor*, he was getting an Oscar nomination, and everyone was like, 'There's no way that Richard Jenkins is going to want to do the movie. He's an Oscar nominee now.' [laughs] It was never spoken that this was beneath him, but people were just realistically being wary about actors and knowing Hollywood. And I said, 'Well, look, it can't hurt to ask, because the worst he can do is say no and then we'll go to somebody else, but he's our dream guy. Let's just see what he says.' And they all said, 'Okay, Drew, we'll give you one. You have to be realistic.' I said, 'Let me just see.' And so we sent it on a Friday night. Monday morning, the phone rings and he said, 'Yeah, I'm in. I'll do it. I love it.' He just understood it. He was the first person we cast. Well, Fran and Richard were about the same time, I think, because we knew Fran. But Richard just said, 'Yes, I'm doing it, I'm in,' no questions asked. He didn't have any notes, he just said, 'I get it, I want to do it.' And that, I think, that just invigorated the whole process. Everyone had energy, like, 'Oh, he didn't negotiate?' He just understood it and loved it and wanted to do it, and the second that happened, all the dominoes started falling. It sort of creates that momentum that once you hear that Oscar nominee Richard Jenkins is doing it, people started to understand what we were going for, which is a much more serious film than I think people at first realized when reading the script. It was already green-lit, but I think it helped us get a better cast. You never know, because Bradley and even some of our younger actors probably would have done it anyway, who knows, but I do think we got better talent all around. Even on our crew — when you hear that actors of that caliber are doing it, it makes people gravitate toward the movie. So it helped us — there's no doubt.

Right: Amy Acker as Wendy Lin.

Opposite top: Richard Jenkins as Steve Hadley.

Opposite bottom: Anna Hutchison as Jules Louden.

The Director is played by a Top Secret Actress (whose name we won't mention so as not to spoil the surprise) — how did you come to cast her?

GODDARD: Once we sat down and started thinking, 'Oh, who should it be?', as soon as we decided on the character being a woman, it was her. We always wanted her. As soon as we thought, 'A woman,' we thought she should play it.

WHEDON: The Director was written not necessarily gender-specific. We needed somebody who would make an impression, who had cachet in the world of horror but wasn't a cliché in the world of horror, who when they explained what was going on, you would believe, no matter what. And she has played heroes and she's played villains and she has great gravitas, but at the same time, she's just very girly and delightful and had never been in a movie with a werewolf, let alone one where she gets an axe in her head. So she had a lot of fun. The choice was based on the fact she's a genuine, dignified actress who really commands the screen, but it was mostly justified by how much fun she was.

Did anybody surprise you and take a character in a different direction than you had envisioned?

GODDARD: I would say Fran definitely brought more to Marty than we ever could have dreamed. I mean, we knew he had it in him — Joss has worked with him on *Dollhouse* — but he really took it to a place that we never thought possible. Most actors came in to audition and it was one dimension, it was just 'I'm the stoner.' But Fran was able to find that pain and loneliness and humanity within the fool that we thought was so important to the film.

WHEDON: I have to say, the biggest surprise for me probably was Anna Hutchison. She came on last and it was difficult, because this is the girl who has to take her top off in a horror movie and get killed. If it's an art film, you're in the money, no problem. If it's a horror film, nobody wants to be that. A lot of people have a real problem with that in terms of their careers, and there's one actor that we liked very well who said, 'I have control over very few things in my career, but my boobies are one of them.' And quite frankly, Drew and I were made uncomfortable by the whole thing. Then in comes Anna, who just couldn't care less, who is very bouncy. She went, 'Not a problem, great, just really excited, let's rock.' She was charismatic as hell and lovely and delightful and cute and had that energy. Whereas Drew and I were both very serious and respectful, Anna was just

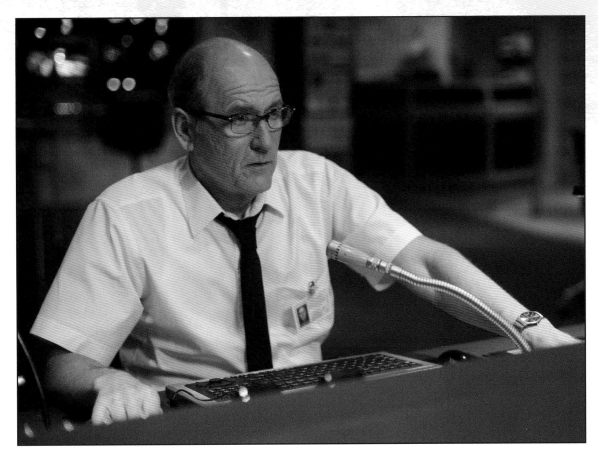

like, 'This is the job, let's do it. It's all part of acting, it's fine.' And that isn't the part that surprised me. The part that surprised me so much was just how interesting she was to watch. She kept making funny, unexpected choices and besides lighting up the screen in a very classical sense, she kept changing it up every take, without not matching [doing the same actions], take after take. You'd go, 'There's more here. There's always more here.' And the intuitive intelligence of that kind of performance is lovely and very useful.

Did you have any concerns about staging Jules' nude scene/ death scene?

GODDARD: Certainly. As a first-time director and a bit of a prude, I was definitely nervous. You want to make sure everything is being done to make your actors feel comfortable and everyone is as professional as possible. Those types of things have the potential to be weird. Luckily, I had the best assistant director in the business [Richard Cowan], who was great about keeping the set very private and quiet, and I had two actors who couldn't have been more relaxed and comfortable and they set the tone. I think that they really made everyone else comfortable. I think the person who was most nervous was me! Everyone else was just calm and professional about it. Once we actually started doing it, it was fine. It's just like any other day at the office. But there was definitely some apprehension leading up to it.

Were any scenes or dialogue changed to accommodate the actors' performances?

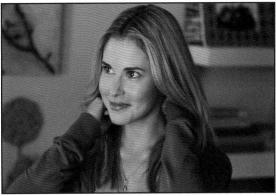

WHEDON: Not really. Some things, some lines went away or got shifted slightly if they sounded too arch in a character's mouth, but by and large, we knew what we were looking for and we found people who were able to pull it off.

GODDARD: I'm trying to think — we don't really do that [laughs]. We probably should, but particularly with Bradley and Richard, I think we had so much of them in our minds when we were writing it, it really was like, 'Okay, here you go.'

How did you find your key crew people? I believe film editor Lisa Lassek has been working with you since dinosaurs roamed the Earth.

WHEDON: But she's actually only twenty-four.

Top: Drew Goddard with Matthew Buckner (played by Dan Payne), and (above) Judah Buckner (Matt Drake).

like New York on no money whatsoever, and he is just a joy to work with, so I think he was our first crew person. He just clicked immediately. In getting ready for this, I was watching lots of horror movies. I was sitting in the house watching *Scream*, which I'm a huge fan of, and you're always thinking, 'Okay, who would be good crew?' and I was watching this going, 'My God, this is beautifully shot, who shot this?' It's [cinematographer] Peter Deming, so I think, 'Where do I know Peter Deming's name from?' and I looked his credits up. He did *Evil Dead 2* and he did a lot of David Lynch's films and he did the *Austin Powers* movies. I thought, 'Now, you could not design a more perfect resume for this film than *Scream*, *Austin Powers*, *Evil Dead 2* and *Mulholland Drive*. We sort of have elements of all those films, so that is the most perfect resume I've ever seen.' And I called our head of production. 'Do you know Peter Deming?' and he said, 'Peter Deming is one of my best friends.' And I said, 'Do you think he'd be interested?' And he said, 'It never hurts to ask.' So we called Peter and in my mind, there was no one else I wanted. It was Peter or I didn't want to make the movie. Our creature designer, David LeRoy Anderson, came from the studio. I had not met him, but the head of production had just worked with him on a few movies and loved him and Dave was great. Dave just understood the movie and we totally hit it off right away.

How long was pre-production?

GODDARD: I think we started pre-production in January and we started production in the middle of March. So eight weeks, ten weeks, somewhere in there.

How long was the actual shoot?

GODDARD: It was fifty-three days, March 9 through May 29.

Did you always plan on filming *Cabin* in Canada?

GODDARD: No, we wanted to shoot it in Los Angeles. We wanted to keep it in California for a variety of reasons. A, we just wanted to stay close to home, B, we wanted to keep employment in California, C, I think probably for me as a first-time director, I wanted to stay close to Joss, because we knew Joss was going to be in L.A. a lot doing *Dollhouse*, so I think there was part of me that was a little nervous to stray so far but, quite frankly, when you do the numbers, it's just so much cheaper to go to Canada. In hindsight, it was the right choice for sure, it wasn't just financial. We never would have found as beautiful a woods as we found up in Canada. They're just staggeringly beautiful up there, that's what they're known for up in British Columbia, and so I definitely think we made the right choice. It made the movie better.

WHEDON: It was supposed to be shot at Sony [in Culver City, California] and we were really close to production when the Canadian dollar dropped, the rebate became incredibly attractive and they showed me a spreadsheet wherein we saved millions of dollars. I couldn't pretend that it wasn't going to happen. And it was a curse and a blessing. It was a curse because I don't like to be away from my family, it was a curse because it was snowing outside while we were trying to shoot, it was a curse because it just made everything a little bit harder, especially the commute. And it

Is there a Tardis involved?

WHEDON: There was a Tardis. There's always a Tardis somewhere. Drew met with other editors, but he said, 'I know she can get this.' Lisa saved our lives so many times, I can't describe it. In addition to cutting a cool movie, her sensibility and her standards and her sense ability, her sensibleness, certainly saved me when things were just completely hectic. And as I said, Amy and Anya have done *Buffy*, *Angel*, *Firefly*, *Serenity* — they've been with me in the trenches for a long while. Most of the people that we got were new people and we got really lucky for the most part. Another of the old gang is [costume designer] Shawna Trpcic, who obviously did *Firefly*, *Angel*, *Dr. Horrible's Sing-along Blog* and *Dollhouse*. So those were really the people that we knew we wanted to bring on for sure, and then we did try to find new people who would bring new things to it.

GODDARD: The production designer, Martin Whist, was the production designer on *Cloverfield*. I just loved him on *Cloverfield* and thought he did a spectacular job of making Los Angeles look

was a blessing, because we really got some nice woods, which are hard to find in Southern California. Vancouver is an extraordinary place, really lovely, a great place to be, and the crew we got, the people up there, were crackerjack and very focused and ultimately, it was kind of a great experience.

How did you prepare to direct? Did you do storyboards?

GODDARD: I'm a big storyboard fan. I hired a bunch of storyboard artists to come in and I really meticulously worked out what the storyboards would be, which gave me a tremendous amount of confidence going in, because I already knew what the plan should be.

Did you direct any shorts or music videos?

GODDARD: I sure didn't. And I kept waiting for someone to be like, 'Why again are we going with this guy who has no experience?' [laughs] In hindsight, I really started on *Cloverfield* [which Goddard wrote and Matt Reeves directed]. I was so thankful I came up through TV, because there is no better training ground than television, I have to say. In television, it's very different. The writers get a lot of the power that directors have in the feature world. You really oversee things — you supervise your own edits of episodes and you're on set all the time. So directing *Cabin* didn't feel like this weird foreign environment. I knew what cameras did and what lenses did and what crew members did and I knew how to talk to actors, all of the things you learn by being a writer/producer on television shows, and Joss in particular was very aggressive about making sure his writers did all that work. He threw me in the deep end right away as a staff writer on *Buffy* — he made sure I was on the set all the time and doing all those things.

Even when I was scared, he would make me do it. So that was definitely where that confidence came from. But to some extent, you never really know until you do it. You never really understand until you do it. So there was definitely a learning curve the first couple of days, that's for sure.

WHEDON: I was also a first-time producer in the sense of I'd never just solely produced a movie, and I had a learning curve there, too. I was constantly calling the studio, saying, 'What should I be panicking about? Because I can't choose — I have so many ideas.'

What did you wind up panicking about?

WHEDON: Well, schedule for a while. We had a problem on Day One when Drew and I kept saying, 'It looks like it's snowing,' and they said, 'No, no, no, the gas station scene will be great. Where the gas station is, it's going to be great.' We're like, 'The earth and sky are covered in snow.' And that was when I learned one of my producer lessons, which was, be in charge. So we trucked all the way out to the gas station — which was covered in snow. It was so dark outside, we couldn't even shoot an interior. And so we lost half a day, and after that, we never got it back. You know what? There were a ton of problems and some of them I knew how to deal with, and some of them I didn't. It's a very complicated movie.

What are the differences between problems on a TV show and problems on a feature film?

WHEDON: Producer problems on a TV show are of a certain weight. Ultimately, whatever mistake you make, you can rectify

Left: Day One on location, and there's a problem: snow.

next week. In a movie, everything has enormous weight and the producer has power, and in my case, I was very, very much in tune with the crew and we have a good working relationship, but it is not the producer's set. A television show is the producer's set. A movie is the director's set. And I wanted to be respectful of that. So if there was something that I felt we needed, Drew and I would always talk about it. When it came to schedules and stuff, that was really my purview. I couldn't make things miraculously work the way I wanted them to and we had a pace at which we moved, and it never changed. It was hard for me to accept that, because I come from the land of, 'Go faster, get it done, think of something tricky to get all the footage in the time allotted.' Drew came from the school of, 'I'm going to do this the way I think I should until it's right,' which by the way is how you direct a movie. So I was sort of dealing with this schedule make-up issue, and terrible playback problems that were making Drew crazy — we were lucky because we had a great cast who were spot-on and understood what he was telling them and really got his vision, so we had a lot of good breaks in that sense. We'd lose time technically, between fifty-seven playback screens in the control room that needed to be filled with footage and a unicorn. I shot most of what was on those control room screens and you'd spend three hours putting together a gag and then it would be, 'Congratulations, we just shot one-fiftieth of one shot!' And then we did have technical snafus and scheduling problems, weather problems — it was freezing up there and it was tough. And we had fifty-two, or a hundred gallons of blood — how many gallons of blood? — *so* many gallons of blood in the lobby that nobody could walk without squeaking for two weeks.

GODDARD: Frankly, I think television is more tiring. Television, the pressure is definitely higher, because a movie, at the end of the day, is two hours. I have a year to do two hours, whereas TV you have a year to do twenty-two hours. So there's just a sheer amount of volume that you have to create for TV that you just don't for a feature, which is not to say that there's not tremendous pressure in movies. I mean, I think because it's only two hours, there's much more pressure on every small decision, whereas TV, you've just got to go. Every eight days, an episode's coming on the air, so you've got to turn in an episode. There's a much greater time pressure in TV.

Did you direct second unit on *Cabin*?

WHEDON: I did. Which was everything from a couple of first-unit days to get us back on schedule, to inserts, which made sense, because again, I was basically working for Drew. I was trying to find out from him what he was looking for before I would go with a video camera and shoot options and bring them to him and say, 'Tell me what you like and what you want.' I was very much trying to get his vision, and sometimes the footage I got was very good and he was really happy, and sometimes the footage I got wasn't that good and he was very polite. But it was getting it done for him by the one person who has as good a sense of him and what he was trying to do, or as close to him as I could, of what he was trying to achieve.

Is working in Canada any different than working in Los Angeles?

WHEDON: Work is work. People work just as hard and the only difference is that, because of the weather, I could occasionally go outside without burning to death, so I liked it. As a producer, I didn't love it snowing, but as a human being, I found it very refreshing.

GODDARD: [laughs] Ask me that after my next film. I don't think so. I've been around enough crews on TV shows to know good crews and bad crews, and the crews in Canada are spectacular, they were really top of the line, so I think, other than that there's Canadians everywhere, the crews are really no different.

WHEDON: I had expected to walk away from the shoot much more than I ended up doing, and when I did walk away, I would get nervous, because I found myself being very proprietary. But also we were being buffeted about so much by scheduling issues, mostly due to weather, that I felt like I always had to be around. So what I thought was going to be, 'Oh, I'm the producer, excuse me while I wear a cool shirt and sunglasses and go hang out at home' [laughs] turned out to be, 'Let's figure this out.' I was there 'til the bitter end, by which time, I was pretty bitter [laughs] and then spent the next month working on *Dollhouse*, so I was a little cross-eyed with exhaustion. But being in Vancouver and that crew's energy and their inventiveness and their readiness to roll with the enormous number of punches that were coming our way on a show with so much make-up and practical effects and much visual effects and gallons of blood — it was incredible that Drew could get up in the morning and control it all. And the crew was really solid, and solid meant that we could get what we wanted, which was a really classical look to the film, and not compromise.

Were there any narrative issues that were dictated by production?

WHEDON: Not really. It was just a question of figuring out how to get what we wanted in the environment that we had. Ironically, I think the most beautiful stuff in the wood is the seduction and death of Jules, where you really get a sense of the depth of the woods and the grandeur of it, the scope of the woods — and all of that was shot indoors. It was shot indoors because we were like, 'We're going to have a girl take her shirt off and she'll *die* in this weather if we try to do this at night.' Plus, night shoots were brutal

on us. They just took a really long time to not get a lot of footage. So a third of the way into production, we were like, 'Re-figure out the schedule and we have to put this indoors. It's just unfair to the actors [to shoot outdoors at night] and we'll never get the footage if we don't.' We built these beautiful woods and every time I look at them, I think, 'Ah, Canada!' It's actually, 'Ah, a room in Canada!'

GODDARD: I'm sure there were, but luckily, I had such a good crew, I didn't have to compromise much. We got it all done — the biggest problem was weather. But I don't think it really affected the final product. But our shooting plan went out the window on Day One, because we got to the gas station and it was snowing. That definitely put a damper on our 'cabin in the woods' movie [laughs]. If you look, you'll see the kids' breath sometimes, because it's so cold. But I think if I didn't tell people that, they wouldn't notice.

Was the gas station bathroom scene shot and cut out, or was it never shot because of time?

GODDARD: We shot it. It wasn't time. It was just a rhythm thing. It wasn't a decision they made us do — Joss and I both said, 'You know, it's taking too long. We kind of want to get to the cabin.' And so we just found those places for trims. It'll be a great DVD extra [laughs].

WHEDON: We shot it and then cut it. It just seemed draggy a little bit and it seemed less important than the introduction of Mordecai, played by Tim De Zarn. He's terrific. He's one of those guys who's been working for a long time, does a lot of theatre and training, and he's funny and grateful and exciting and just a lovely man. A lot of people who play crazy people *are* crazy people. Tim is the furthest thing from that.

How would you describe the look of *Cabin*?

GODDARD: I definitely wanted a very classic look. I found reference in old horror movies and old prairie photos. We did a lot of research on Buckner times. We set our sights on that. And with our control room, it was very important to me that everything felt real, even when we get ridiculous and over the top, and I wanted to ground it in government and institution and reality, so that when things went surreal, everyone felt grounded. So I definitely pulled a lot of stuff from historical archives.

Below: The cabin exterior set on location.

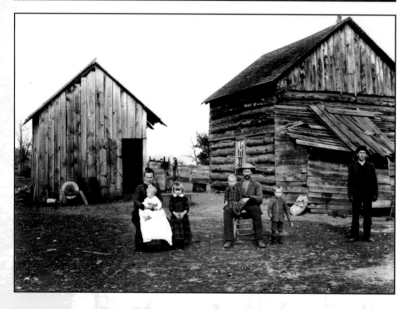

The look of the control room, in a way, looks a bit like a movie sound mixing stage.

GODDARD: There's a little bit of that, absolutely. I think to some extent that's just inevitable [laughs]. Whenever you have screens up and a control board, it's just going to make it feel like a mixing stage. We were definitely going more towards mission control at NASA, but it also sort of looks like a mixing stage. They all sort of had that vibe.

What did you need to do to achieve the look you wanted?

GODDARD: Well, it's funny, because so much of this has been a learning experience for me. Now, with all the digital [post-production equipment] — you take the film and you run it through the computer, essentially, and so you do all your color balancing and timing in the computer. So that was the biggest surprise to me, just how much of that now gets done after the fact. In the past, so much of this usually would get done before, like choosing the right filters. You can now put the filters on later, to some extent, as long as you don't want to go too weird. I really just wanted it to have a classic look. I felt like this movie gets so crazy, we didn't need the visuals to be crazy. We wanted the visuals to show restraint and elegance to them, so that when we go crazy, the movie still feels grounded, not like some crazy music video. I worked against a lot of the things I'm seeing in cinema today. I wanted to go back to a more classic feel.

WHEDON: I would describe it as classical, in the sense of, Peter Deming gave the light in the wood of the cabin a very beautiful sort of burnished glow, without making it *On Golden Pond*, so it informed the entire feel of that section. Then with Drew's camerawork we talked a lot about John Carpenter and Drew wanted widescreen — which I was on the fence about, but part of that was the fact that Carpenter had used it so well [and there was a risk that *Cabin* might be seen as visually too close] — and those not in-your-face, reserved kind of Steadicam shots. Just keeping it classically telling the story, pointing the camera at the story and not getting tricksy and jump-cutty and not using footage tricks, but really letting it unfold in a classical fashion. That was something we jibed on completely. There are so many movies that get all of their 'boo' out of doing something with the film and something jumps out and people are going, 'Yeah, but didn't you cheat?' And we wanted a much more classical 'boo,' in the same way that we wanted more classical zombies.

How did that hideous painting over the two-way mirror come about?

GODDARD: We knew the idea of what it needed to be and so it was just conversations with Martin Whist, our production designer. He had a great take on it. He pulled some old reference photos and mostly I kept pushing it to be more hideous. He would show me versions, and I'd say, 'No, make it worse, make it worse, make it worse.' Which was kind of a constant refrain on the *Cabin* set — 'We need more blood, make it worse!'

Was it difficult to shoot the scenes on the dock?

GODDARD: Yeah. It was miserable [laughs]. It was so cold and

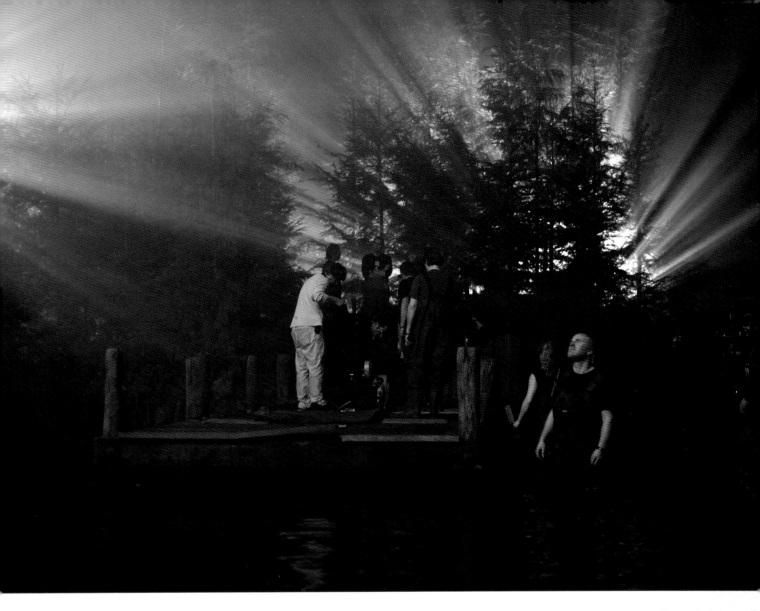

wet and it was the middle of the night and it was a tough one, but I think that toughness came across on screen, because the fight certainly wasn't supposed to be fun for Dana, and I think it comes through in her performance.

Between what we see when we're with Dana on the dock and what we see on the monitor, do we see the entirety of that fight?

GODDARD: We do. It is all there, but it's not always accentuated, because a lot of times, we're playing the fight in the background, which was the single most challenging part of the production. That was one of the things that only I understood. It was so hard to get people to understand what I wanted to do there, because it was counterintuitive. I said, we have to shoot a fight but then not show it [laughs], shoot a fight but then play it in the background. The logistics behind how do you shoot a fight and edit a fight, put it in on all your screens and then time your dialogue, so when people have dialogue in front of the screens, the fight still can happen in the background — it was a logistical nightmare, and it was probably one of the things I never would have attempted had I done this before, in my own naïveté about how hard it would actually be. If I had known how hard it would be to pull off, I probably wouldn't have done it, but luckily, I was just stupid,

because it's my favorite thing in the film. And it's all there, but we worked very hard to make it seem like it was just in the background.

How long did that take to shoot?

GODDARD: We had to shoot it all once on the dock and that probably took a day. And then we had to shoot it again in the party where we then play it back in the background while we're shooting the party, and I think the party took two days. So three days total. We shot the fight all on video for the video screens. Then we would shoot the aftermath. All of that dock stuff, before and after, is film. We shot that over two days, so it was a portion of those two days.

Is what we're seeing on the control room monitors what was actually playing back on the monitors when you shot or was it playing on the monitors for timing and then you digitally replaced it?

GODDARD: At the stage of post-production we're at now, we have not digitally replaced anything. Everything that you're seeing is stuff that we shot and was playing back on the day. Which was hilarious, because that scene is full of extras and we were very

Above: Shooting the dock scene.

Opposite: A selection of the period photos used by Goddard and production designer Martin Whist to develop the look of the film.

Right: Attack of the
Merman!

Opposite: Concept art for
one of the many, many
background creatures
seen during the third act
of the film.

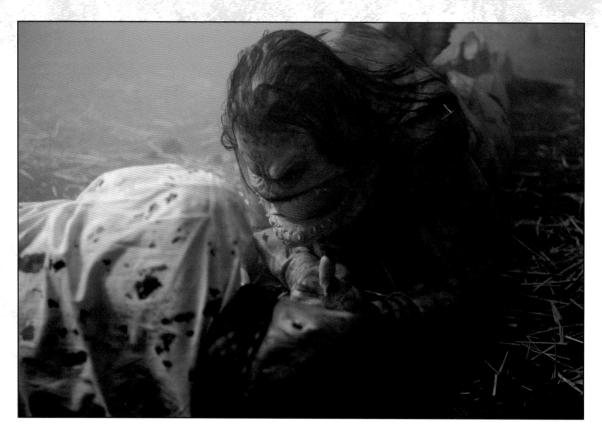

secretive, we didn't give anyone the script, and so those people
had no idea what was going on. They were like, 'I'm dressed up
like a lab scientist, but there's a vicious zombie beating up a girl
on the screen, but yet I'm being told I'm not supposed to look at
her?' They had no idea what the movie was.

**What was it called in Canada so that people wouldn't know they
were in** *The Cabin in the Woods***?**

GODDARD: We had a variety of names. I think one was *Mordecai*;
one was *Northern Practice*, which was just delightfully generic.

**Besides the Buckners, were there specific monsters you
especially wanted in there? Were there always a werewolf and
a unicorn?**

WHEDON: We didn't know if we'd get away with the unicorn, but
by God, we were going to shoot it, and that was really fun.

GODDARD: Definitely Joss and I had our favorites. I was obsessed
with the merman. Joss was obsessed with the ballerina. If there
was a ballerina note, I was like, 'Just talk to Joss.' He loved the
ballerina. I loved the merman. All of them, though, were our
obsessions [laughs]. We took those monsters far more seriously
than I think anyone expected us to. The amount of time we spent
discussing how the doll-mask people should move I think caught
everyone by surprise, because we just loved it so much. It was
very important to me that they had a real elegance to them, that
they always had confidence that they were going to get their prey,
and so they were never chasing. They had this slow walk, kind
of like artists, because to me, they weren't the scary people. So

if you watch, everything's sort of slow. It almost looks like a bit
of a dance as they move, even when they're dousing people with
gasoline and things like that.

WHEDON: The ballerina with the ring mouth was just the sort of
thing I like to think about. And you know me, I like ballerinas and
I like ring mouths. So that gave you two for one there. Deciding
what monsters we would have is a conversation that, by the way,
is still going on, because some monsters we did practically on
set we're replacing with CGI to find something that will have
a little more punch. We still have some elevators to fill. I was
instrumental I think in finally saying, 'Okay, budgetarily and
timewise, we don't have time for' what I think was one of Drew's
favorite monsters, Kevin. They had all the monsters, and on the
list was just 'Kevin.' Kevin was a very sweet-looking person who
looked like he might work at a Best Buy, he just wandered down
the hall and then off-screen in horrible fashion exsanguinated
someone. I said, 'I think people will be confused — I think we're
going to have to lose Kevin.' Drew, he loved Kevin. But we also
wrote the thing going, 'The one thing we *know* we're not going

"YOU KNOW ME, I LIKE BALLERINAS AND I LIKE RING MOUTHS."
— JOSS

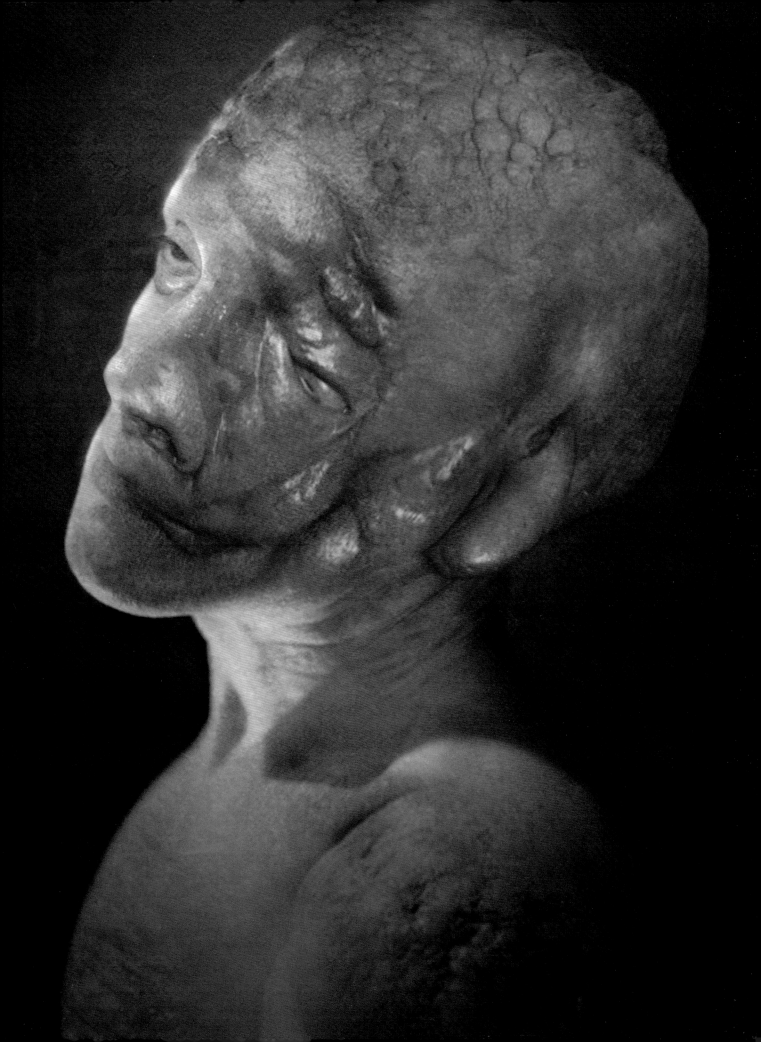

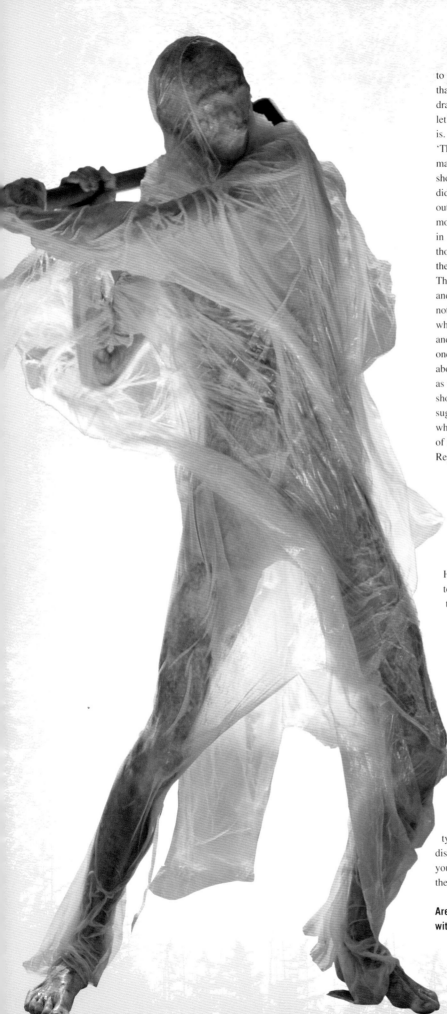

to get is a dragonbat. We're ready to give up the dragonbat.' And that's sort of my style [laughs], I'd be like, 'We can give up the dragonbat,' and Drew's like, 'We haven't shown it to anyone yet, let's not give it up yet!' And then there this adorable dragonbat is. And then Drew wrote the scene with the board and the phrase, 'The Angry Molesting Tree.' And that's some video footage that may end up on the DVD extras that was shot for a background shot that I don't know if it actually made it into the final, but we did have an Angry Molesting Tree. Well, there is a tree coming out of one of the elevators, but we had another shot where it's more molest-y. Knowing which creatures they were going to see in the elevators was probably the most important part, because those are sort of our heroes. We had all of those monitors going in the control room, and then of course we had the 'Brady Bunch.' The 'Brady Bunch' was the nine monitors that we pull out from, and those were our hero gags that we spent a lot of time deciding not only who's in the Brady Bunch, but who's the Alice, and then who's the Peter and the Jan? Because you see the middle one first, and then as you pull out to wide screen, you see the two flanking ones second, and then you see the other six. So we had long talks about who's the Alice, and then we had to figure out all the others as well. It really came down to Drew. [On second unit], I shot and shot and shot, Lisa put them together, she had suggestions, I had suggestions, and then Drew made the final call on what belonged where. And the doll mask people, which were a particular favorite of both of us, they drew the — they pulled the W on Alice, with Reptilius and the vomiting mutants as Peter and Jan.

Is the merman based on anything in a movie?

GODDARD: No. We didn't want everything to be a reference. Here's what happened with the merman — originally, it was a wendigo, because we thought it would be great if one of the guys always wanted to see something. He always wanted to see a wendigo, but he never got the chance to, and then later the wendigo came out. But then we realized that nobody knew what a wendigo was. It was like, even Joss and I — I sort of remember what a wendigo is, but I didn't quite, so we had to pick something that you hadn't seen. I can't remember seeing a merman in a horror film, but still, if I say 'Merman' to you, you at least know what it is, whereas if I said 'Wendigo' to most people, they'd say, 'I don't know what you're talking about.'

Is *Hellraiser* a favorite of someone's? There's a being who looks something like a Cenobite.

GODDARD: [laughs] We have a lot of love for *Hellraiser*. I have a signed picture of Pinhead that I got at the last Comic-Con. It was very exciting. So that is on my wall here. We wanted to say, 'Hey, we are standing on the shoulders of these giants. We have tremendous love and respect for these types of films,' and to act like they're not influences would be disingenuous, so there are places where we're like, 'Yes! We want you to understand that *Cabin* should be seen through the filter of these other films.' So it was definitely intentional.

Are there any vampires, or do you feel you have too much history with those particular monsters?

GODDARD: No, there are vampires. Particularly when all the chaos is going on — I could point the vampires out to you if we paused the screen, but they don't really register, because they just look like people. They sort of have a *Lost Boys* goth thing going on, but when you have them on the screen or you have a robot slaughtering something, blood flying or a giant snake, your eye tends to go to the giant snake. But there are vampires in there.

There also appears to be something resembling a short version of a Reaver.

GODDARD: There are lots of hidden gems in the movie from our past, for people who are paying close attention.

Do we ever see the killer clown, apart from when he's on the monitor?

GODDARD: Yeah, there's a scene in all the chaos where he's coming at a woman who's shooting him and he just keeps coming at her. It's funny — I've said this to everyone as we were working on it — this movie is designed to be watched repeatedly. You're not supposed to get it, to see everything the first time. There's just so much — I feel like when you watch the second time and you watch the cellar and you now know all the monsters, you're going to see stuff that you didn't notice before in the cellar, you're going to see stuff in that chaos that you're like, 'Oh, I had no idea that was there.' We worked very hard to make it pleasurable to see it again and again and again, because those are the types of movies I like. I don't like movies that get less interesting the second time you see it — I like movies that get more interesting the second time around.

In behind-the-scenes photos, we can see that some of the creatures exist sometimes as heads on set, like the werewolf head and the unicorn head. Are those easier or harder to work with than a whole body?

GODDARD: It just depends on the shot. Sometimes if you're doing a close-up, it's easier probably with the partial; if you're doing movement, you need the whole thing. It just depends. Every shot has its own needs.

WHEDON: Obviously, we had a horse with a horn and then we had a head that would gore someone. We couldn't even convince the editing assistants that the head wasn't real until the cameraman accidentally panned right and they saw the machinery of the person holding it up, and they were shocked. And then, for the werewolf, we ended up using almost exclusively the man in the suit, because he really, really brought the energy to it, and the separate animatronic head, as is often the case, didn't actually end up getting play. Although he had some animatronics in the head he was wearing that are not as extensive.

Were there any monsters that you couldn't accomplish?

WHEDON: Not really. It was a question of, what do we want to do? And what would be scary chasing you through the woods? And what feels classical? The monsters that we couldn't do were really just monsters that we ruled out. We knew which ones we were

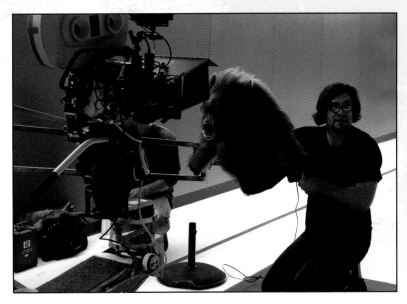

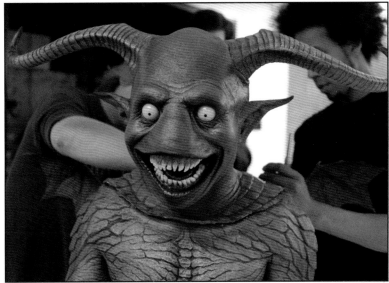

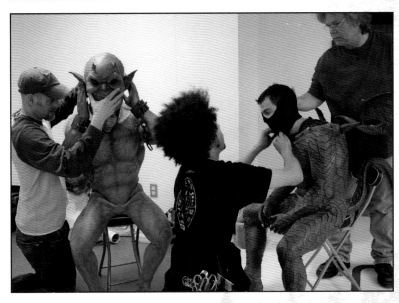

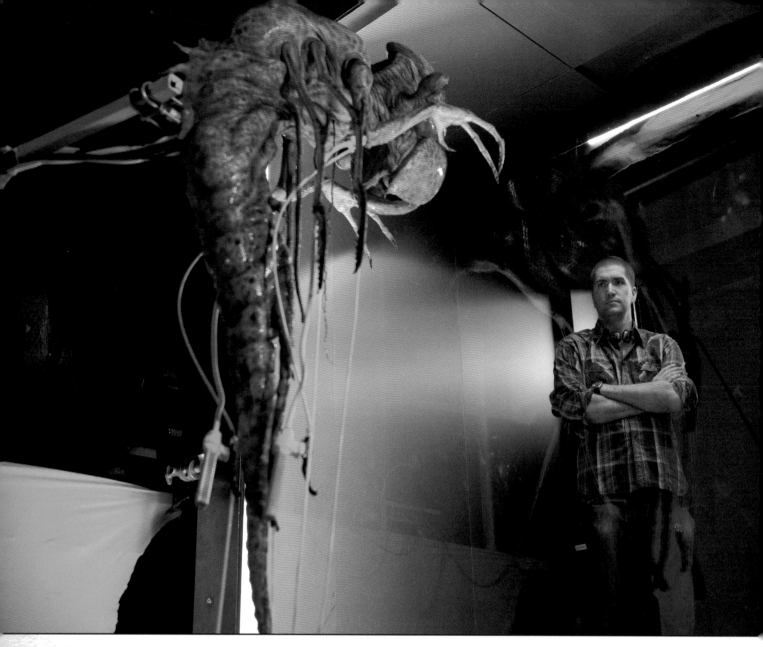

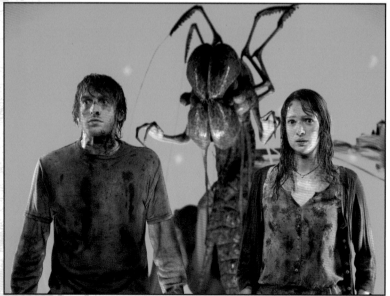

going to animate with CGI, which we wanted to use as little of as possible. And then it was just our imaginations got to do whatever they wanted, because there's nothing that can't be done now. We have a Kraken, for God's sake.

GODDARD: I was lucky. I got to do pretty much everything I wanted.

Do you work differently with actors than you do with technicians?

GODDARD: A little bit. For the most part, on a film set, everyone is an artist. Every department has their art. So you communicate differently because you're talking about a different medium. Actors are working with themselves, whereas a cameraman is working with the camera, but all of it is, you're communicating about the art and what you want it to be. And so in that regard, they're all very similar. With actors, you do have to respect that they don't have a camera they can turn on, so you can't be as technical. You have to go to it from a purely emotional side. I'm very specific and I'm very meticulous. I take all of this very

seriously. I do love it, but I get very hung up on details. You learn that sometimes to get what you want, you don't want to micromanage. With actors in particular, you need to let them find it. Every actor and every technician, every crew member — you learn which person needs what. Some people don't need to talk about it, you just need to say, 'Faster,' and they do it faster. And some people need to know, 'What is the artistic intent?' and then you do that, you sit down and you talk with them for hours. It's different for every person.

Did any of the staging/filming of killings cause you concern?

GODDARD: Yeah. It's weird. It's much more fun to shoot a joke. It's more fun to shoot people doing comedy. The kill stagings — they're just hard. In order to do them right, you have to be pretty violent and doing something like Jules' death — those are hard days on the set. I care so much about these characters and these actors, you really start to love them just from going through this process, and so watching them get butchered, it's hard. I wasn't expecting it to be as hard as it was.

Did you have any concerns about staging the stunts in terms of safety?

GODDARD: We had such a good stunt team — if ever I wanted them to do something that wasn't safe, they'd simply say, 'No, I'm sorry, that's not safe.' And I worked on *Alias* for two years, there's

not a whole lot that people can surprise me with, we did everything on that show [laughs], so between me and the team, everything was safe. I always was saying, 'It's not worth it, it's just a movie. If anyone's going to risk their life, let's do it for a different movie, don't do it for mine [laughs]. It's not worth it.'

Was there anything that actually grossed you out?

GODDARD: Not really. There's a zombie stairwell feeding frenzy — we shot video coverage of it and we shot some close-ups of zombies pulling guts out and eating people's guts that look particularly gross. I remember when we were shooting, my script supervisor had to just look away. She was like, 'I can't even look at that, it's so disgusting.'

WHEDON: Well, vomiting mutants — that actually went on for a long time. And Drew definitely has a higher tolerance for blood than I do. A lot of the time, I said, 'I don't think there's this much blood in the world,' and then I'd look at the footage and go, 'This is pretty. Drew was right. This is pretty. I wish I had more blood in that movie I did.' There are some stabbings in there — I think stabbing Jesse [Williams as Holden] in the top of his head — they made a top of Jesse's head that was kind of phenomenal, and because his head is shaved, the blade going in is difficult to watch, but honestly, there wasn't anything — you know, we're not actually huge gore fans. Drew is perhaps slightly more than me, but always in the service of the movie, not for its own sake, not

Below: Joss Whedon: "Drew definitely has a higher tolerance for blood than I do."

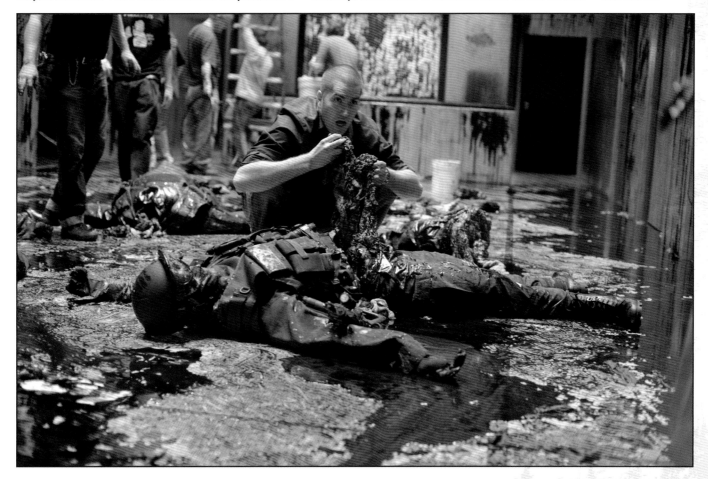

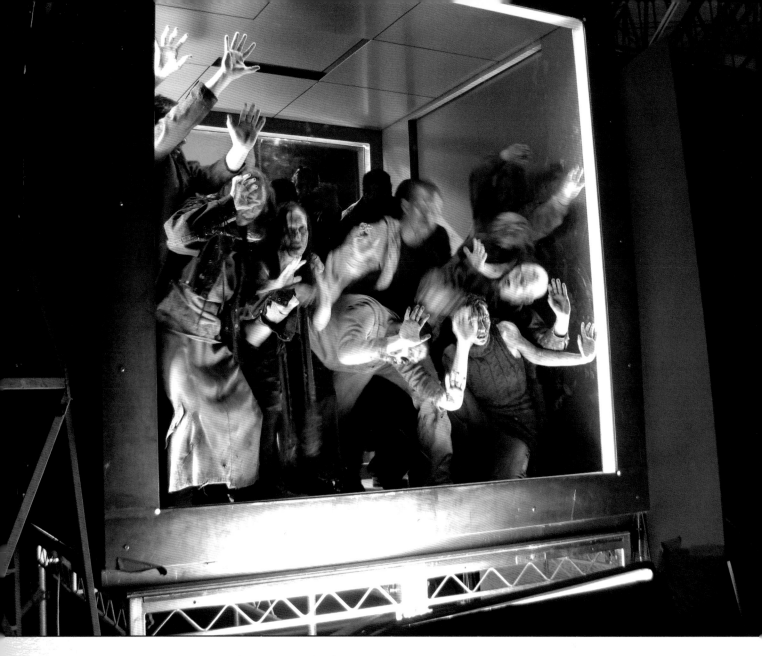

to become pornographic, not to become just like buckets of blood for their own sake. Drew definitely loves it, but at the same time, he knows there has to be integrity behind it. There is a bloodbath because they tried to off these kids and they are getting payback for that. So neither of us was really going for the gross. And so it's really a family film.

What were you most looking forward to shooting when you wrote it?

GODDARD: It's funny. This movie was a director's dream, in the sense that I remember looking at the schedule a week before we started shooting and looking at every scene and going, 'Oh, there's something fun in that.' Every scene, I was like, 'That's going to be fun, that's going to be fun, oh, *that*'ll be fun.' Some scenes were more fun than others, but every scene, there was something fun about it. It was not your average everyday at the office, that's for sure. I think probably the Harbinger speakerphone would be the thing I was looking forward to the most, just because I love that scene so much and any time you get a guy on a speakerphone,

arguing with Bradley Whitford and Richard Jenkins, you know that's going to be a fun day. And that did not disappoint. That day was an absolute blast.

WHEDON: That's really a Drew question, but I would say probably one of the most exciting days for me was the introduction of Dana and Marty in the lobby. We had been in the woods — we actually shot the cabin stuff first — and then to bring them to this stark, white Kubrick-esque place was so startling. It was in our heads and in the script, but when you see it in the movie, it has a more visceral effect for them to be bloody and muddy. They're in this perfectly white environment, and that for me was so startling and so exciting, I felt it was grand.

What was the most arduous scene that made you say, 'Thank God we got through that'?

GODDARD: In terms of shooting, it would probably be any time you're at night. We were at night in March in Vancouver, which means it's raining, so there were a couple of nights outside the

Above: Shooting an elevator scene.

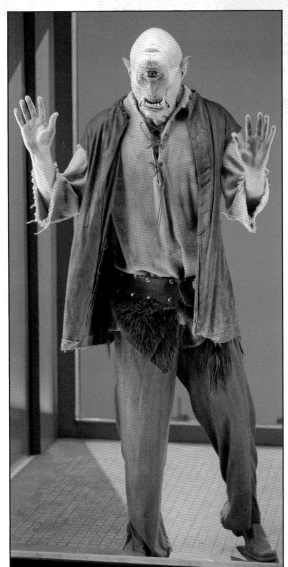

cabin, like when Marty's getting dragged away, I remember that night being particularly hard, because it was raining like hell and it was cold. Something happens around five in the morning when everyone's wet and tired [laughs]. You just want to go home and go to bed. I think that was one I was glad when it was done.

Were there any shots for you that were particularly tricky to compose and execute?

GODDARD: Yeah. The shot where the elevator doors open and all the monsters come out — we're still working on it, there's so much visual effects involved — but that so far has been at least one year in the making. I started storyboarding that a year ago. I've been working on that shot and the composition of all the different monsters and what comes out of the elevators and when and how. I knew I wanted to do it all in one shot, and that shot in particular has taken, in the amount of man hours, over a year.

Is that a big composite shot?

GODDARD: Yeah. We had all eight elevators, and so you shoot one by one. I wanted to do as much of it practical, on set as I could, without visual effects. Of course, there's stuff in there that's visual effects, like the giant snake, but a lot of that is not CGI, a lot of that is creatures and guys on wires getting ripped around. We had to build a whole stage for it. There's a whole making-of section on the DVD just for that shot, because we have so much material.

How long is your post-production schedule?

GODDARD: It's hard to say. My personal feeling is that post never really ends until the movie comes out [laughs], because you're always doing something. There are official dates, but in my mind, I'm going to be tinkering with it until it comes out. It's getting better every day. Part of it is that Joss and I are so used to television deadlines that we get things done quicker. We're used to eight days to finish an episode, so when we have ten weeks to finish it, it's like, 'We don't have to worry about when it's going to be on the air next week? Okay, good. What do we do with all the spare time?' Every day, we're doing more work and getting the

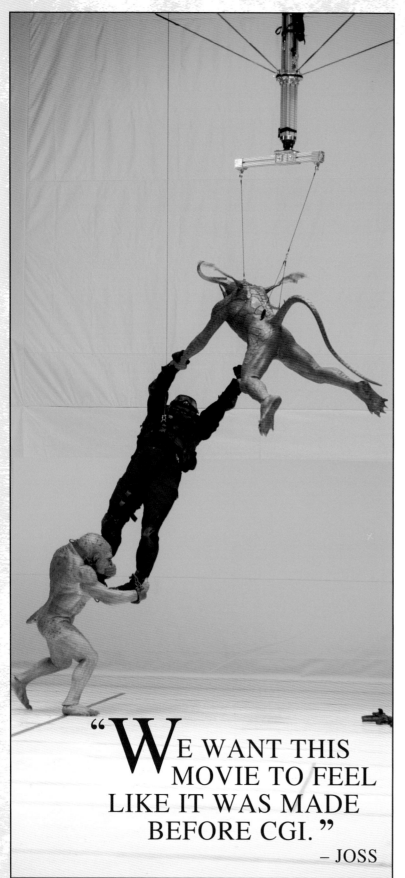

> ## "WE WANT THIS MOVIE TO FEEL LIKE IT WAS MADE BEFORE CGI."
> — JOSS

effects done, getting all the ducks in a row. If you liked it before, it's going to be even better the second time.

Are things looking different in CGI than you had expected, or are they just fleshing out what you had in your mind's eye?

GODDARD: No, they definitely get better. The team that we've got at Rhythm and Hues is just spectacular. I usually give them a version, and then they just take it and make it better in every way.

WHEDON: Things always look different in CGI than you expect. Some things look much worse and some things look much better, and you're constantly the judge of that. We have John Swallow, who was at Universal, worked with me on *Serenity*, and is co-producing this film. He's a phenomenal problem-solver, so he's tracking all of that, and Drew has a very precise eye for that, too. The last thing we want is anything that looks fake. We want this movie to feel like it was made before CGI. We're very fierce about trying to get everything practically if we can, because it feels more present.

Is music affecting your vision of the film and/or bringing out any qualities you hadn't expected?

GODDARD: Yes, for sure. I've just started working with our composer David Julyan, whose work I love. I just heard his first stuff today, and as it comes in, it's giving it this new layer that is breaking my heart in all new, wonderful ways.

WHEDON: We got the person we really hoped to get, David Julyan. We used a lot of him for our temp score, so right now, I've only heard very short cues, but it's like, 'Ohh, good… look, it's our movie.' I'm excited to hear what he's going to do with a lot of the other more specific things.

What surprised you most about directing?

GODDARD: I think the exhaustion [laughs]. It's really tiring and I remember thinking, 'How do these old directors do it?' Because I'm a young guy in relatively good shape and I thought I was going to die by the end of it. You're just so tired. It's amazing how tired you are by the end. I have tremendous respect for guys who've been doing this their whole lives. It's definitely exhausting.

What did you like most about producing?

WHEDON: I've explained what I like least. Besides being a control freak, I kind of would go [regarding directing], 'God, that looks fun.' But what I liked best was that I could walk away, that I could go and solve another problem. Drew was there weeks before I was; it was his air and his meat and drink every second. I occasionally could go have *real* meat and drink somewhere else. I could leave and come back. I could see my family on occasion. What you get is a little more freedom — not as much as I would have liked, because I had to end up doing two weeks of line-producing [being in charge of the physical day-to-day production], I had be more of a grown-up than I care to stomach, but the fact of the matter is, it's also fun. At one point, I was in New York while Drew was in Canada, and I met Kristen [Connolly] for drinks before we

started filming, to say 'Hey' and get to know her a little bit. And I talked to Drew. He was like, 'I spent the entire day feeling like I'm having things taken away from me.' 'Really? I've been having drinks with Kristen. Welcome to the difference between a director and a producer.' He was like, 'I hate you. It's not funny or a joke — I hate you.' Being a director is more fun, but being a producer, it did free me up a little bit.

Were there any big disagreements between the two of you?

GODDARD: No. Certainly nothing that either of us was unhappy about. There were times when we disagreed, for sure, but passion always won, so if I felt strongly, then he would back down, and if he felt strongly, I would back down. There was no time when we both felt strongly, because we both have tremendous respect for one another and so all the disagreements were little things and were overcome. Any time I disagreed with him, I'd usually come back and go, 'You were right.' And it worked out well.

WHEDON: You know, I think we never had any major disagreements. We disagreed about some things, but in general, if it was a matter of the aesthetic of a scene, Drew is extremely collaborative and he knows how much I'm invested in the story, and we're old friends. He listens. At the same time, it's his set and I will not mess with that. I do not mess with that. I have not messed with that with my directors in TV. As long as I'm getting what I need emotionally, I don't mess with what they're doing visually. So Drew made me feel completely comfortable making suggestions right from the start, and I only tried to be helpful, and say, 'Can you take a shortcut here, is the actor giving us enough of this, are we worried about how this is going to…?' The same things anyone would say.

I would never say, 'You can't have any more takes.' I remember one time I did say, 'Do we really need to go again on this?' and Drew said, 'Oh, no, I changed set-ups.' 'Oh, I used up my only 'can we hurry up' for the day!' I tried not to be that pushy schedule guy, even though I am that pushy schedule guy. But at the same time, and I think this is the other fun part about being a producer, I would say, 'Well, we can't do this,' or 'We can do it this way,' and Drew would say, 'Well, we're looking at this, but there's a worry that it's going to cost this,' and I would look at him and go, 'We'll get the money.' I got to say the producer thing — 'Shut your penny-pinching mouth and build him that platform!' like Kirk Douglas in *The Bad and the Beautiful*. The only time I felt like I sounded like a real producer was when we were in the woods and we had a crane shot going from the end of the house, and I was sitting there going, 'There's my woods! I paid for those woods! Film those woods!' I felt suddenly I sounded like Joel Silver. But I was actually being entirely truthful. When I came to Canada, I wanted to get some beauty shots of these woods. I'm fierce about schedule, fierce about budget and I will sacrifice what I'm doing, or at least compromise to make it work, to stay on time and under budget. It's because I was a producer before I was a director and produced a lot of TV, so I would be much more worried about that, and Drew would be much more focused on just, 'Am I getting what I need from this scene?' And again, Dan Kolsrud, head of production, was a great help with that. He came down, he'd been a line producer for years and he said, 'You don't need to worry about this. Here's what you need to worry about. And maybe you guys can look for a place to lighten your load down the road, but you can stop obsessing over it.' I mean, I'm obsessive to the point of compulsive, so the fact that we started off half a day late because of snow kind of haunted us in a way, and the fact is that

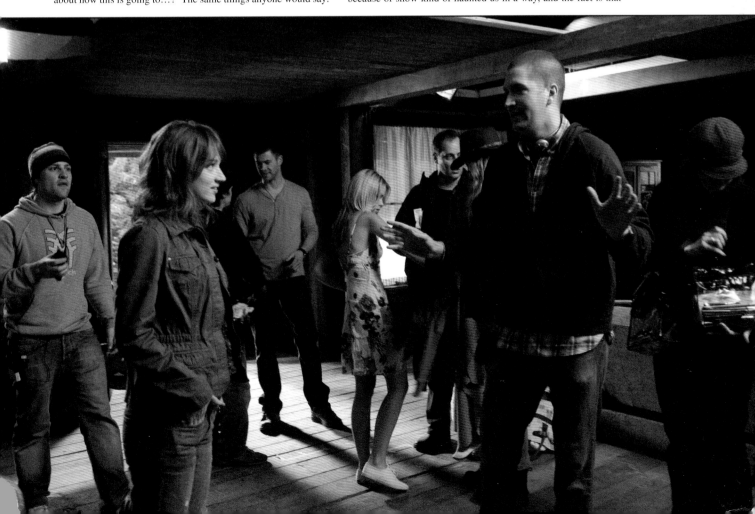

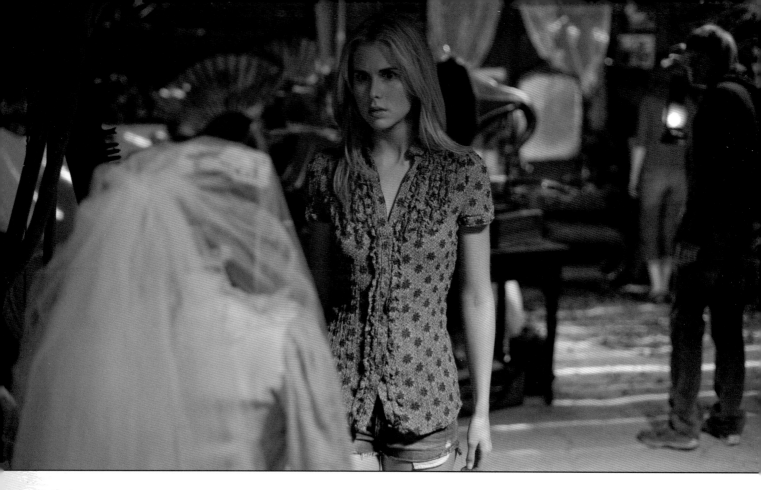

it was a very rough shoot, where we just had to keep everything under control. That was difficult for me, because I felt like part of the job of a producer is to make sure that everybody gets what they need, but at the same time, 'everybody' includes the studio [laughs].

Now that the film has been acquired by Lionsgate and is scheduled for a 2012 release, what has that experience been like?

GODDARD: It's been a dream, I have to say. You always want your movie to find the right home, and there's no question that Lionsgate is the right home for *Cabin*. I mean, you look at all the films that inspired *Cabin* — most of them were released by Lionsgate in the first place! It gives you a shorthand. With some places, there's a bit of a horror disconnect, but with Lionsgate I can say something in a meeting like, 'I'm thinking it should be red, but not *The Descent* red, more *Haute Tension* red,' and they don't look at me like I'm insane. It definitely feels like we're speaking the same language. They've been wonderful.

In both of the feature films you've written, the world ends at the end. Is that just because that's your way of wrapping up the story?

GODDARD: You're not wrong. I'm definitely going to try to avoid it [laughs] — I've said what I needed to say now about the world ending, at least for the foreseeable future. Who knows? It might be a theme I come back to later in my career. We'll see.

Is it possible to do a sequel to *Cabin in the Woods*?

GODDARD: It's funny, because we talked about it. I was a huge Douglas Adams [*The Hitchhiker's Guide to the Galaxy*] fan growing up. There's probably no bigger influence on me growing up than Douglas Adams. And I remember, I went and saw him talk, and someone asked him, because he had ended the universe several times, 'How can you do a sequel? You've ended the universe.' And his response I thought was genius. He said, 'Well, first of all, it's fiction,' and everyone laughed. And then he goes, 'Second of all, it's science fiction, and third of all, it's comedic science fiction, so I could probably find a way if I needed to.' [laughs] I thought that was a very elegant way of saying, 'If we need to, we could.' I don't know that we will. We didn't write it with a sequel in mind, but I'm not preventing it. You never know. There might be an idea where we go, 'Oh, that would make us love to write a film,' but when it comes to these types of comedic genre films, there's probably a way that we could get into a sequel if we needed to.

What is your favorite scene in terms of how it turned out?

WHEDON: I would say the scene in the cellar. I am visually so compelled by that scene and I am absolutely certain that every single one of them is going to do the thing [of summoning a monster], that the thing they're holding is going to cause something terrible, even though I know what's going to happen. The way that's shot and the way it's cut — it's without a word, and you know I loves me my words, don't get me wrong, but I love Marty in that scene and mostly I love what Drew did with it. He fought to get it to be as dark as it was. He was very fierce about it looking like they had one lantern. They had wall sconces, they did all the things that people always did in movies to cheat, and

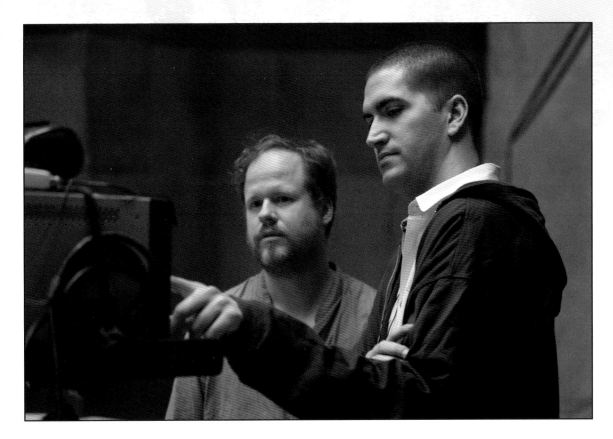

Drew said, 'We're not going to cheat, we're going to keep this dark, and we're going to light the lamp and it will be a different kind of darkness.' I get really tense during that scene, even though I'm well aware what's going on.

It does make you want to do a frame search and look at all the objects, then match the objects to the monsters they summon.

WHEDON: Well, that is actually part of it. Although we loved making jokes, figuring out what was going to be on the betting board and all this good stuff, some stuff that was on the board we knew that we'd see and some we wouldn't, but at the same time, we're very fierce about the reality of these things. They do summon something, we do know what it is, we know why you don't want to see it. And we know why it belongs in the cabin in the woods. Even to the point of, one of the monsters on the board is the Huron, which is literally just an Indian, because going back to the earliest settlers and their fears, that was the thing they were afraid of in the woods — the people who were actually supposed to have the woods. And so we really wanted to go back to show how this classic ritual had evolved over the years, from before movies.

GODDARD: I'd say my favorite scene is the ending, Dana and Marty on the steps, when everything's happened and the two of them are just sharing a joint back and forth. That is the scene that I go, 'Okay, this is why I'm alive.' [laughs] Joss wrote that interaction between the two of them and I remember reading it going, 'That's the best scene I've ever read.' I had nothing to do with it, so I can say that — I'm allowed to say that I love that scene.

Did *Cabin* always end with the apocalypse?

GODDARD: Absolutely. Yeah.

Is it liberating to finally do an apocalypse where you don't have to go, 'Okay, well, we get to the brink' and then have to figure out how to get back from the brink?

WHEDON: You know, I will say yes. It is an apocalypse that's straight up. We end it, you got it, and it isn't a rage virus. We can have an apocalypse with no extras. Now that's really straight ahead.

Was there ever a version where either Dana did shoot Marty or Dana refused to shoot Marty?

GODDARD: No.

WHEDON: No, she was always attacked by a werewolf. We felt like we wanted to bring up the question, but then we wanted a werewolf to come in instead.

Is it important to not definitively answer the question?

WHEDON: I think it is. I think it's important to say that there is no right decision where she is. There's no decent way out. We don't want to come down on either side in that case.

GODDARD: I feel like it's one of those organic 'this is what the story is.' It just felt right. I can analyze it and explain why I *think* it's right, but at the time it was just like, no, this is what should happen.

Above: Rehearsing the final scene, in which Marty and Dana fail to save the world.

Opposite: The animatronic werewolf head produced by AFX Studio.

If, to save the world, you have to execute your friend, you should say no. There wasn't a whole lot of thought in terms of why we should do it, it really came from a gut place.

What do you feel is being said with Dana being prevented from shooting Marty, but not preventing herself from doing it, either?

GODDARD: I'm not even sure she doesn't decide. I think that it can be read a variety of ways, and again, that's one where, if I answer it, I feel like whatever I answer, people will then take that as gospel, and it's not meant to. I leave it to people to decide if it is or not. And I don't have the answer. At the end of the day, once the movie comes out, it belongs to everyone, and everyone will have their own interpretation of that very thing. All I can say is, the movie says exactly what we want it to say. If it feels ambiguous in places, it's supposed to be, from our point of view.

WHEDON: It's really a comment on the dark side of the psyche and our society. We do have a need, which I, and everybody else, have always failed to explain, to see these horror things. We have a need in us to delight in the terror of monsters and people in trouble. But then society has dictated more and more specifically that it be young people punished for drugs and sex, and that that is the theme of the classic American horror movie now, and I'm not necessarily on board with that. I feel like that wasn't part of the original plan.

Is there a suggestion that a society that is built on this punishment might deserve what it gets if it backfired?

WHEDON: I believe we actually just say that in the movie, that we deserve what we get. I mean, you want a little bit to tear down these basic assumptions and start again. Now obviously, I don't want everyone in the world to be killed by giant gods, just some people in the world. But I do feel like it's so ingrained in our society that this is the normal course of horror entertainment and that there is this weird obsession with youth and sex, and at the same time this very puritanical desire to punish it that I think is unseemly and really, really creepy.

Do you think these are the answers you would have given prior to a long history of every detail of *Buffy* and *Angel* and *Firefly* and

Lost being scrutinized relentlessly?

GODDARD: What I feel these days is, we now live in a time, thanks to the Internet, when we are not used to not having answers. As a society, we want to know the answer to everything immediately online, but particularly when it comes to art, some things should not have answers, or at least, we shouldn't treat the artists like they are the final say on it. I don't feel like I'm the final say, even though I wrote and directed this movie. I don't feel I'm the final say about what it means. I leave it to the people who are watching it to decide what it means. I feel really strongly about that.

Do you feel like, if you had the answer to all of the questions, then you wouldn't need to make art — people could just meet you?

GODDARD: Absolutely. I think that that's absolutely right. And it wouldn't be as interesting.

What are you happiest with about the film?

GODDARD: I'm happiest that it is so close to what we originally intended. So much of this filmmaking process is about compromise and I can honestly say, so far, knock on wood, I have barely had to compromise. It really is what we wrote. It is what we came out of that hotel room with, for better or worse. If people don't like it, there's no one to blame other than me, because it is what I wanted all along, absolutely. I hope there are people out there that like it and I hope it plays late nights in horror theaters for a while and we go and we dress up [laughs]. I always wanted to — those are my ambitions.

> ## "I LEAVE IT TO THE PEOPLE WHO ARE WATCHING IT TO DECIDE WHAT IT MEANS."
> — DREW

What are you going to dress up as?

GODDARD: I don't know. It'll be different every time. Probably Hadley or Sitterson — that's a fun costume, just be guys in those shirts and ties. But yeah, I like cult movies. Ten years from now, I want this to be playing at midnight on a triple bill with Peter Jackson's *Dead Alive* and Sam Raimi's *Evil Dead 2*. That's my ambition. *Dead Alive*, *Evil Dead 2* and this, I'm happy.

Do you and Joss have any specific plans to work together again?

GODDARD: Nothing specific, but believe me, I will be bothering Joss to come work with me for the rest of my life. ✛

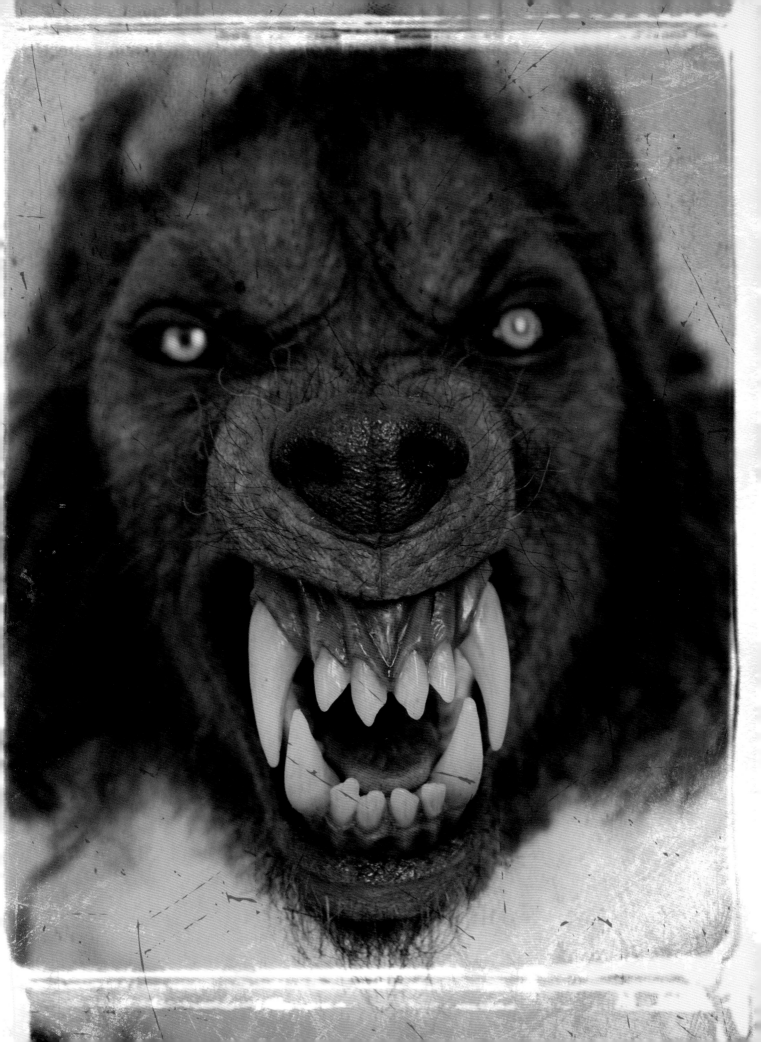

THE SCREENPLAY

INT. BREAKROOM — MORNING

Steve HADLEY and Gary SITTERSON
are workaday white collar joes getting
coffee and vending snacks as they chat.
They have a sweet rapport.

HADLEY
It's hormonal. I mean, I don't usually fall
back on, you know, "it's women's issues"...

SITTERSON
But child-proofed how? Gates and stuff?

HADLEY
No no, dude — she *bought* gates, they're
stacked up in the hall — she did the
drawers! We're not even sure this fertility
thing is gonna work and she's screwed in
these little jobbies where you can't open
the drawers.

SITTERSON
At all?

HADLEY
They open, like, an inch, then you gotta dig
your fingers in and — it's a nightmare!

SITTERSON
Well, I guess sooner or later —

HADLEY
Later! She did the upper cabinets — kid
won't be able to reach those 'til he's thirty!
Assuming, you know: *kid*.

Hoisting files and, in Sitterson's case, a
small white cooler — the kind that might
carry organs — they exit into:

INT. HALL — CONTINUOUS

It's an anonymous concrete maze. A few
other workers pass by as the men talk.

SITTERSON
It's a talisman. It's an offering.

HADLEY
Don't even — you have women's issues.

SITTERSON
Please. You of all people —

HADLEY
Me of no people! It's a *jinx*. Guarantees we won't get pregnant and it takes me twenty minutes to get a fucking beer.

Wendy LIN, a nervous woman in a lab-coat, joins them.

LIN
Stockholm went south.

SITTERSON
Seriously? I thought they were looking good.

HADLEY
What cracked?

LIN
I haven't seen the footage; word's just going around.

HADLEY
That scenario's never been stable. You can't trust... what do you call people from Stockholm?

SITTERSON
Stockholders?

Hadley points at him, 'oh no you didn't' making a big —

HADLEY
Haaah!

LIN
That means there's just Japan. Japan and us.

HADLEY
Not the first time it's come down to that.

SITTERSON
Japan has a perfect record.

HADLEY
And we're number two so we try harder.

LIN
It's cutting it close.

They turn a corner and find a row of golf carts at the end of a long, featureless hall. The boys hop in.

HADLEY
That's why it's in the hands of professionals.

SITTERSON
They hired professionals? What happens to us?

LIN
You guys better not be messing around in there.

SITTERSON
Does this mean you're not in the betting pool this year? Big money...

LIN
I'm just saying it's a key scenario.

HADLEY
I know what you're saying. '98 was the Chem Department's fault. And where do you work again? Wait, it's coming back to me...

He peels out, Sitterson trying not to spill his coffee. We stay with them...

HADLEY (CONT'D)
Gonna be a long weekend if everybody's that puckered up. Hey, you want to come over Monday night? I'm gonna pick up a couple power drills and liberate my cabinets —

Below: Designs for the golf carts used to get around the complex.

"GREATEST SHOW ON EARTH..."

SITTERSON

RICHARD JENKINS

MY agent called me and said, 'They're interested and would you take a look at the script?' And I said, 'I don't really think this is my genre.' She said, 'You should read it, because these guys are really talented.' And, as soon as I read it I said, 'Yeah, I'm gonna do this.' I thought the writing was very good, funny and smart. It took me two seconds to make up my mind, once I read it. I just loved it.

I've never come across anything remotely like this. It's a genre that I have not been in. A lot of things happen in this movie that aren't [nice], and yet it's the happiest set I've ever worked on. Everybody's having a great time and Joss and Drew both love their work.

Joss does in movies what I love in the theater. I love it when people look at something and try to re-conceptualize it without changing what it is. I think Joss is trying to understand this genre, trying to explain it. Where do these things come from? We see them on screen but where did they come from? And he goes after it, and in his imagination, says, 'This is what I think it could be.' I love that; I think that's really the sign of an artist.

I loved the board scene when we were placing the bets. You got to see all of these creatures, and the kitchen staff and all the different departments — everybody had their money in there, and it was so normal. I love the fact that they wrote that. An office pool, it's so cool.

I've really enjoyed it. I think we found some fun things, and some interesting things, and I'm really glad Bradley's doing this with me because he's really good. It's hard not to have fun with Bradley, you know. ✛

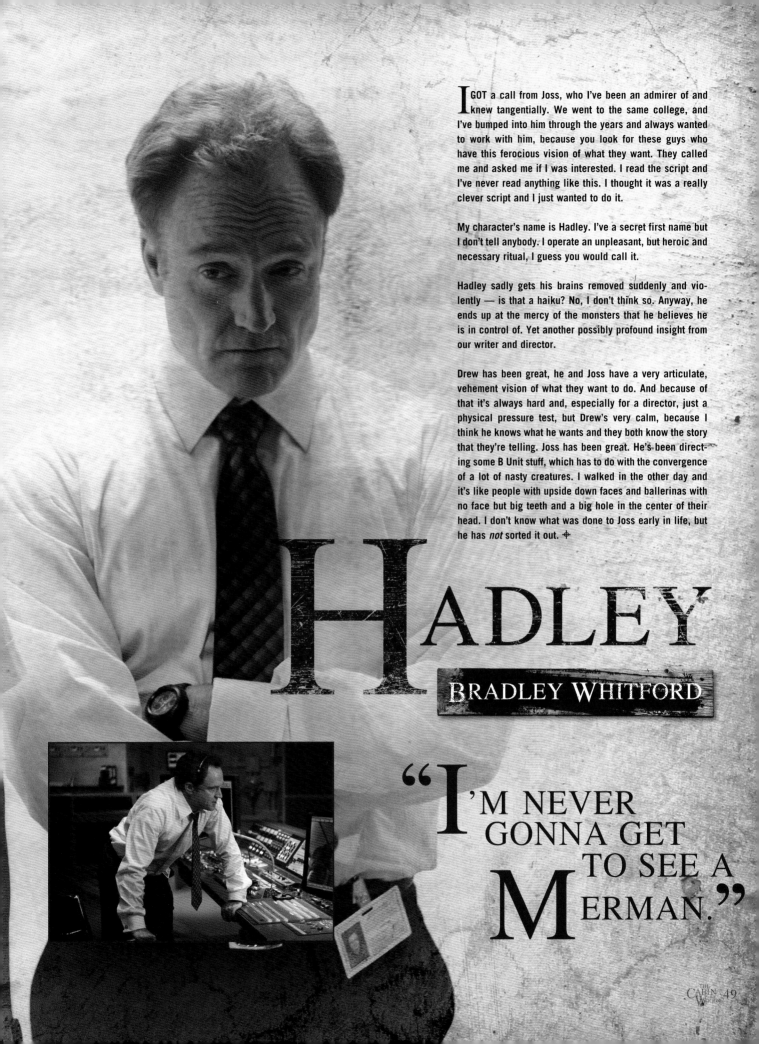

I GOT a call from Joss, who I've been an admirer of and knew tangentially. We went to the same college, and I've bumped into him through the years and always wanted to work with him, because you look for these guys who have this ferocious vision of what they want. They called me and asked me if I was interested. I read the script and I've never read anything like this. I thought it was a really clever script and I just wanted to do it.

My character's name is Hadley. I've a secret first name but I don't tell anybody. I operate an unpleasant, but heroic and necessary ritual, I guess you would call it.

Hadley sadly gets his brains removed suddenly and violently — is that a haiku? No, I don't think so. Anyway, he ends up at the mercy of the monsters that he believes he is in control of. Yet another possibly profound insight from our writer and director.

Drew has been great, he and Joss have a very articulate, vehement vision of what they want to do. And because of that it's always hard and, especially for a director, just a physical pressure test, but Drew's very calm, because I think he knows what he wants and they both know the story that they're telling. Joss has been great. He's been directing some B Unit stuff, which has to do with the convergence of a lot of nasty creatures. I walked in the other day and it's like people with upside down faces and ballerinas with no face but big teeth and a big hole in the center of their head. I don't know what was done to Joss early in life, but he has *not* sorted it out. ✚

HADLEY

BRADLEY WHITFORD

"I'M NEVER GONNA GET TO SEE A MERMAN."

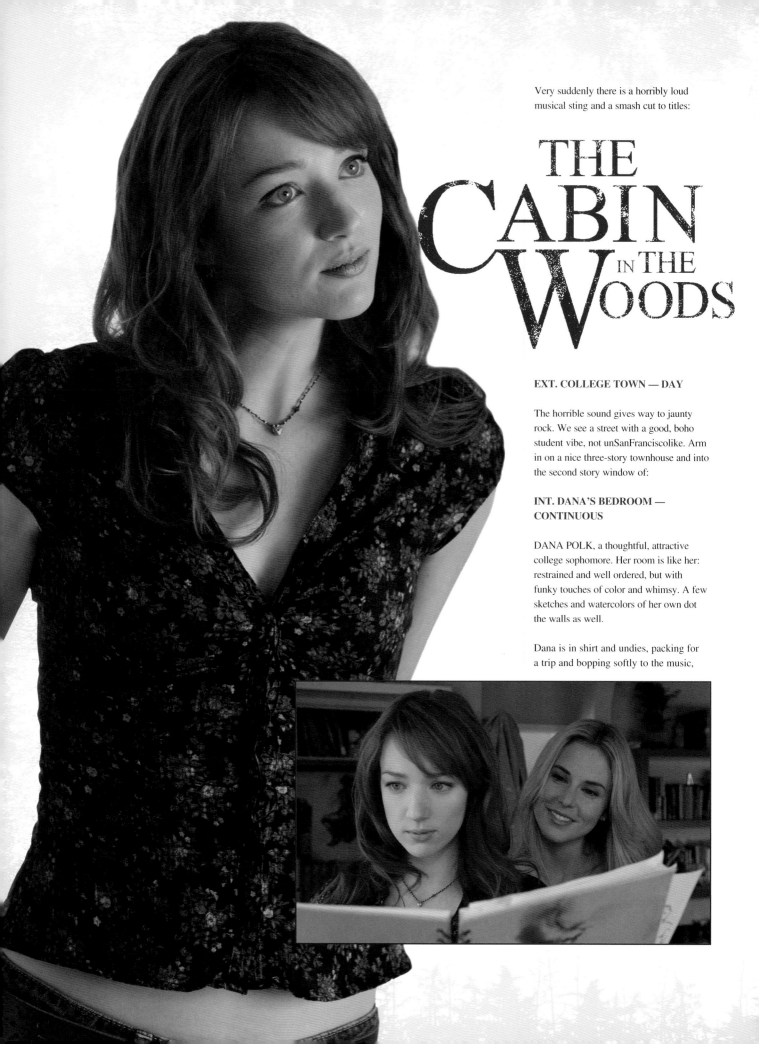

Very suddenly there is a horribly loud musical sting and a smash cut to titles:

THE CABIN IN THE WOODS

EXT. COLLEGE TOWN — DAY

The horrible sound gives way to jaunty rock. We see a street with a good, boho student vibe, not unSanFranciscolike. Arm in on a nice three-story townhouse and into the second story window of:

INT. DANA'S BEDROOM — CONTINUOUS

DANA POLK, a thoughtful, attractive college sophomore. Her room is like her: restrained and well ordered, but with funky touches of color and whimsy. A few sketches and watercolors of her own dot the walls as well.

Dana is in shirt and undies, packing for a trip and bopping softly to the music,

which now comes from her little stereo. She does that singing-along thing where you start to sing too soon, looks sheepish even though she's alone.

She takes a couple of political science textbooks, drops them in her suitcase. Crosses to grab some art supplies, including a battered sketchbook. She pauses, flipping through her sketches — which aren't bad — til she gets to a portrait of a handsome thirtysomething man with longish hair and glasses.

CLOSE ON Dana staring sadly at the picture when Julie "JULES" Louden comes into frame next to her. Jules is bubbly, sexy and as of ten minutes ago, blonde.

JULES
What a piece of shit.

DANA
(not looking up)
I was in a hurry.

JULES
You know what I mean. Why haven't you stuck that asshole's picture on the dartboard yet?

DANA
It's not that simp — oh my God your hair!

JULES
Very fabulous, no?

DANA
I can't believe you did it!

JULES
But very fabulous, right — hurry up with the very fabulous, I'm getting insecure about it now.

DANA
Oh God, no, it's awesome! It looks really natural, and it's great with your skin. I just didn't think you were gonna —

JULES
Impulse. I woke up this morning and thought "I want to have more fun. Who is it that has more fun?"

DANA
Curt's gonna lose it.

JULES
He'll have more fun too. And so will you —
(plucks the pad from Dana)
— while we are burning this picture.

DANA
(grabbing back)
I'm not ready to — seriously, this isn't his fault.

JULES
What's not his fault? Being thirty-eight and married, fucking his student or breaking up with her by e-mail?

DANA
I knew what I was getting into.

JULES
Right: Dana Polk, Homewrecker. Please. You know what you're getting into this weekend?

She holds up Dana's bikini from her open drawer.

JULES (CONT'D)
This. And if Holden's as cute as Curt says he is, possibly getting out of it.

DANA
That's the last thing — if you guys treat this like a set-up I'm gonna have no fun at all.

JULES
(crossing to the suitcase)
I'm not pushing. But we're packing this. Which means we definitely won't have room for —

She pulls the text books out.

DANA
Oh come on, what if I'm bored?

JULES
These'll help? "Soviet Economic Structures"? "Aftermath of the Cultural..." No! We have a lake! And a keg! We are girls on the verge of going wild — Look at my hair, woman!

DANA
It *is* great...

CURT
Think fast!

CURT Vaughn is Jules's boyfriend and yes, that's a football he's throwing right at the girls.

REVERSE on them yeeping and flinching as the ball goes right between them and *out the window*.

CURT (CONT'D)
Well, faster than *that*...

JULES
Curt!

Dana moves to look out the window, is in time to see:

ANGLE: DOWN ON THE STREET

Curt's friend HOLDEN McCrea rushes into the street and catches the ball, a slowing car bumping his leg. It's an impressive catch.

HOLDEN
Yes!
(to the driver)
Sorry. Sorry. Move along.

ANGLE ON: the two girls at the window, Curt behind Jules, all looking out.

CURT
Niiice!

DANA
Is that Holden?

CURT
(calling)
Come on up!
(to the girls)
Transferred from State. Best hands on the team. He's a sweet guy.

JULES
(to Dana, archly)
And he's good with his hands...

CURT
(to Jules, shyly)
Um, hi. I'm sort of seeing this girl, but, uh, you're way blonder than she is, and I was thinking we could... what is this?

He pries the books from Jules.

CURT (CONT'D)
What are these? What are you doing with these?

DANA
Okay, I get it, I'll—

CURT
(to Jules, ignoring Dana)
Where did you get these? *Who taught you about these?*

JULES
(à la PSA:)
I learned it from *you, okay?*

In mock weep, she flees the room. Curt holds the first book up to Dana.

CURT
Seriously? Professor Bennett covers this whole book in his lectures. Read the Gurovsky; it's way more interesting and Bennett doesn't know it by heart so he'll think you're insightful. And you have no pants.

He tosses the books back on the bed, calling out to:

CURT (CONT'D)
Holden! Crazy mad skills of catching!

Dana, panicked, hoists her jeans on, heading out after Curt into:

INT. LIVING ROOM — CONTINUOUS

Jules is opening the door for Holden, and he's even better looking up close. Less of a wild man than Curt.

HOLDEN
You laid it in my hands, I did but hold them out.

He tosses it back to Curt and grabs his weekend duffle bag, entering.

JULES
Hey, I'm Jules.

HOLDEN
Hi. Man, Curt did not exaggerate.

JULES
(pleased)
That's a first...

CURT
Dude, this is Dana.

DANA
Hey.

HOLDEN
(shakes her hand)
Holden. Really nice to meet you and thank you guys for letting me crash your weekend. I'll just put a disclaimer upfront: you don't have to explain any of your in-jokes. I'll probably be drunk and think they're funny anyway. Should I have left out the part about being drunk?

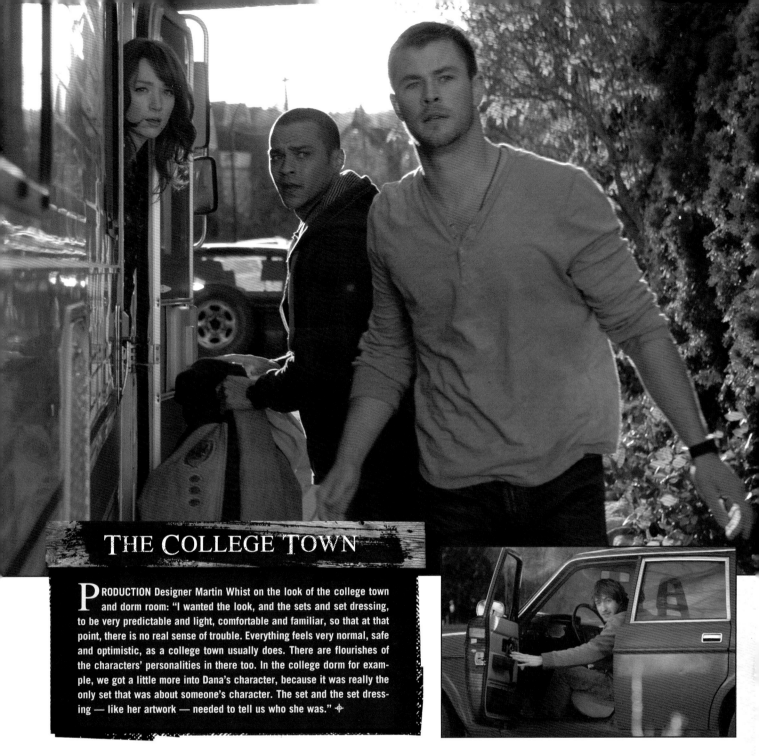

THE COLLEGE TOWN

PRODUCTION Designer Martin Whist on the look of the college town and dorm room: "I wanted the look, and the sets and set dressing, to be very predictable and light, comfortable and familiar, so that at that point, there is no real sense of trouble. Everything feels very normal, safe and optimistic, as a college town usually does. There are flourishes of the characters' personalities in there too. In the college dorm for example, we got a little more into Dana's character, because it was really the only set that was about someone's character. The set and the set dressing — like her artwork — needed to tell us who she was." ✥

CURT
With hindsight, yeah.

HOLDEN
Damn. Can I help anybody carry anything?

EXT. STREET OUTSIDE — A BIT LATER

Holden is dumping Jules's last suitcase (she has overpacked) into the RAMBLER, the trailer Curt owns, with the dirt-bike attached to the rear. Dana's inside, takes it

from him (polite smile between them) as he turns back to Jules and a bag-laden Curt.

HOLDEN
That pretty much it?

CURT
Fuckin' better be! Jules, it's a weekend, not an evacuation.

JULES
Trust me when I say there is nothing in those cases you won't be glad I brought.

CURT
I'm shuttin' right up.

DANA
(looking off)
Oh my god...

ANGLE: A CAR has just finished parking. Martin "MARTY" Mikalski is getting out of the driver's seat *while smoking a huge bong*. It's difficult to maneuver, but definitely not his first time.

His friends instantly look around for, oh, say, police...

JULES
Marty...

CURT
Fuck is wrong with you, bro?

MARTY
People in this town drive in a very counterintuitive manner, and that's what I have to say.

CURT
Do you *want* to spend the weekend in jail? 'cause *we'd* all like to check out my cousin's country home and *not* get boned in the ass by a huge skinhead.

JULES
Marty, honey, that's not okay.

MARTY
Statistical fact: cops will never pullover a man with a huge bong in his car. Why? They fear this man. They know he sees farther than they and he will bind them with ancient logics.
(staring at Jules's hair)
Have you gone grey?

CURT
You're not bringing that thing in the Rambler.

MARTY
A giant bong, in your father's van?

He pours the water out. Removes the bowl, sticks it in a little holder inside the tube and telescopes the entire thing down, pulls a lid off the bottom and pops it on the top, making it look exactly like a silver COFFEE THERMOS.

MARTY (CONT'D)
What are you, stoned?

As Holden raises his eyebrows and Jules rolls her eyes Marty hops in, calling out

MARTY (CONT'D)
(from inside van)
Dana! You fetching minx! Do you have any food?

INT./EXT. VAN — A BIT LATER

The key is turned, the gas stepped on. Curt looks in the rear view at his peeps.

CURT
Everybody ready?

General assent.

CURT (CONT'D)
Then let's get this show on the *road*!

ANGLE: FROM UP HIGH we see the

Rambler rolling off into the distance. The camera arms up to watch it go, the side of the building in frame. It reaches the roof and pans over as we find a group of six men in Clean Room Suits standing silently. After a beat, one speaks into his earpiece.

CLEAN MAN
Nest is empty, we are right on time.

A beat, then he circles his finger in the air, scrambling the men to pick up cases and head for the door to the stairwell.

CLEAN MAN (CONT'D)
Go for clean-up. Go, go, go.

INT. CONTROL ROOM — DAY

A thick metal door (not vault-sized, but impressive) wheezes open, a military guard standing behind it. His name is Daniel TRUMAN, and his exact military affiliation is unclear. He is upright, exacting, and pretty new at all this.

TRUMAN
Identification, please.

REVERSE on Sitterson and Hadley as they pull off their badges and swipe them over Truman's handheld reader. He confirms:

TRUMAN (CONT'D)
Mister Sitterson, Mister Hadley, thank you. Please come in.

The control room has two levels. On the lower level are a couple of tables with built-in monitors and phones. The upper level, behind, is a wonderland of screens, switches and dials, with two rolling chairs for Sitterson and Hadley to move about in. On the far wall, over the lower space, are three big screens, also off. The place resembles a movie mixing stage, or a tiny Houston Control.

Hadley and Sitterson make their way up, talking with Truman.

HADLEY
What's your name?

TRUMAN
Daniel Truman, sir.

HADLEY
Well, this isn't the army, Truman, so you

can drop the "sir". But Sitterson does like to be called "ma'am".

SITTERSON
(sliding the cooler under a counter)
Or "Honey Toes".

HADLEY
He will also answer to "Honey Toes". Are you clear on what's gonna be happening here?

TRUMAN
I've been prepped extensively.

HADLEY
And did they tell you that being prepped is not the same as being prepared?

TRUMAN
They told me. I'll hold my post, Mister Hadley. I'll see it through.

HADLEY
Not much else you gotta do. Stand watch, check I.D.'s, shouldn't be a lot more than that. And you have to get us coffee.

TRUMAN
They also told me you would try and make me get you coffee.

HADLEY
Balls.
(quieter, indicating Sitterson)
Can you make *him* get us coffee? With your gun?

TRUMAN
And that you would try to make me do that.

SITTERSON
(from off camera)
It wasn't funny last time, either!

Hadley is shrugging, hitting a bank of switches on the wall that audibly powers up the control room. He crosses to his chair and starts flipping switches there as well. Sitterson is already entering data into a computer, locking and testing knobs and levers.

Sitterson rolls to another bank of controls, flips the cover off a row of buttons.

SITTERSON (CONT'D)
Let's light this candle, boys. Up is go

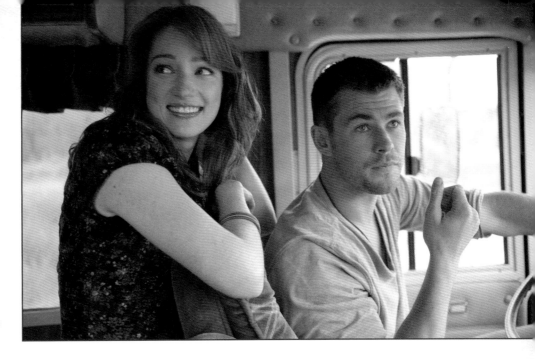

on your command.

The screens all come to white, blank life, their light brightening the dim room.

EXT. RAMBLER — DAY

It trucks along an old road, nothing but brush visible.

INT. RAMBLER — CONTINUOUS

The gang is in mid-ride, clearly a couple hours in. Curt is still driving. Jules, riding shotgun, is checking both a map and the GPS. Marty sits at the little table, cautiously rolling an elegant, filtered row of joints. Dana sits with him, Holden in the

bathroom with the door open, where we can see they've stashed a keg. He's filling three cups.

JULES
I hope this is the right road, 'cause right now it looks like the only road.

CURT
What about that thing we crossed back there?

Right and opposite: The gas station, from production design art to final location.

JULES
Doesn't even show on the GPS. It's unworthy of global positioning.

DANA
It must feel horrible...

MARTY
That's the whole point. Get off the grid. No cellphone reception, no markers, no traffic cameras... go somewhere for one goddamn weekend where they *can't* globally position my ass. This is the whole issue.

JULES
(heard this before)
Is society crumbling, Marty?

MARTY
Society is *binding*. It's filling in the cracks with concrete. No cracks to slip through. Everything is recorded, filed, blogged, chips in our kids so they don't get lost — society *needs* to crumble. We're all too chickenshit to let it.

JULES
I've missed your rants.

He grins at her, holds up a gorgeous joint.

MARTY
You will come to see things my way.

JULES
I can't wait. Is that the secret stash?

MARTY
The secret *secret* stash. I haven't told my other stash about it because it would become jealous.

DANA
(pointing ahead)
A sign. Up there.

JULES
(turns back)
Yes. And... okay, left. Bear left.

CURT
You sure?

JULES
Not even a little bit.

Holden brings up beers for Curt, Jules and Dana, who smiles at him shyly.

HOLDEN
What is this place exactly?

CURT
Country home my cousin bought. He's crazy for real estate, found this place in the middle of nowhere, it's like civil war era, seriously.

JULES
There's a lake, and woods everywhere...we saw some beautiful pictures.
(to Dana)
You will be doing some serious drawing. No portraits of pedophiles...

Dana gives her a 'shut up' look.

HOLDEN
(settling by Dana)
You're an art major?

DANA
Art and political science.

HOLDEN
Ooh, triple threat.

DANA
(after a small beat)
That's only two things.

HOLDEN
Yes, a double... threat that sounds weird — let's just say I find you threatening.

CURT
I thought you were *dropping* art.

JULES
Uh, no, never mind...

Jules swats Curt, gives him a look.

DANA
I'm switching a few courses.

HOLDEN
How come?

CURT
For no reason! For very good reasons that don't exist. Hey look, trees!

MARTY
We have patterns. Societially. The beautimous Dana fell into one of the oldest patterns and we are here to burn it away and pour ash into the grooves it has etched in

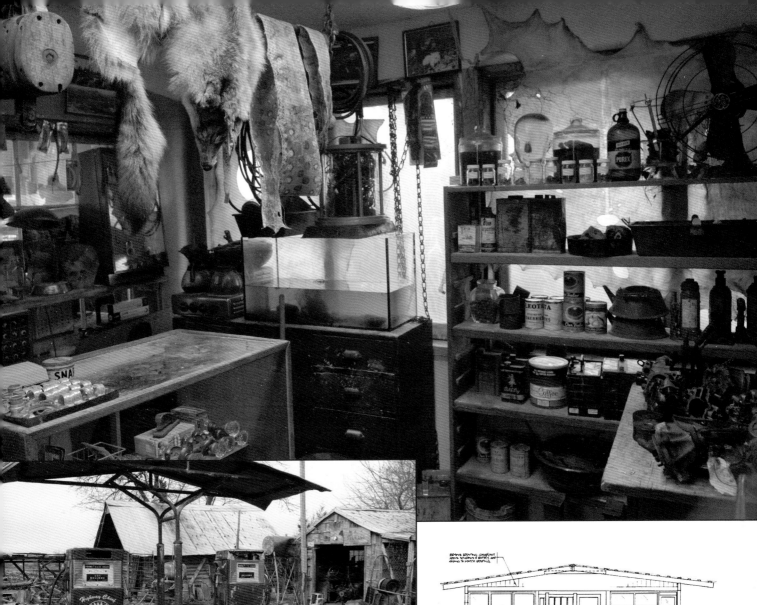

THE GAS STATION

PRODUCTION Designer Martin Whist on the gas station: "The building was already there. We just brought in pumps and dressed it. That was a crazy location! It was one of those strange houses at the end of a road… I did very little to it. I just dressed it, did some minor painting and built the store in the people's front living room by putting in a couple of dividing walls. When we left, we built them back their front room so that they could keep on living in their house! I like some of the weird stuff we put in the gas station store. Strangely enough, maybe my favorite — and Drew's favorite as well — was just a line of glass doorknobs. It was so strange and so not trying to be scary that it was great." ✚

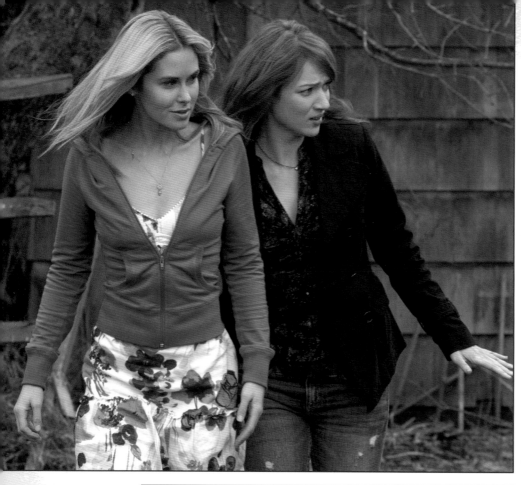

inviting than the outside. Once upon a time things were fixed and goods were sold in here, but not of late.

The kids pile out, stretching, looking about. Curt and Marty examine the pump.

CURT
I'm thinking this thing doesn't take credit cards.

MARTY
I don't think it knows about *money*. I think it's *barter* gas.

Curt moves a pace to see if anyone is around.

ANGLE: HOLDEN is inside, moving slowly toward the back. We hear Curt's offscreen:

CURT
Hello?

But no reply. Holden keeps walking, tracing his finger along the countertop:

CLOSE ON: HIS FINGER trailing a line of clear glass into the grime.

ANGLE: THE GIRLS

Are making their way nimbly around back.

JULES
Because I hate going in the Rambler!

DANA
You think the toilet here's gonna be better?

JULES
I don't like to pee when all my friends are two feet away from me. I'm quirky. At least this has gotta be HOAH!

They stop, staring in horror.

REVERSE ON: THE BATHROOM. It's just as horrible as it could be. The door off, the room tiny — the walls stained with what might be actual slime. The toilet is lidless, broken and filled with brownish sludge.

A weird little gurgle comes from it.

Dana moves forward, brow furrowed. She leans in and looks down.

her brain. Cover the tracks and set her feet on new ground.

HOLDEN
(to Dana)
Is it okay if I didn't follow that?

DANA
I'd take it as a favor.

CURT
Gas!

They all look ahead.

CURT (CONT'D)
Gas. And maybe someone who knows where we actually are.

EXT/INT. GAS STATION

It is as decrepit and abandoned looking as it can be. An old pump squats in front of a monument to rust, windows clouded with grime.

ANGLE: FROM INSIDE through the windows we see the Rambler pull up. The inside of this place doesn't look any more

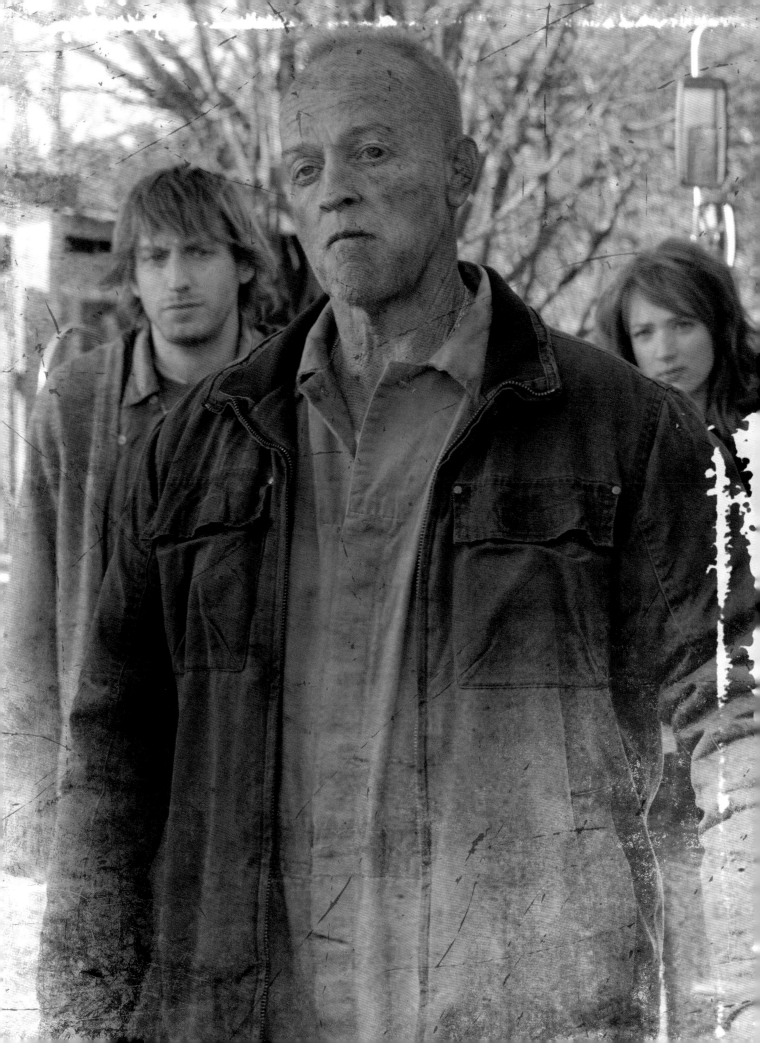

Opposite: The route to the cabin through the mountain tunnel, as envisaged in pre-production.

In the toilet, a scorpion struggles, drowning in the fetid muck.

ANGLE: HOLDEN is heading back outside. We're behind him, and through the open doorway we can see Curt and Marty trying to figure out how to work the pump.

HOLDEN
I don't think there's gonna be any —

The ATTENDANT fills the doorway, having come around from the outside. He speaks as he appears, over the surge of music and Holden's shocked jump —

ATTENDANT
You come in here uninvited?

HOLDEN
(over this)
Fuck!

The attendant is old, weathered, and creepy as hell. One eyeball is hideously red, tobacco chaw spills over his stained lips, and he carries a permanent scowl of disgust.

HOLDEN (CONT'D)
Dude....

ATTENDANT
Sign says closed.

Curt is making his way over to him, Marty judiciously hanging back.

CURT
We were looking to buy some gas? Does this pump work?

ATTENDANT
Works if you know how to work it...

But he doesn't move to help. The girls come around, no more anxious to get close once they've seen him than Marty was.

HOLDEN
We also wanted to get directions...

CURT
Yeah, we're looking for…
(to Jules)
…what is it?

JULES
(coming forward)

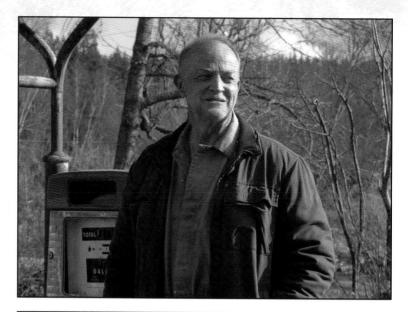

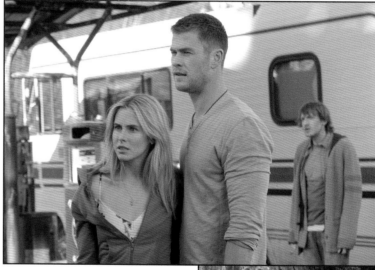

Tillerman Road? Do you know if it's this way?

The attendant looks at her, the name registering. She kind of wriggles under his gaze.

ATTENDANT
(mutters)
What a waste.

He starts ambling toward the pump, pulling out a ring of keys and unlocking a latch.

ATTENDANT (CONT'D)
Tillerman Road takes you up into the hills. Dead ends at the old Buckner place.

CURT
(to Jules)
Is that the name of —

JULES
There wasn't a name...

The attendant sticks the nozzle in the
Rambler's gas tank. The numbers on the
pump start going up manually (like they
used to back when), but creak to a stop
almost immediately.

CURT
(to the attendant)
My cousin bought a house up there, you go
through a mountain tunnel, there's a lake,
would that be...

ATTENDANT
Buckner place. Always someone looking to
sell that plot.
(bad, bad smile)
Always some fool looking to buy.

JULES
You knew the original owners?

ATTENDANT
Not the first. But I've seen plenty come and
go. Been here since the war.

JULES
Which war?

ATTENDANT
(flaring up)
You know damn well which war!

She takes a step back, freaked. Dana takes
her arm.

MARTY
Would that have been with the blue, and
some in grey? Brother, perhaps fighting
against brother in that war?

ATTENDANT
You sassin' me, boy?

MARTY
You were rude to my friend.

The attendant stops for a second, not
expecting this guy to have come back at
him. Glances at Jules, mutters:

ATTENDANT
That whore?

Curt is about to clock him but Holden puts
a hand to Curt's chest, steps forward.

THE CABIN IN THE WOODS

HOLDEN
I think we've got enough gas.

ATTENDANT
Enough to get you there. Gettin' back's your own concern.

He pulls out the nozzle as the gang moves back in, Curt contemptuously throwing a twenty at the guy's feet.

MARTY
Good luck with your business. I know the railroad's comin' through here any day now, gonna be big. Streets paved with... actual street.
(to himself)
Fucker.

ANGLE: THE RAMBLER'S TIRE
Spins in the sand and takes the heap right out of there,

cruising down the road.

The attendant watches, spits chaw. Watches.

EXT. WOODS — DAY

A helicopter shot floats over the Rambler as it winds through an endless expanse of firs, finally consumed by them.

EXT. MOUNTAIN TUNNEL — AFTERNOON

The Rambler comes up the side of a steep drop-off. We see Jules in the passenger seat smiling...

> **JULES**
> Guys, take a look...
>
> And we pan with the vehicle as it enters the mountain

tunnel, slowing down a bit — it's a tight fit. The camera moves up the mountainside, looking down to see the Rambler come out the other end.

A bird comes from behind camera, flying directly above the tunnel. About halfway across it hits an invisible barrier and falls in a shower of sparks as for one moment an electrical grid seems to appear where it struck, before sparking away into nothing.

EXT. CABIN/INT. RAMBLER — AFTERNOON

There's no audio but music as the kids all crowd the front of the van to look at their vacation spot. The lake appears up ahead, sun rippling over the water, and they look and point, talking a bit.

The camera follows the Rambler through the forest to find THE CABIN: it squats uninvitingly, a fairly ramshackle — though not overly rustic — single story structure. Windows on either side of the door, not unlike closed eyes.

The Rambler pulls up and the kids come out, more slowly than they did at the gas station, taking it in.

Dana's a little entranced, Holden curious, Curt pumped, Jules mildly excited, Marty wary.

JULES
Oh my god, it's beautiful!
(to Curt, sotto voce)
One spider and I'm sleeping in the Rambler. I mean it. Uno spider-o.

MARTY
(to himself)
This house is talking a blue streak...

As the boys start unloading the keg, Dana approaches the front door... slowly turns the knob…

INT. LIVING ROOM — CONTINUOUS

She enters the living room. It's also, if you turn to the right, the kitchen; the stove is a classic old wood-burning Kalamazoo Wonder, the sink clearly retro-fitted. The decor is sparse and antlery. A wolf's head is mounted on one wall.

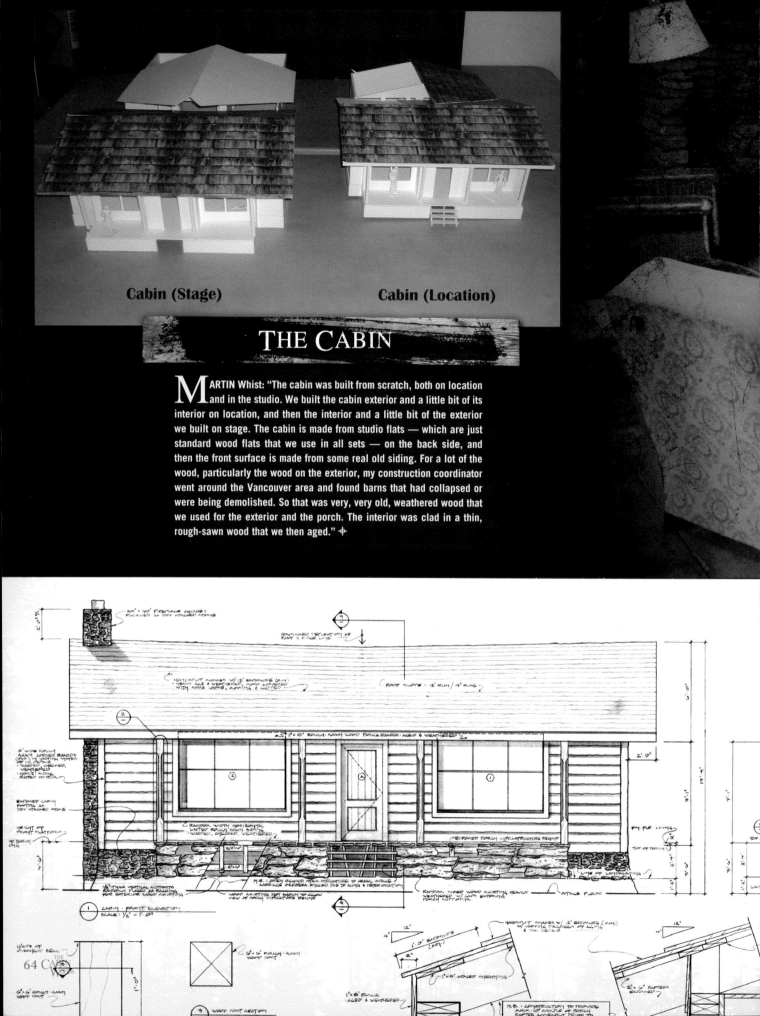

Cabin (Stage) **Cabin (Location)**

THE CABIN

MARTIN Whist: "The cabin was built from scratch, both on location and in the studio. We built the cabin exterior and a little bit of its interior on location, and then the interior and a little bit of the exterior we built on stage. The cabin is made from studio flats — which are just standard wood flats that we use in all sets — on the back side, and then the front surface is made from some real old siding. For a lot of the wood, particularly the wood on the exterior, my construction coordinator went around the Vancouver area and found barns that had collapsed or were being demolished. So that was very, very old, weathered wood that we used for the exterior and the porch. The interior was clad in a thin, rough-sawn wood that we then aged." ✛

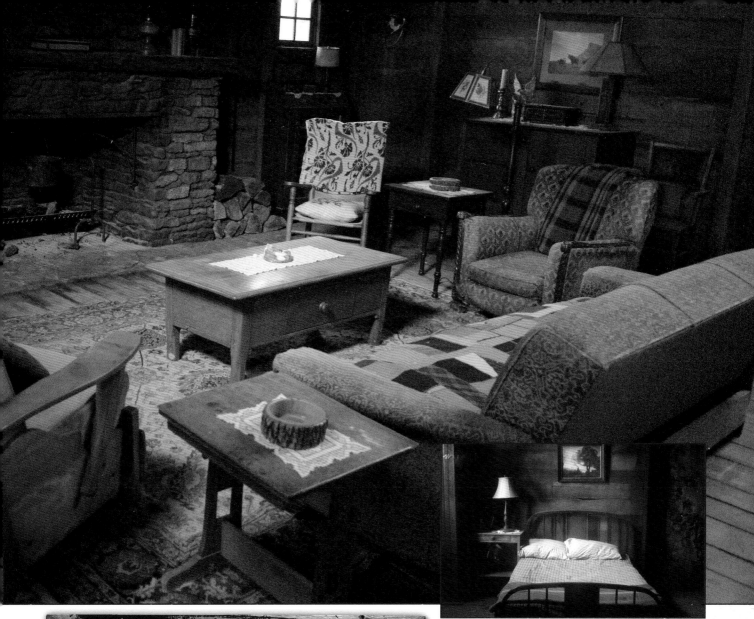

THE INTERIOR

MARTIN Whist on the cabin interior: "All the rooms within the cabin are truly connected. All the going in and out of doors to the bedrooms — that was all one set. The cellar was a cheat, in that the interior of the living room and the kitchen area where the cellar door goes down, that set was built on a riser about three-and-a-half feet off the ground, so we could open the door and start walking down the stairs, and then the cellar itself was built on a separate stage.

"We wanted it to be creepy in the sense of you wondered who actually lived here and when... the space was almost a period piece, rather than a contemporary cabin with contemporary furnishings. We tried to keep everything old and original, imagining the Buckner family living there. So that all by itself created enough of a creepy quality to it, rather than intentionally trying to make it cobwebby and scary and those sort of obvious things. Though with the cellar we went full-tilt creepy! The other thing that I did with the cabin interior was design it maybe ten percent bigger than it should have been. The main living space was just a little too big, and made them feel small and a little alone — uncomfortable, almost as though the walls were observing the people inside..."

mordecai

DIRECTOR/WRITER DREW GODDARD
PRODUCER/WRITER JOSS WHEDON
PRODUCTION DESIGNER MARTIN WHIST

Int. Cabin

DRAWING TITLE
Porch/Front Elevation & Details

LOCATION
Stage 8

DRAWN BY
DATE Jan 29/2009

SCALE
SHOOT DATE

SET NO: 23

DWG NO: 6

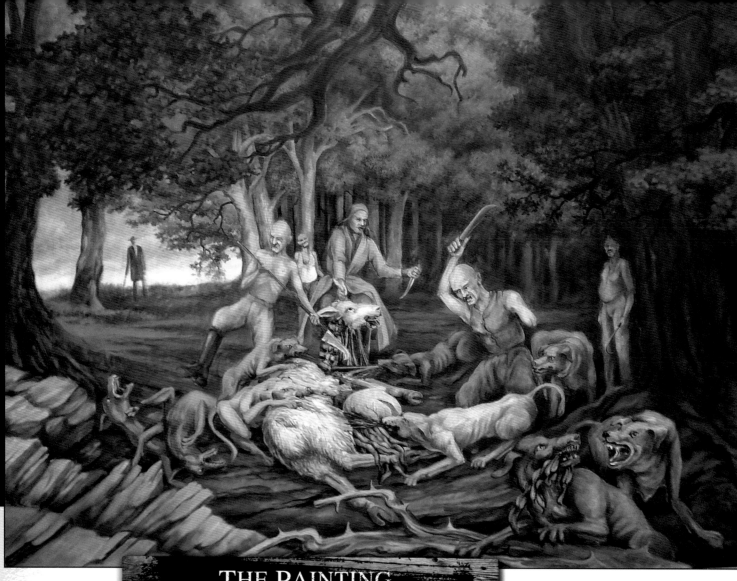

THE PAINTING

MARTIN Whist on the painting: "That was fun. This poor guy who actually had to paint it, he was very classically trained, a wonderful painter. I started by giving him classical references, Gainsborough and wonderful English landscape painters, and then started adding the layer of Goya and the darker painters, and he sort of understood that, but then as we kept going on and on, he kept bringing it back to something more restrained, and I would just keep making him put more gore and more blood into it! At a certain point, he would roll his eyes. He almost couldn't do it. In the end, he was just shaking his head. 'You guys are nuts.' 'No, more gore! The dogs need to be ripping the flesh out! There needs to be pools of blood!'" ✤

A hall goes down the middle, with two bedrooms on either side. Dana makes her way around the room as the rest of the gang pours in.

CURT
Oh, this is awesome!

JULES
It is kinda cool. You gonna kill us a raccoon to eat?

CURT
(nodding)
I will use its skin to make a cap.

Jules runs down to the hall, to look in the rooms, grabbing a doorknob —

JULES
Dibs on whichever room is — OW!

She pulls her finger back — it's cut, slightly on the tip, a little blood welling up.

JULES (CONT'D)
Curt, your cousin's house attacked me.

CURT
I smell lawsuit...

HOLDEN
When was your last tetanus shot?

JULES
Thanks, that's very comforting.

CURT
Jules is pre-med. She knows there's no

coming back from this.
(stroking her hair)
I'll miss you, baby. I'll miss your shiny
new hair.

Dana looks over at Marty, who stands in
the doorway, looking around warily.

DANA
Marty? Are you planning on coming in?

He looks around, not ready to make his
move.

**INT. HOLDEN'S ROOM —
AFTERNOON**

Holden throws his bag on his bed, which
squeaks appallingly. He looks around the
decrepit — but not entirely un-homey —
room, focusses on a picture opposite the
bed.

ANGLE: THE PICTURE is like a 19th cen-
tury print, but it's of a hunting party with
machetes and dogs tearing a lamb to pieces
and, upon close examination, is repulsive.

HOLDEN
Yeah, I don't think so.

He takes the picture off the wall, camera
follows him as he leans it on the floor,
comes back up to find *Dana* staring at him
blankly through a hole in the wall. Once
again, he jumps.

HOLDEN (CONT'D)
Wow. I've heard about the walls being
thin, but —

She bares her teeth at him. He stops, not
getting what's going on at all, then as she
starts picking between them, he gets it.
Moves forward and puts his hand to *the
one-way mirror between them.*

HOLDEN (CONT'D)
No way...

He watches her for a bit, first amused, then
a little hypnotised. She really is kind of
beautiful. She musses her hair a little, gives
up, grinning at her own vanity. Moves to
her bed and starts unbuttoning her shirt.

W E have archetypal roles: The scholar, the jock, the fool, the whore and the virgin. I can tell you I'm not the whore. This film plays with that character construction — do we make our own choices? What is within my control? Is this nurture, nature or nonsense? Or are we controlled by vapor coming through the vent? Just asking the hard questions...

Everybody's having a great time on set. The makeup trailer is amazing when it's busy. Yesterday I was sitting beside a 7'2" zombie, reading the *Wall Street Journal* very intently. Or eating lunch on set watching them dump barrels of blood down a stairway and somebody's carcass getting mauled to the bone. I've got a steel stomach now. I can eat in any conceivable scenario.

I remember reading the script for the first time... 'Yes! I live! No, I get scythed to death.' Which I did not see coming. Holden meets his end very romantically I think — looking into the eyes of a 300 year old zombie gentleman in suspenders. Underwater. So yeah, there was love, a sea of passion you might say. A fair amount of raw desire and death. My extensive stunt work on this film has become the stuff of legend, and a source of some neck discomfort. Just really giving it my all to entertain these fine folks!

HOLDEN

JESSE WILLIAMS

"DUDE, SERIOUSLY — YOUR COUSIN'S INTO SOME WEIRD SHIT."

"AN ARMY OF NIGHTMARES, HUH? LET'S GET THIS PARTY STARTED."

DANA

KRISTEN CONNOLLY

FLEW to L.A. and met Joss and Drew. I read with Fran at my audition, as he had already been cast. I just walked in the room and I was like, 'Oh man, even if I don't get to do this movie, it's really cool to hang out with these guys for a while.'

I like that Dana is a regular person who doesn't start out thinking that she's really a bad-ass. She's just a regular kid whose strength comes out of her love for her friends and out of necessity. Dana and Marty aren't people that you would think of as the heroes of a movie. But they both find this strength from each other and from their friends and from the situation. And I think a lot of people can identify with that. I mean, I can identify with that.

It's been physically challenging, and it's emotionally challenging. It's a lot in terms of running and swimming and going down holes and getting beat up and fighting werewolves and zombies. It's pretty intense. But it's really fun. There were some days when you're like, 'Oh man, I've gotta get *real* bloody...' And it's definitely sticky, but when I see it on the monitor it looks so great. And it's definitely more fun to be really dirty than to have to worry about looking really pretty and messing up some outfit or hairdo. I like it.

HOLDEN (CONT'D)
Oh shit, ah no, ahh...

He bobs back and forth between this golden opportunity and common human (yawn) decency. Moves away from the hole, out of frame. Moves back.

Finally bangs on the wall, ducking his head just as she's about to take it off —

HOLDEN (CONT'D)
(calls through)
Hold up!

INT. HOLDEN'S ROOM/HALL/ DANA'S ROOM — MOMENTS LATER

The gang is all in there, checking it out.

JULES
You have got to be kidding me.

DANA
That's just creepy.

MARTY
It was pioneer days; people had to make their *own* interrogation rooms. Out of cornmeal.

HOLDEN
(touches the edge)
This from the... seventies, judging by the weathering. Who did your cousin buy this place from?

CURT
We should check the rest of the rooms. Make sure this is the only one.
(to Jules)
You know Marty wants to watch us pounding away.

MARTY
(wincing)
I didn't even like *hearing* that.

JULES
(as they exit)
Don't be an ape, Curt.

He makes ape noises off screen. Dana is still staring at the glass.

HOLDEN
How about we switch?
(she turns to him)
Not that I'd... I mean I'll put the picture back but you might feel better if we switched rooms.

DANA
I really would.

He grabs his bag and they head out as she says:

DANA (CONT'D)
Thanks for... being decent.

HOLDEN
Least I could do, since Curt and Jules have sold you to me for marriage.

She makes cringe face.

DANA
They're not subtle.

HOLDEN
I'm just here to relax. And so can you.

DANA
Yeah, I'm not looking for... But I'm still grateful that you're not a creep.

HOLDEN
Hey, let's not jump to any conclusions there. I had kind of an internal debate about showing you the mirror. Shouting on both sides, blood was spilled...

In her (now his) room, he dumps his stuff and she grabs hers.

DANA
So you're bleeding internally.

HOLDEN
Pretty bad.

DANA
Well, Jules is the doctor-in-training. You should probably talk to her.

HOLDEN
Yeah.

Dana exits, clearly frustrated with her lame exit line. She enters her new room and, dropping her luggage, moves to put the picture back. She's stopped by the sight of Holden, also looking a little frustrated. A moment, and he pulls his shirt over his head. He's in pretty good shape. He pulls his bathing suit out of his bag, starts unbuttoning his pants —

DANA
Uhhh... ah! God!

Sheepishly, she grabs the picture and replaces it. Takes a moment to look at the slaughtered lamb scene...

DANA (CONT'D)
Yeah, I don't think so.

We cut to a high and wide of her placing a little blanket over the picture, and suddenly the frame is that of a monitor, as we pull back to see:

INT. CONTROL ROOM

...we're watching Dana on a MONITOR. And as we continue to PULL OUT, we see MORE MONITORS. ON THE SCREENS: we see a surveillance view of Holden in *his* room...

...and Marty in *his* room... and Jules with Curt... In fact —

ALL THE MONITORS on the control bank are now lit up, each showing different views of the cabin and surrounding area. Sitterson rolls into frame on his office chair, looking the screens over —

SITTERSON
All right — places everyone — we are *live* —

Hadley stares at DANA'S MONITOR. Keys the microphone in front of him —

HADLEY
Engineering, we've got a room change. Polk is now in Two, McCrea's in Four. Story department — you copy? We'll need a scenario adjustment...

STORY DEPT GUY (V.O.)
(over speaker)
Have it back to you in fifteen...

Sitterson glances up as —

SITTERSON
Ms. Lin!

Wendy Lin enters the area, clipboard under her arm. Sitterson wheels himself towards her.

LIN
We've got bloodwork back on Louden.

ANGLE: ON A MONITOR is JULES, going through her stuff.

LIN (CONT'D)
Her levels are good — but we're recommending a fifty milligram increase of Rhohyptase to increase libido.

SITTERSON
(nods)
Sold.

LIN
Do we pipe it in or do you wanna do it orally?

SITTERSON
(closes his eyes)
Ask me that again only slower.

LIN
You're a pig. Guess how we're slowing down her cognition.
(off his not asking)
The hair dye.

SITTERSON
(impressed)
The dumb blonde. That's artistic.

LIN
Works into the blood through the scalp,
very gradual.
(to Hadley)
The Chem Department keeps their end up.

HADLEY
(not looking up)
I'll see it when I believe it.

And ANOTHER VOICE rings out over the
speakers —

SECOND VOICE
Control?

HADLEY
Go ahead.

SECOND VOICE
I have the Harbinger on line two...

Hadley and Sitterson share a glance.
Sitterson holds up his hands — don't look
at me. This is all yours...

HADLEY
Christ. Can you take a message?

SECOND VOICE
Uh... I don't think so. He's really pushy.
(beat)
To be honest, he's kinda freaking me out.

HADLEY
(looks to the other two...)
Yeaaaahh. Okay, put him through —

Hadley hits a button on his keyboard —

HADLEY (CONT'D) (into mic)
Mordecai! How's the weather up top?

YET ANOTHER VOICE
The lambs have passed through the gate…

EXT. GAS STATION

The ATTENDANT (who, it turns out, is
named MORDECAI) speaks into the gas
station payphone —

ATTENDANT
...They are come to the killing floor.

INT. CONTROL ROOM

Hadley nods, moves to hang up —

HADLEY

Yeah, you did great out there. By the numbers; started us off right. We'll talk to you later, oka—

ATTENDANT (O.S.)

Their blind eyes see nothing of the horrors to come. Their ears are stopped; they are God's fools.

HADLEY

(hangs his head)

Well, that's how it works.

ATTENDANT (O.S.)

Cleanse them. Cleanse the world of their ignorance and sin. Bathe them in the crimson of —

(pause)

Am I on speakerphone?

HADLEY

No, no of course not.

ATTENDANT (O.S.)

Yes I am. I can hear the echo. Take me off. Now.

Sitterson starts laughing. He clamps his hands down over his mouth to keep quiet.

Lin keeps mostly cool...

HADLEY

Okay, sorry.

ATTENDANT (O.S.)

I'm not kidding. It's rude. I don't know who's in the room.

HADLEY

Fine. There — you're off speakerphone.

ATTENDANT (O.S.)

(not off speakerphone)

Thank you.

Sitterson's nearly *crying* now —

ATTENDANT (O.S.) (CONT'D)

Don't take this lightly, boy. It wasn't all by your 'numbers'; the Fool nearly derailed the invocation with his insolence. Your futures are murky; you'd do well to heed my —

(beat)

I'm still on speakerphone, aren't I?

That does it. Everyone loses it — even Truman is grinning. As the room erupts with laughter —

HADLEY

No. You're not. I promise.

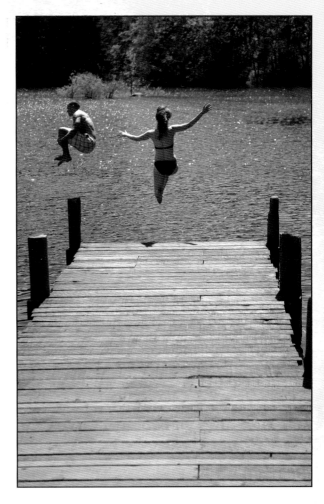

ATTENDANT (O.S.)

Yes I am!

(furious)

Who is that? Who's laughing?

Sitterson pounds his head on the console, he's laughing so hard. Off which —

EXT. DOCK — DAY

Footsteps ring out as Dana and Holden race down the wooden dock. They're both in their swimsuits, running at top speed. As they reach the end, they dive into the lake —

DANA

(as she emerges from the water)

OH! Cold! That's what cold feels like —

HOLDEN

Fight through the pain. It's worth it. I'm nearly convinced it's worth it.

Reverse on Curt, Jules, and Marty (all also in swimwear except Marty, who at least

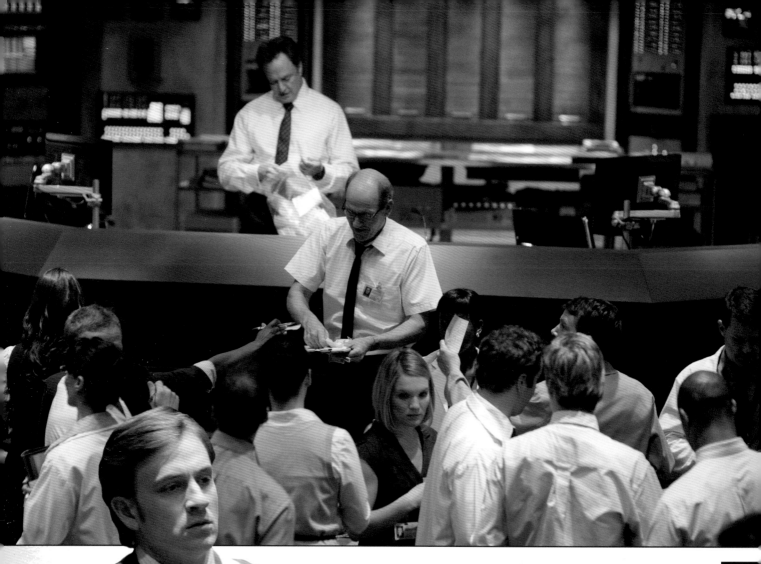

has bare feet and rolled-up pants) as they casually walk down the dock —

JULES
(to Dana and Holden)
Does it seem fresh? Lotta funky diseases sitting in stagnant lake water.

DANA
What? *This* water?
(takes a gulp of the lake water)
This water's *delicious*.

HOLDEN
Oh my god, she's right —
(cups it into his mouth)
It tastes like... vitamins. And hope.

DANA
C'mon Jules — life is risk.

JULES
Yeah, I might just risk lying out in the sun for a while.

Curt steps to the edge of the dock, face

falling as he looks into the water —

CURT
What is that?

DANA
What?

CURT
In the lake. I swear to god I...

DANA
Yeah, right...

CURT
(scared)
No, seriously. Right there. Don't you see it? *There*. It looks just like —

He puts his hand on Jules back —

CURT (CONT'D)
My girlfriend.

And with that, he shoves Jules straight into the lake. Splash!

JULES
(as she surfaces)
Oh! Oh my god! I'm gonna kill you!

Curt points at another part of the lake —

CURT
Look — there's something *else* in the lake —

He jumps out right where he was pointing — SPLASH — as he surfaces —

CURT (CONT'D)
It's a gorgeous man!

JULES
(swimming over to him)
You are so dead —

He laughs as she tries to dunk him —

CURT
Don't kill the gorgeous man! They're endangered!

Dana laughs, looks up at Marty —

DANA
Marty — *get in here* —

MART
Nah, man. I'm cool. Just seeing the sights...

He sits down on the edge of the dock, dangles his feet in the water. Leans back. High as the proverbial kite —

MARTY (CONT'D)
Just seeing the sights.

And with that, we CUT WIDE ON THE LAKE. On the horizon, the sun is just starting to set. We HOLD ON THIS TABLEAU as the kids splash and laugh and frolic in the lake.

For a moment, all is right with the world.

INT. CONTROL ROOM

WHUMP! A large wad of CASH slams down onto the console. Widen to reveal Sitterson — for some reason he's holding large wads of cash. As he steps up onto the console —

SITTERSON
Last chance to post! C'mon people, dig deep. Betting windows are about to close!

The room is bustling with activity. Several people are clustered around Hadley,

thrusting papers and cash in his face, everybody talking over each other —

HADLEY
(to Sitterson)
Who's still out?

Sitterson looks at his clipboard —

SITTERSON
I got Engineering, I got R&D, I got Electrical —

HADLEY
Did you see who they picked? They're practically *giving* their money away.

SITTERSON
Yeah, you're one to talk, Aquaman.

A CHEM DEPT GUY in a labcoat hands his form to Sitterson. As he looks at it —

SITTERSON (CONT'D)
I'm not even sure we *have* one of these...

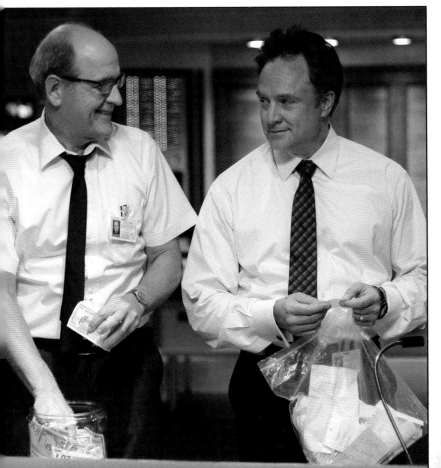

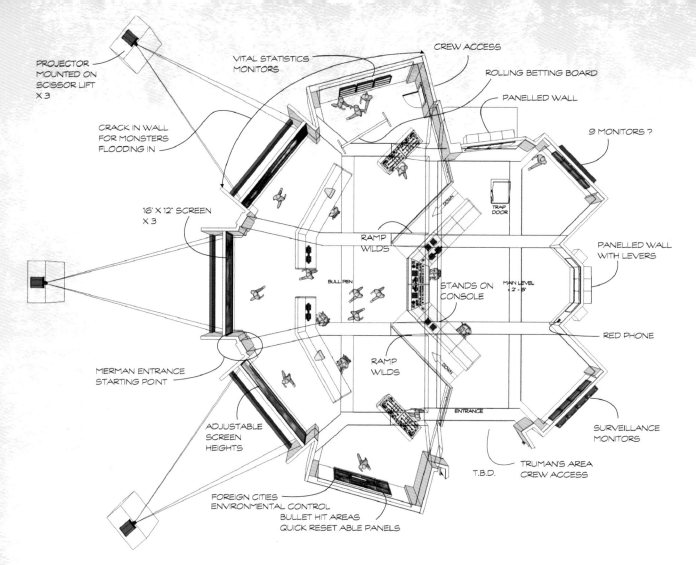

PROJECTOR
MOUNTED ON
SCISSOR LIFT
X 3

CRACK IN WALL
FOR MONSTERS
FLOODING IN

VITAL STATISTICS
MONITORS

CREW ACCESS

ROLLING BETTING BOARD

PANELLED WALL

9 MONITORS ?

16' X 12" SCREEN
X 3

TRAP
DOOR

RAMP
WILDS

BULL PEN

STANDS ON
CONSOLE

MAIN LEVEL
- 2'- 6"

PANELLED WALL
WITH LEVERS

RED PHONE

MERMAN ENTRANCE
STARTING POINT

RAMP
WILDS

ENTRANCE

ADJUSTABLE
SCREEN
HEIGHTS

SURVEILLANCE
MONITORS

T.B.D.

TRUMAN'S AREA
CREW ACCESS

FOREIGN CITIES
ENVIRONMENTAL CONTROL
BULLET HIT AREAS
QUICK RESET ABLE PANELS

This page: Pre-production
plans and designs for the
control room.

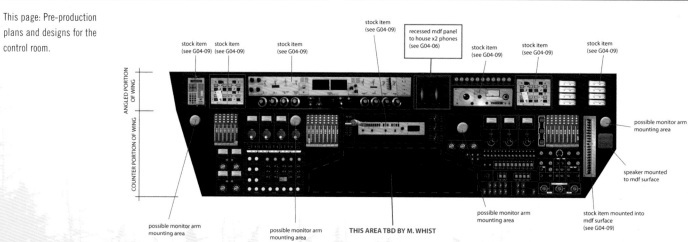

stock item
(see G04-09)

stock item
(see G04-09)

stock item
(see G04-09)

stock item
(see G04-09)

recessed mdf panel
to house x2 phones
(see G04-06)

stock item
(see G04-09)

stock item
(see G04-09)

stock item
(see G04-09)

ANGLED PORTION
OF WING

COUNTER PORTION OF WING

possible monitor arm
mounting area

possible monitor arm
mounting area

speaker mounted
to mdf surface

possible monitor arm
mounting area

possible monitor arm
mounting area

THIS AREA TBD BY M. WHIST

possible monitor arm
mounting area

stock item mounted into
mdf surface
(see G04-09)

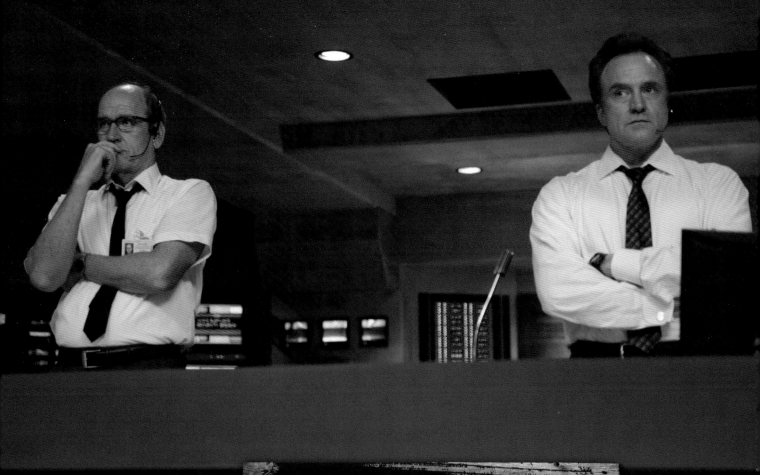

THE CONTROL ROOM

MARTIN Whist on the control room set: "We wanted an era feel to it and it was a balance: it couldn't be too old-school, because we had some pretty strong technology in there, but the reference starting point was 'vintage NASA control room', and so we built that. We wanted it to feel a bit anachronistic and bunker-like. It had to feel as though those walls were very, very thick concrete: we were subterranean, we were safe — so when it was breached, it heightened the drama of that safe place becoming ripped apart." ✛

CHEM DEPT GUY
Zoology swears we do.

SITTERSON
(shrugs, takes his money)
Well, they'd know.

Across the room, A YOUNG GUY who looks a lot like an INTERN hands his form to Hadley —

HADLEY
(re: form)
No no — they've already been picked.

RONALD
(angry)
What? Who took 'em?

HADLEY
Maintenance.

RONALD
Maintenance! They pick the same thing every year.

HADLEY
What do you want from me? If they were creative, they wouldn't be in Maintenance.

If you win, you're gonna have to split it. You wanna switch?

RONALD
(thinks, then)
Nah. Leave it. I got a feeling on this one.

Lin is off to the side, where Truman stands at attention, stoically watching the proceedings.

LIN
Not betting?

TRUMAN
Not for me, thanks.

LIN
Seems a little harsh, doesn't it. It's just people letting off steam.
(looks at Hadley and Sitterson)
This job isn't easy, however those clowns may behave.

TRUMAN
Does The Director... do they know about it downstairs?

HADLEY
(joining them)
The Director isn't concerned with stuff like this. Long as everything goes smoothly *upstairs* and the kids do... what they're told...

TRUMAN
But then it's *fixed*.
(off their looks)
How can you wager on this when you control the outcome?

Hadley glances up at the monitors. ON THE SCREENS — we see Dana, Holden, Jules, Curt, and Marty crossing through the cabin, heading towards the living room.

HADLEY
No, no. We just get 'em to the cellar, Truman. They take it from there.

SITTERSON
They have to make the choice of their own free will. Otherwise, system doesn't work. Like the harbinger: creepy old fuck practically wears a sign saying "YOU WILL DIE", why would we put him there? The system. They have to *choose* to ignore him. They have to *choose* what happens in the cellar. Yeah, we rig the game as much as we have to but in the end, if they don't transgress...

Hadley counts the money —

HADLEY
...they can't be punished. Last chance, Truman. Window's closing.

TRUMAN
I'm fine.

HADLEY
(yells to the crowd)

All right! That's it, gang. The board is *locked*.

He hands the rest of the money to Sitterson, who slams it on the pile with the rest of the cash.

SITTERSON
(looking at screens)
Let's get this party started!

INT. CABIN — LIVING ROOM — NIGHT

Curt pumps the keg, sprays beer into a plastic cup as Jules puts on a song —

CURT
Let's get this party started!

He hands the beer to Jules, who dances through frame in time to the music pumping out of the stereo.

HOLDEN
No, I've played it before — I just don't get the third part.

DANA
Well, the lecture is our own addition.

MARTY
It's the X factor.

JULES
It redefines the whole concept.

DANA
Come on, it's your turn.

HOLDEN
Okay, uh Marty,
(tiny bit hesitant)
Truth or dare or lecture.

MARTY
I could go for a lecture about now.

Holden smiles wanly — that's exactly the pressure he didn't want from a room full of people he doesn't know.

HOLDEN
(muttering)
Lecture. How'd I guess.

He thinks a moment...

MARTY
Wait, hang on —

He a grabs a joint, lights it, and takes a massive hit. But he doesn't exhale. He just looks at Holden — all right, bring it on...

HOLDEN
You guys really know how to party.
(gearing up)
Okay. Marty. I don't like to, you know, *lecture*, but we've been friends for so *many* minutes now that I feel I can be honest.
(points at him)
You are not Marty. You are "Pot Marty". You are living in a womb of reefer and missing out on the real joys of life. I'll tell you, I've learned a lot out on the football field. I've learned about achievement, teamwork, homoerotic butt slapping and good clean fun. Curt here — he doesn't smoke weed. Because he knows it doesn't make you a winner, and because it interferes with his enormous daily dose of steroids.

CURT
(offscreen)
I eat them like candy!

HOLDEN
Maybe, Marty, you should take a hit from
the *life*-bong, and don't take your finger off
the life-carb till the chamber's filled up...
(got nothing...)
...with opportunity. For the love of god let
me be done.

DANA
Yes!

JULES
Bravo!

As the group applauds, Holden lets out a
breath, smiling, locking eyes with Dana for
a moment — that both of them pull out of
almost awkwardly.

Marty exhales a huge cloud of smoke.

MARTY
(genuine)
Thank you for opening my eyes to what-
ever it was you just said.
(then)
Jules! Truth or Dare or Lecture.

JULES
Let's go dare!

MARTY
All right.
(thinks)
I dare you to make out with —

CURT
...please say Dana, please say Dana...

MARTY
— that moose over there.

Everyone turns, looks to where he's
pointing. MOUNTED ON THE
WALL is the large, snarling
WOLF'S HEAD. For the
record, it couldn't look
less like a moose.

DANA
Um, Marty... have you
seen a moose before?

MARTY
Whatever that mysterious
beast is —

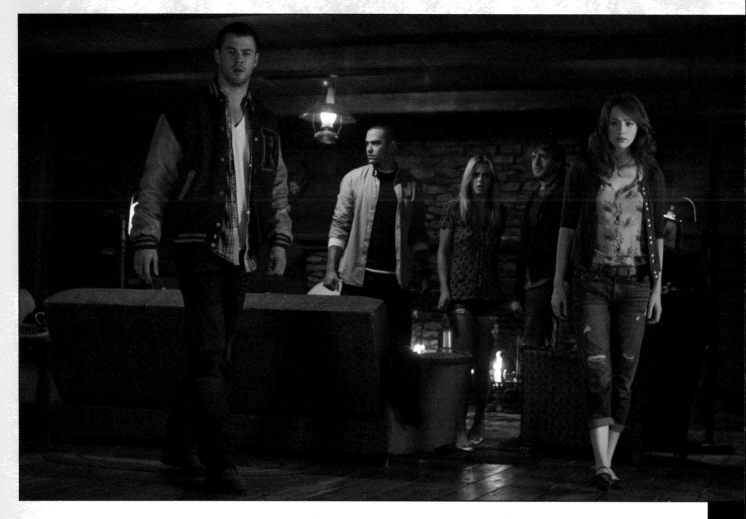

CURT
It's a wolf.

HOLDEN
Yeah, it's a wolf.

MARTY (CONT'D)
I'm living in a womb of reefer, leave me alone.
(then)
Jules, I dare you to make out with *the wolf*.

Jules nods, takes a drink, hops to her feet.

JULES
No problem.

The group cheers. As Jules makes her way across the cabin, she drops her hips a bit, adding a sultry swagger to her step.

WOLF'S POV: We're looking out at the cabin as Jules walks right by us. And just as she's about to exit frame, she stops in her tracks. Looks over at us.

She glances over her shoulder. Bashful. Looks back at us wolf, points to her chest.

JULES (CONT'D)
Who? Me?
(pretends to listen, then)
I am new in town, how did you know?

Everyone laughs, cheering her on. But Jules pretends they're not even there — it's just her and the wolf.

She blushes, twirls her hair around her finger —

JULES (CONT'D)
(to the wolf)
Oh my god, that is *so sweet* of you to say. I just colored it, in fact...
(then)
Yes I'd love a drink, thank you.

She steps towards the wolf, then acts like she trips —

JULES (CONT'D)
Whoops —
(looks towards the ground)
I seem to have dropped my birth control pills all over the ground...

While the group hoots and hollers, Jules turns around, bends over right in front of the wolf. Pretends like she's picking something from the ground.

Then, without turning around, she stands up straight, so that the wolf is now directly over her shoulder. She nuzzles it, cheek to cheek —

JULES (CONT'D)
Oh.. Mr. Wolf. You're so big. And *bad*.
(then)
No no no — there's no need to huff and puff...

She turns around, takes the wolf's head in her hands —

JULES (CONT'D)
I'll let you come in.

And with that, Jules leans in and gives the wolf the most passionate kiss we've ever seen. She just goes for it — full-on, tongue-to-taxidermied-wolf-tongue action.

The group loses their minds. Everyone leaps to their feet, giving Jules a standing ovation.

Jules looks to the group, takes a bow even as she makes a face, spitting out stuffed-wolf taste. As she walks back to the group, Curt hands Jules her beer, the others keep applauding —

HOLDEN
I didn't know it was possible, but I think you just officially won Truth or Dare.

DANA
Or Lecture.

HOLDEN
Sorry.

JULES
The night is still young. Now then...
Dana —

CURT
(bored)
"Truth."

Dana frowns. Glances at Curt —

DANA
What's that supposed to mean?

CURT
I'm just skipping ahead.
(to explain)
You're gonna say "Dare," she's gonna dare you to do something you don't like and then you'll puss out and say you wanted "Truth" all along.

DANA
(studies him)
Really.

CURT
(nods)
Or "Lecture".

DANA
No, I wouldn't want one of *those*...

ANGLE MARTY — he's glancing at Curt. Frowning. Something about all this seems a little off...

And Dana seems to notice it too. But she's not about to let Curt get under her skin —

DANA (CONT'D)
Okay, Jules...
(defiant)
Dare.

And just then, behind her — WH-WHAM — the cellar door blows open. Everyone screams, startled.

JULES
What the hell was that?

They all look back at the now-open hole in the floor. As they move toward it —

DANA
It's the cellar door...

MARTY
I thought it was locked.

CURT
The wind must have blown it open...

JULES
What wind...?

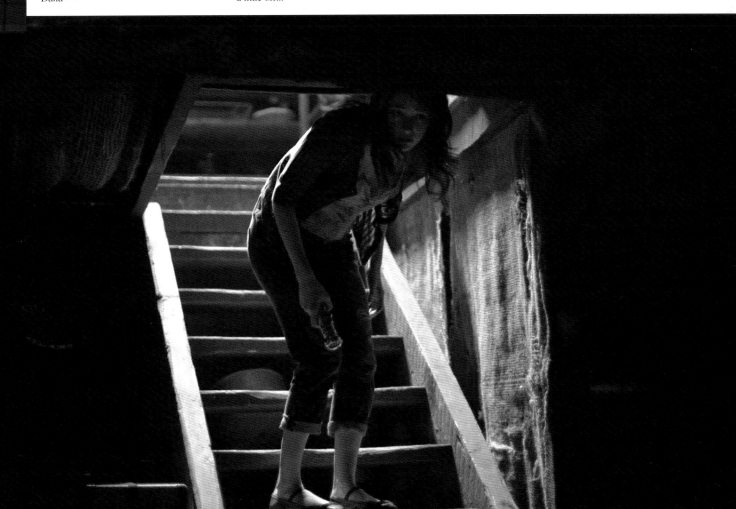

They all cluster around the hole. A set of stairs leads down into the foreboding darkness. The group stares down at it, all a little spooked —

HOLDEN
What do you think's down there?

JULES
(shrugs)
Why don't we find out?
(then)
Dana...

Dana glances up at her. What?

JULES (CONT'D)
(pointed)

I dare you.

And we're CLOSE ON DANA as she tries not to show just how much that scares her. OFF HER LOOK —

INT. CELLAR

Crrreak. Dana cautiously makes her way down the old wooden staircase. It's *dark*; Dana's flashlight barely illuminates three feet in front of her.

She reaches the landing. Tries to keep her voice steady as she calls back to the others —

DANA
How long do I have to stay down here?

CURT (O.S.)
Oh, you know, just 'til morning...

She stands at the base of the stairs, trains the flashlight beam around the room. Curiosity getting the better of her, she steps into the darkness.

Creak...

The flashlight beam scans the room, catching a glint of metal — OLD RUSTY TOOLS hang from hooks along the walls.

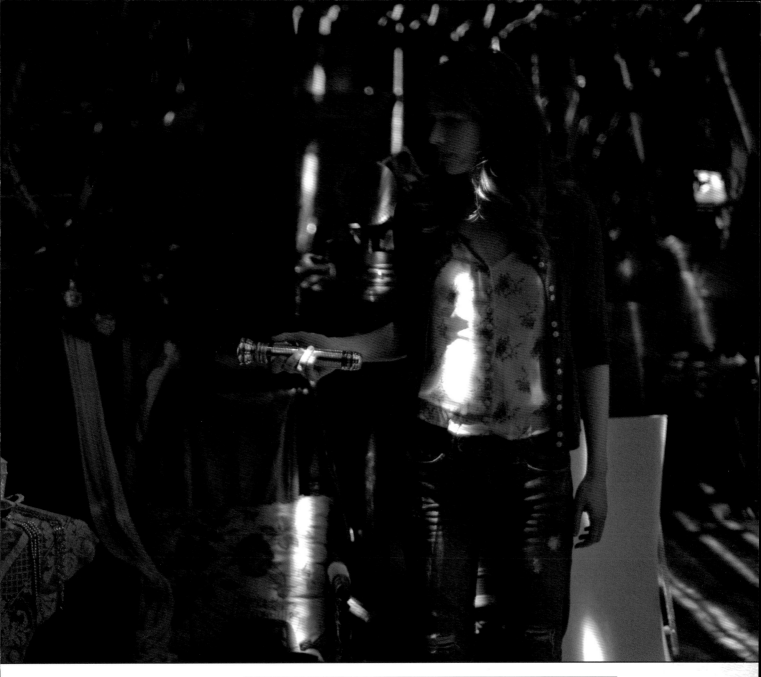

Creak...

Dana keeps moving, heart pounding in her chest. Her flashlight sweeps the area, finding a dusty old RECORD PLAYER... a CHILD'S TOY CHEST... a dressmaker's MANNEQUIN...

Dana turns, beam sweeping across the wall. As it does so, it finds —

A GHOSTLY FACE.

Staring right at her. Dana screams, nearly jumps out of her skin —

HOLDEN (O.S.)
Dana?

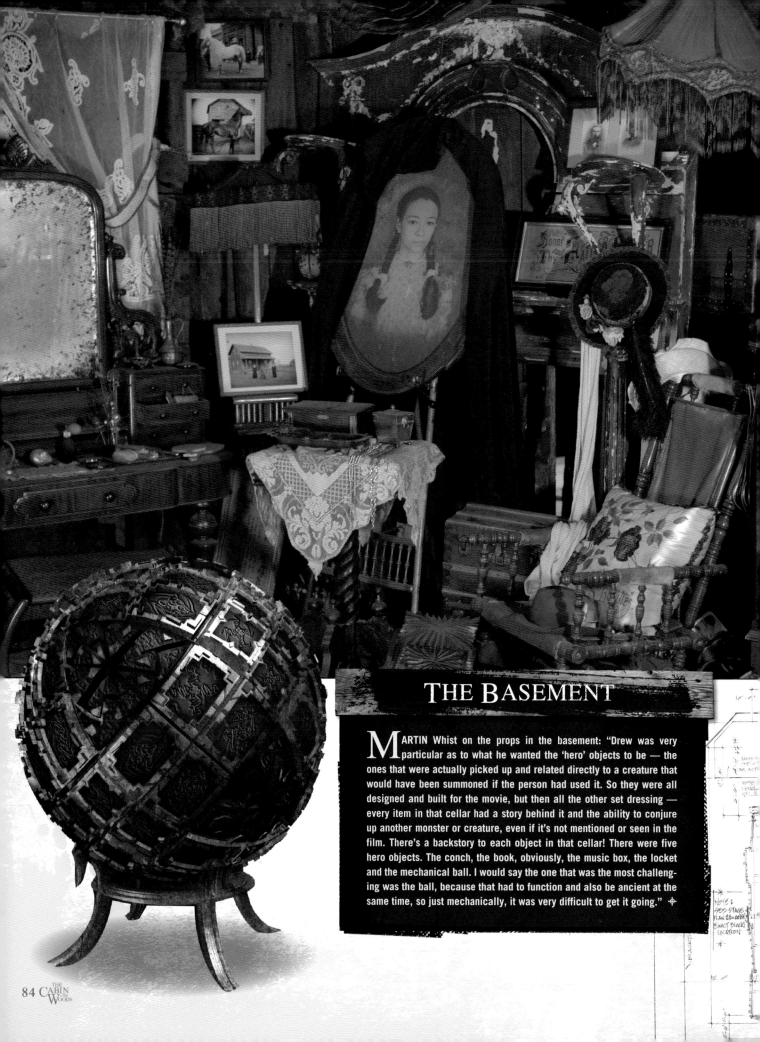

THE BASEMENT

MARTIN Whist on the props in the basement: "Drew was very particular as to what he wanted the 'hero' objects to be — the ones that were actually picked up and related directly to a creature that would have been summoned if the person had used it. So they were all designed and built for the movie, but then all the other set dressing — every item in that cellar had a story behind it and the ability to conjure up another monster or creature, even if it's not mentioned or seen in the film. There's a backstory to each object in that cellar! There were five hero objects. The conch, the book, obviously, the music box, the locket and the mechanical ball. I would say the one that was the most challenging was the ball, because that had to function and also be ancient at the same time, so just mechanically, it was very difficult to get it going."

Below: A pre-production plan showing how the basement set would be constructed on the soundstage.

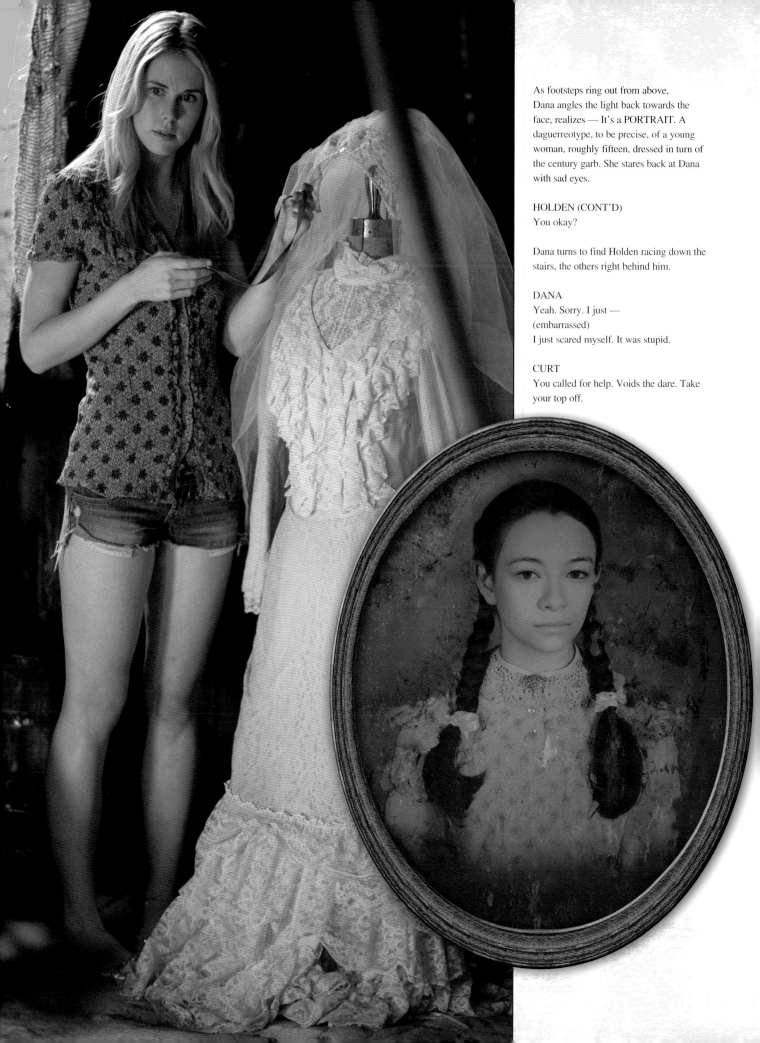

As footsteps ring out from above, Dana angles the light back towards the face, realizes — It's a PORTRAIT. A daguerreotype, to be precise, of a young woman, roughly fifteen, dressed in turn of the century garb. She stares back at Dana with sad eyes.

HOLDEN (CONT'D)
You okay?

Dana turns to find Holden racing down the stairs, the others right behind him.

DANA
Yeah. Sorry. I just —
(embarrassed)
I just scared myself. It was stupid.

CURT
You called for help. Voids the dare. Take your top off.

Marty strikes a match, lights an OLD OIL LANTERN hanging from the wall. As orange light spills across the room...

HOLDEN
Oh my god...

...they get a full view of THE CELLAR. The room is big — much bigger than we expected — and every dark corner seems to be filled with creepy clutter.

JULES
Look at all this...

MARTY
Uh, guys, I'm not sure it's awesome to be down here.

But the others aren't even listening to him. They spread out, each focusing on a different part of the cellar —

Holden looks down at a variety of CHILD'S TOYS scattered across the floor. He picks up an ORNATE MUSIC BOX, he removes his glasses from his pocket, puts them on —

HOLDEN
Dude, seriously — your cousin's into some weird shit.

Curt has picked up a CONCH when he sees a WOODEN SPHERE sitting behind it. He puts the conch down and hoists the sphere. It almost looks like a small globe, it's so ornately carved, but it has dusty brass rings inlaid around it — it can be turned and adjusted almost like a spherical Rubik's cube.

CURT
Yeah, pretty sure this ain't his. Maybe the people who put in that window...

Dana can't take her eyes off the portrait of the girl. On the vanity below it, she notices a variety of personal effects: an old hairbrush... a silver mirror... and a leather-bound BOOK.

DANA
Some of this stuff looks really old.

Jules studies the dressmaker's mannequin. AN AMULET hangs around its neck. Jules touches it...

JULES
(almost to herself)
It's beautiful...

MARTY
Maybe we should go back upstairs...
(then)
I dare you all to go upstairs?

But even Marty can't help but be intrigued as he spots an OLD SUPER-8 PROJECTOR. He finds a film reel, starts unspooling it...

HAUNTING MUSIC fills the air as Holden starts winding the crank on the music box...

Curt starts turning the sphere parts — they seem to be lining up...

Dana brushes the dust off the book, revealing the word "DIARY" on the cover...

Jules takes the amulet off the mannequin, holds it up to her neck, looks for the clasp — as though she were about to try it on...

Marty holds the film strip up to the light, frowns as he tries to discern what's on it...

As Holden continues to wind the crank, the music BUILDS and BUILDS... He's staring down at the box-lid — it's as though something's about to pop right out of it... And just as the music's about to reach crescendo —

DANA
Guys.

Holden stops winding the crank. The world goes quiet. Everyone looks up from what they're doing.

DANA (CONT'D)
Guys, listen to this...

Reluctantly, each person puts down the object of his or her attention and moves towards Dana.

DANA (CONT'D)
(reads from diary)
"Today we felled the old birch tree out-back. I was sorrowed to see it go, as Judah and I had sat up in its branches so many summers..."

JULES
What is that?

Dana looks in the inside cover.

DANA
Diary of Anna Patience Buckner, 1903.

CURT
Wow...

JULES
That's the original owners, right?

DANA
(reading again)
"Father was cross with me and said I lacked the true faith. I wish I could prove my devotion, as Judah and Matthew proved on those travellers..."

MARTY
Uh, that makes what kind of sense?

HOLDEN
You know, it's uncommon that a girl out here was reading and writing in that era.

DANA
(reads)
"Mama screamed most of the night. I prayed that she might find faith, but she only stopped when papa cut her belly and stuffed the coals in."

She stops, look-ing at everyone. Nobody comments. Bewildered, she flips ahead, continues:

DANA (CONT'D)
(reads)
"Judah told me in my dream that Matthew took him to the Black Room so I know he is killed. Matthew's faith is too great; even Father does not cross him or speak of Judah. I want to understand the glory of the pain like Matthew, but cutting the flesh makes him have a husband's bulge and I do not get like that."

MARTY
Jesus, can we not...

CURT
Go on.

MARTY
Why?

CURT
Suck it up or bail, pothead! I wanna know.

Dana looks around. Holden gives her a little nod.

DANA
(reads)
"I have found it. In the oldest books: the way of saving our family. I can hear Matthew in the Black Room, working upon father's jaw. My good arm is hacked up and et so I hope this will be readable, that a believer will come and speak this to our spirits. Then we will be restored and the Great Pain will return."
(looks up)
And there's something in Latin.

MARTY
Okay, I am drawing a line in the fucking sand here, do not read the Latin.

A small voice seems to whisk across the top of the room, barely audible:

VOICE
Read it....

Marty is the only one who seems to hear it. He looks around...

MARTY
The fuck..?

VOICE
Read it out loud...

Marty starts across the room as Dana appears to be about to start. Curt plants a hand in his chest and shoves him back.

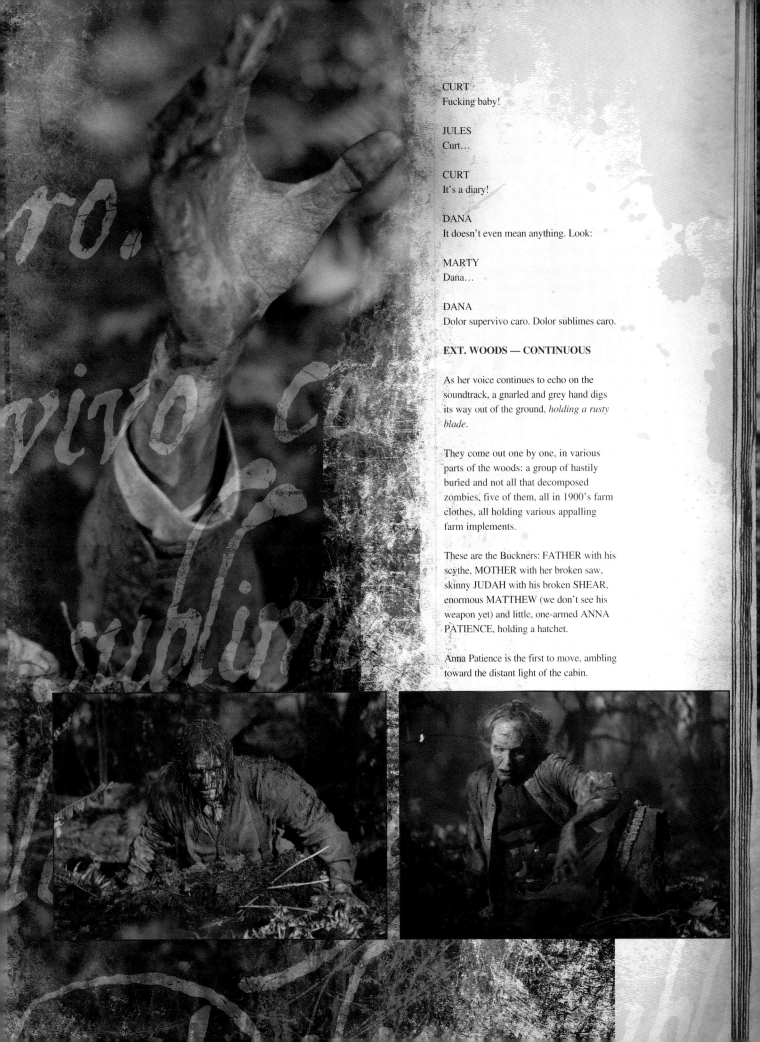

CURT
Fucking baby!

JULES
Curt…

CURT
It's a diary!

DANA
It doesn't even mean anything. Look:

MARTY
Dana…

DANA
Dolor supervivo caro. Dolor sublimes caro.

EXT. WOODS — CONTINUOUS

As her voice continues to echo on the
soundtrack, a gnarled and grey hand digs
its way out of the ground, *holding a rusty
blade.*

They come out one by one, in various
parts of the woods: a group of hastily
buried and not all that decomposed
zombies, five of them, all in 1900's farm
clothes, all holding various appalling
farm implements.

These are the Buckners: FATHER with his
scythe, MOTHER with her broken saw,
skinny JUDAH with his broken SHEAR,
enormous MATTHEW (we don't see his
weapon yet) and little, one-armed ANNA
PATIENCE, holding a hatchet.

Anna Patience is the first to move, ambling
toward the distant light of the cabin.

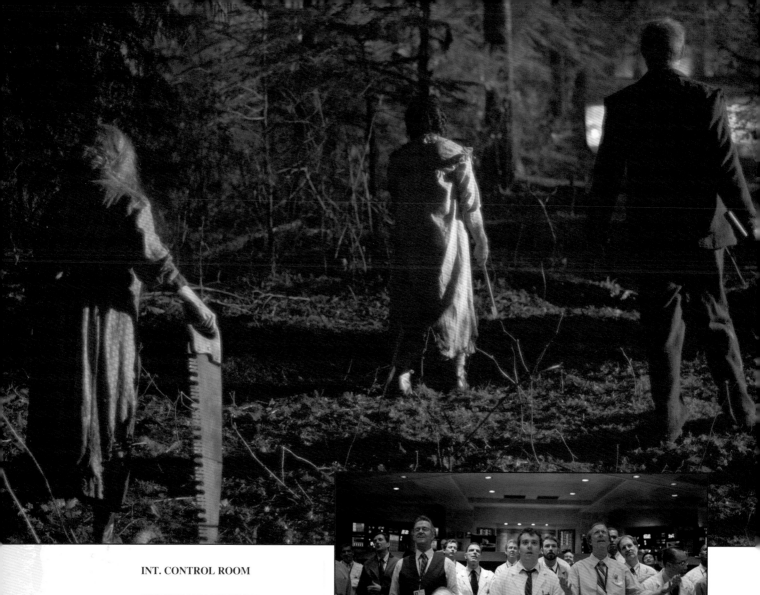

INT. CONTROL ROOM

ON THE MAIN VIEWSCREEN — we see the image of the ZOMBIE FAMILY slowly making their way towards the cabin.

SITTERSON (O.S.)
We have a winner!

Widen to reveal a HUGE CROWD has filled the control room. Everyone's watching the large viewscreen intently.

SITTERSON (CONT'D)
It's the Buckners, ladies and gentlemen! Buckners pull the "W!"

Most of the crowd GROANS in disappointment, throws their betting slips to the ground. But a few BLUE-COLLAR GUYS throw their arms up in triumph —

SITTERSON (CONT'D)
(looks over at the wall)
Looks like congratulations go to Maintenance...

And as he says that, we see behind him:

A LARGE WHITE-BOARD against the wall. Written in marker, down one column, there's a long list of MONSTERS. A few words jump out at us: "VAMPIRES," "WEREWOLVES," "FLOATING WITCHES," "ALIENS," "ZOMBIES," "KEVIN," "CLOWNS," "WRAITHS," "SCARECROWS," "ANGRY MOLESTING TREE," "MUTANTS."

Down another column: a corresponding list of DEPARTMENTS: "ELECTRICAL," "ENGINEERING," "SECURITY,"

"ZOOLOGY" and so forth.

SITTERSON (CONT'D)
(continuing)
...who split the pot with Ronald the Intern.

Hadley hands an enormous wad of cash to the BLUE-COLLAR GUYS and another wad to the happy INTERN we saw earlier.

People shake their heads, begin to file out of the room. A LABCOAT GIRL approaches Sitterson on her way out —

LABCOAT GIRL
That's not fair! I had zombies too!

SITTERSON
Yes, you had "Zombies." But this is
"Zombie Redneck Torture Family..."

Sitterson taps the board. There it is right
there: "ZOMBIE REDNECK TORTURE
FAMILY." Right next to "MAIN-
TENANCE" and "RONALD THE
INTERN."

SITTERSON (CONT'D)
Entirely separate thing. It's like the
difference between an elephant and an
elephant seal.

Her shoulders slump. Knows he's right. As
she goes:

SITTERSON (CONT'D)
There's always next year....

Truman stares at the screens, at the
shambling Buckners corpse-clan.

TRUMAN
They're like something from a nightmare...

LIN
No, they're something that nightmares are

from. Everything in our stable is a remnant
of the old world, courtesy of...
(pointing down)
...You know who.

TRUMAN
Monsters, magic...

LIN
You get used to it.

TRUMAN
(turning to her)
Should you?

Sitterson walks over to Hadley. He's just
standing there, staring up at the screens.
Looking a little despondent —

SITTERSON
I'm sorry, man.

HADLEY
(can't believe his bad luck)
He had the conch *in his hands*...

SITTERSON
I know. Couple more minutes, who knows
what would have happened...

HADLEY
(frustrated)
I'm *never* gonna get to see a merman.

SITTERSON
Dude, be thankful. Those things are
terrifying. And the cleanup on them's a
nightmare.

Hadley nods — I suppose you're right. He
gestures towards the screens.

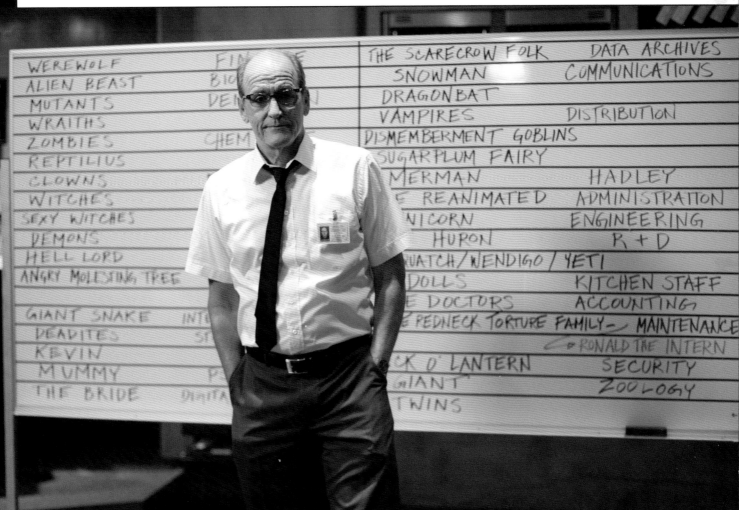

HADLEY
So... the Buckners, huh?

SITTERSON
I know.
(watches the screens)
Well, they may be zombified pain-
worshipping backwoods idiots, but...

HADLEY
They're *our* zombified pain-worshipping
backwoods idiots.

SITTERSON
— and they have a hundred percent clear-
ance rate.

Hadley nods, good point. As they start
walking back towards their console —

HADLEY
True. We may as well tell Japan to take the
rest of the weekend off.

SITTERSON
Yeah, right. They're *Japanese*. What are
they gonna do — *relax*?

HADLEY
I don't know. Maybe they can do some
group calisthenics or something...

And as Sitterson and Hadley clear
frame, we HOLD ON ONE OF THE
MONITORS.

ON THE SCREEN: we see a video feed
of a JAPANESE SCHOOL ROOM.
Several schoolchildren run screaming in
terror from a SOPPING WET YOUNG
GIRL who's floating through the air like
she's hanging from an invisible noose. As
the children SCREAM and SCREAM, the
WET GIRL floats TOWARDS US and
we CUT TO —

INT. LIVING ROOM — NIGHT

The music is blaring and Jules is danc-
ing up a storm. Curt is going with it,
occasionally getting behind her for the
butt-cupping dance, but she's all over the
room — really working it. Pops a couple
of buttons to show more cleavage.

Everyone else is sitting, Dana and Holden
on the couch, Dana still holding the book,
and Marty slumped in armchair, smoking
sullenly.

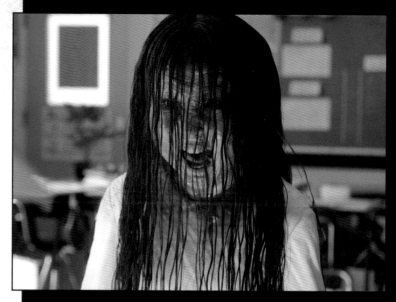

Jules dances over in front of Holden
and does a little impromptu lap-dance
wriggle for him. He looks a little
awkward, glancing at Dana, who isn't
exactly thrilled.

CURT
Go baby, oh yeah... that's the goods right
there, fuck yeah.

MARTY
This is so *classy*.

CURT
Like you wouldn't want a piece of that.

MARTY
Can we not talk about people in *pieces*
anymore tonight?

JULES
(kittenish, turning)
Oh, are you feeling lonely, Marty?

She moves to him, gives him a little
wriggle action as she takes his joint and
sucks hard.

JULES (CONT'D)
Marty and I were sweeties on our
freshman hall.

MARTY
(to the others)
We made out *once*. I never did buy that
ring.

JULES
(pouty)

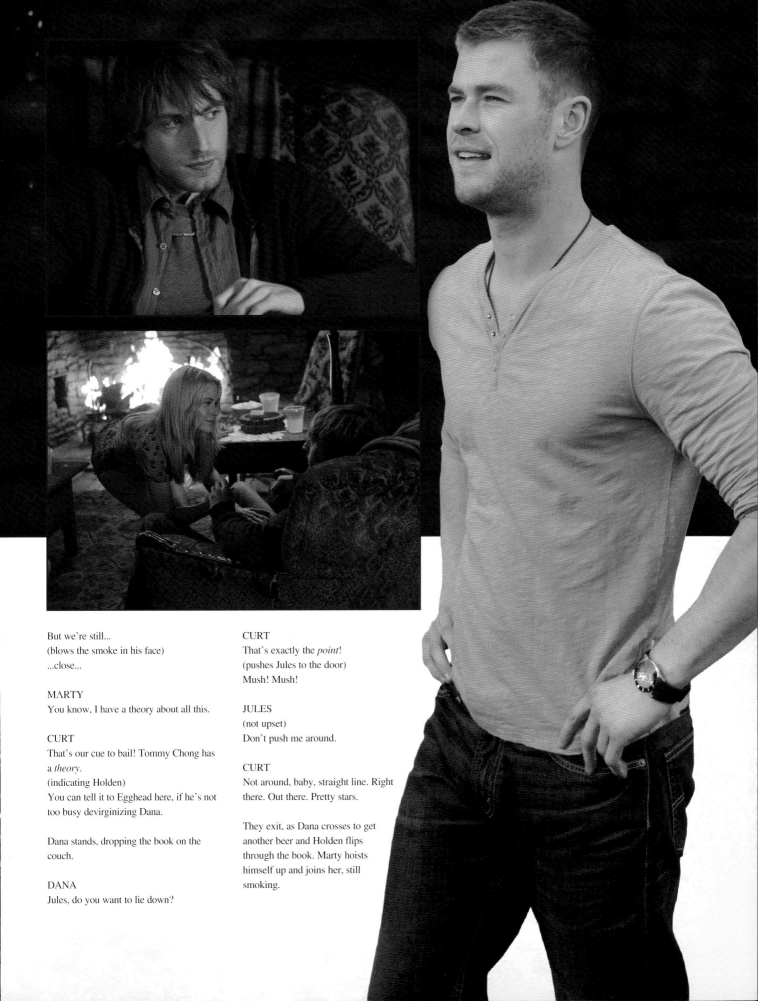

But we're still...
(blows the smoke in his face)
...close...

MARTY
You know, I have a theory about all this.

CURT
That's our cue to bail! Tommy Chong has
a *theory*.
(indicating Holden)
You can tell it to Egghead here, if he's not
too busy devirginizing Dana.

Dana stands, dropping the book on the
couch.

DANA
Jules, do you want to lie down?

CURT
That's exactly the *point*!
(pushes Jules to the door)
Mush! Mush!

JULES
(not upset)
Don't push me around.

CURT
Not around, baby, straight line. Right
there. Out there. Pretty stars.

They exit, as Dana crosses to get
another beer and Holden flips
through the book. Marty hoists
himself up and joins her, still
smoking.

MARTY
Do you seriously believe that nothing
weird is going on?

DANA
(wryly)
A conspiracy?

MARTY
The way everybody's acting!

DANA
I'm sorry about downstairs —

MARTY
It's cool, it's not — when does Curt
start with this alpha male bullshit? He's
a sociology major; he's on a full aca-
demic scholarship! Now he's calling his
friend an "Egghead", whose head in no
way resembles an egg...
(looks over at Holden)
...except...ahhh. Okay, kinda, from this
angle, it's...
(holds his own head to keep it from
becoming eggshaped)
...ahhh...

DANA
Curt's just drunk.

MARTY
I've seen Curt drunk — Jules too.

DANA
(pointing at the joint)
Then maybe it's something else.

MARTY
My secret secret stash is a gateway to
enlightenment; it's not a devolveafier.
(to the wolf head)
Moose, back me up on this.
(to Dana)

You're not seeing what you don't wanna
see — the puppeteers.

DANA
Puppeteers?

MARTY
(hears it wrong)
Pop-tarts? Did you say that you have
pop-tarts?

DANA
Marty, I love you, but you're really
high.

MARTY
(dead serious)
We are not who we are.
(closes his eyes)
I'm gonna read a book with pictures.

He ambles off into his bedroom as Dana
comes back to the couch with a beer for
herself and Holden. He takes his, still
holding the book.

HOLDEN
(translating)
"The pain outlives the flesh. The flesh
returns... or re... has a meeting place...
towards the pain's ascension".

DANA
What's that?

HOLDEN
The Latin. That you...

DANA
You speak Latin?

HOLDEN
Not well, and not since tenth grade.
Weird how it comes back.

He sips his beer, tosses the book back on
the couch.

DANA
Well, it's a weird night. I'm so sorry
about... tonight. Everybody.

HOLDEN
Do I lose points if I tell you I'm having a
pretty nice time?

She smiles, looks down.

DANA
No. You can tell me that.

EXT. WOODS — NIGHT

Jules is laughing, running through the
woods, Curt in hot pursuit. He catches her
around the waist with one hand, beer still
held in the other.

CURT
Come here!

JULES
Ah! Don't spill on me!

CURT
Did I get a little beer on your shirt?

He kisses her, deep and hard.

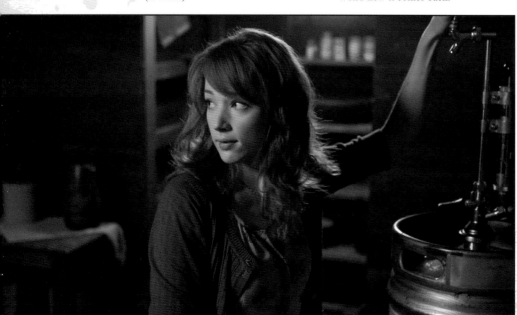

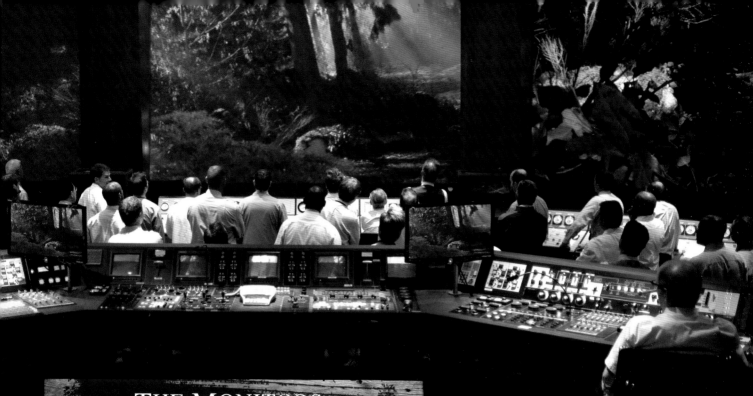

THE MONITORS

MARTIN Whist on the control room monitors: "It was an ongoing debate exactly how many we had, but I think it was ninety to a hundred monitors in the set. It was difficult synching them all up to make the playback work for the shooting; moving images from one screen to the other and having them all play at the same time. The guy in charge of playback had a little hut on the stage and the cabling that was coming out the back of that hut was a set all by itself. It was incredible. Thousands of cables! You'd go inside it and there were these bug-eyed guys in there, in front of their computers, manipulating everything. It was like The Wizard of Oz, behind the curtain."✛

CURT (CONT'D)
I guess it'll have to come off.

He starts pulling at the last buttons. She pulls away a little.

JULES
Not here...

CURT
Oh, come on…

**INT. CONTROL ROOM —
CONTINUOUS**

They're suddenly on three huge screens, being shot with a remote camera on a long lens, with fifteen workers low in frame watching them intently.

CURT
...we're all alone...

**EXT. WOODS —
CONTINUOUS**

He pulls the shirt open but she takes a step back and holds it together.

JULES
I'm chilly.

**INT. CONTROL ROOM —
CONTINUOUS**

A *groan* throughout the crowd causes Hadley to stand up from the control area behind them.

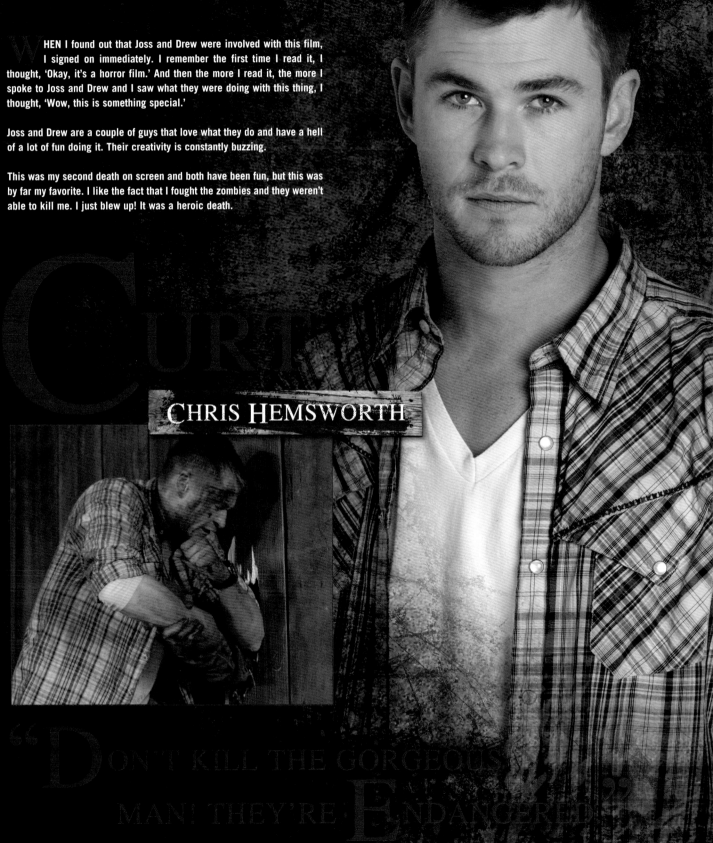

WHEN I found out that Joss and Drew were involved with this film, I signed on immediately. I remember the first time I read it, I thought, 'Okay, it's a horror film.' And then the more I read it, the more I spoke to Joss and Drew and I saw what they were doing with this thing, I thought, 'Wow, this is something special.'

Joss and Drew are a couple of guys that love what they do and have a hell of a lot of fun doing it. Their creativity is constantly buzzing.

This was my second death on screen and both have been fun, but this was by far my favorite. I like the fact that I fought the zombies and they weren't able to kill me. I just blew up! It was a heroic death.

CURT

CHRIS HEMSWORTH

"DON'T KILL THE GORGEOUS MAN! THEY'RE ENDANGERED"

"WE ARE GIRLS ON THE VERGE OF GOING WILD."

JULES

ANNA HUTCHISON

EOPLE ask what kind of film is this and I'm like, 'Hmmm, I don't actually know,' because there's so many different areas that it could be. It could be a teen movie, it could be horror, it could be psychological thriller. But it's definitely cool. I'd put it under the cool category. And there's golf carts going by. That's rad.

Basically I got all the coolest things in the world — I had a fake head, I had a huge cast made, which was so freaky. And I was so lucky that they made a forest. Who ever gets that? It would have been really cold otherwise.

For the scene where my hand gets stabbed, it was funny because I burnt myself cooking one time, so I already had a scar where the knife went, which is kind of... handy. Plus, when Ma Buckner puts on the hot coals that burn me, I just had my appendix out, so I still had quite a ripe scar on my tummy, which the brilliant makeup artist just used. 'We'll work with what we've got, honey, we'll work with what we've got!' We just put a little thing around it and there was my burn.

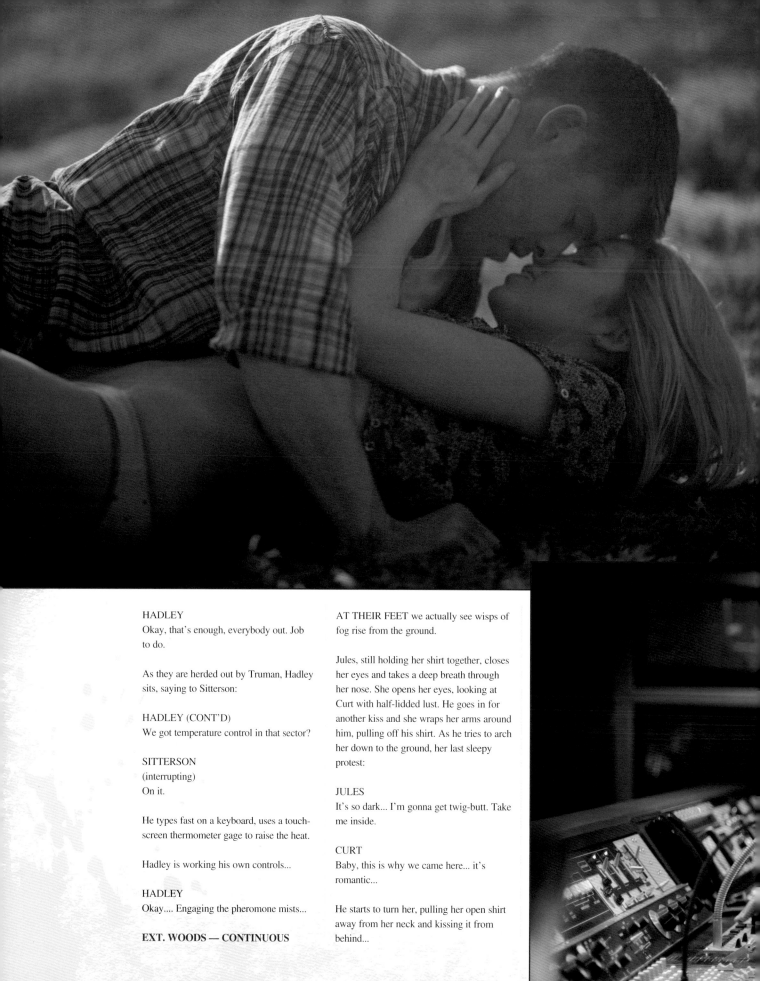

HADLEY
Okay, that's enough, everybody out. Job to do.

As they are herded out by Truman, Hadley sits, saying to Sitterson:

HADLEY (CONT'D)
We got temperature control in that sector?

SITTERSON
(interrupting)
On it.

He types fast on a keyboard, uses a touch-screen thermometer gage to raise the heat.

Hadley is working his own controls...

HADLEY
Okay.... Engaging the pheromone mists...

EXT. WOODS — CONTINUOUS

AT THEIR FEET we actually see wisps of fog rise from the ground.

Jules, still holding her shirt together, closes her eyes and takes a deep breath through her nose. She opens her eyes, looking at Curt with half-lidded lust. He goes in for another kiss and she wraps her arms around him, pulling off his shirt. As he tries to arch her down to the ground, her last sleepy protest:

JULES
It's so dark... I'm gonna get twig-butt. Take me inside.

CURT
Baby, this is why we came here... it's romantic...

He starts to turn her, pulling her open shirt away from her neck and kissing it from behind...

**INT. CONTROL ROOM —
CONTINUOUS**

The boys are working in concert now.

SITTERSON
(to himself, singing)
Music and moonlight and love and
romance...

He pushes a lever — literally a dimmer —
up as he hums. And:

EXT. WOODS — CONTINUOUS

Before the kids, a tiny glen of moss and
soft green fronds suddenly seems to glow
in the moonlight. It couldn't be more
inviting.

Jules smiles, dizzy with lust.

ANGLE: GROUND LEVEL — Jules
drops down into frame, Curt on her, the
two of them only about the business. They
roll over, Jules on top, sliding her hand
down Curt's pants — he moans with
longing, running his hand up her chest.

**INT. CONTROL ROOM —
CONTINUOUS**

The men watch the screens, hands at the
ready to manipulate any dial. They have the
dispassionate focus of porn theater patrons.

HADLEY
(quietly)
Okay, boobies, boobies...

SITTERSON
Show us the goods...

Truman looks over at them, a little
disturbed.

TRUMAN
Does it really matter if we see —

HADLEY
(not looking around)
We're not the only ones watching, kid.

SITTERSON
Got to keep the customer satisfied.
(does turn)
You understand what's at stake here?

TRUMAN
(nodding)
Sorry.

Sitterson turns back to the screens, and the
two men watch their handiwork.

**INT. CONTROL ROOM/EXT.
WOODS — CONTINUOUS**

And now we cut back and forth a bit.

Curt, kneeling, slides Jules's pants off. His
head comes back into frame and takes the
edge of her panties in his mouth, making a
little growl as he lets go and it snaps back
on her waist —

Jules laughs, leaning her head back and
suddenly not laughing, breathing hard...

Hadley and Sitterson stare, (looking
perhaps directly into camera to make us
even less comfortable)...

Jules swings on top and finishes undo-
ing the last few buttons on her shirt. She
takes her time, sliding her hands up her
belly, holding her shirt together coyly for
a moment. She finally lets it fall open,
revealing her breasts, a sheen of sweat (and
the fact that they're not fake) making
them all the more enticing. She smiles
knowingly, a vision of hedonistic
perfection.

Curt looks up at her in silent wonder.

All three men in the control room —
including Truman — look at her the exact
same way.

As Curt slides his hand over her chest,
she leans down into him, his arms coming
around her back.

HADLEY
Score.

SITTERSON
Eat that, Stockholm...

He makes a small tweak on a dial, eyes still
on the screen.

ANGLE: ABOVE THE LOVERS the
camera comes softly down towards them,
the tableau romantic and sensual. He's atop
her and a bit to the side, one hand (out of
frame) working under her panties as she
moans, arms out...

CLOSE ON: HER HAND, running along
the soft moss.

A rusty blade pins it to the earth.

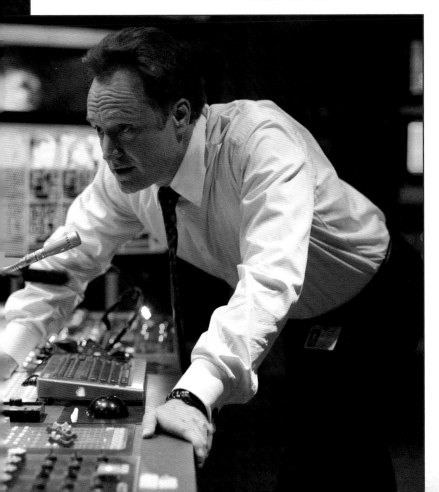

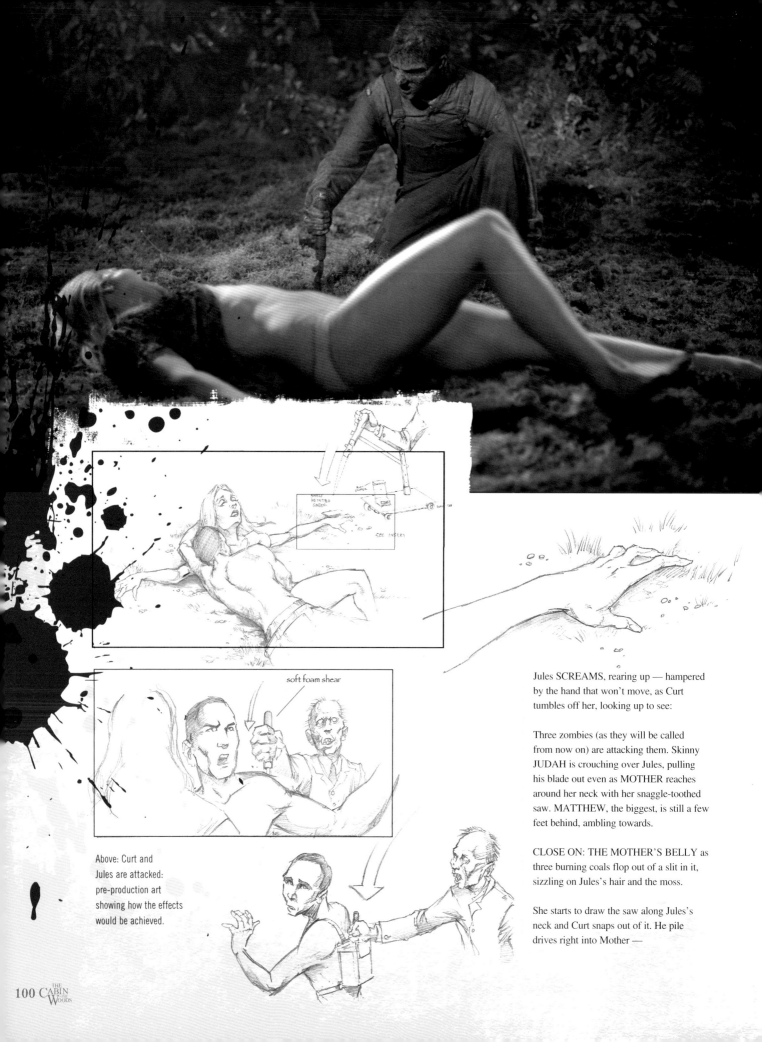

Jules SCREAMS, rearing up — hampered by the hand that won't move, as Curt tumbles off her, looking up to see:

Three zombies (as they will be called from now on) are attacking them. Skinny JUDAH is crouching over Jules, pulling his blade out even as MOTHER reaches around her neck with her snaggle-toothed saw. MATTHEW, the biggest, is still a few feet behind, ambling towards.

CLOSE ON: THE MOTHER'S BELLY as three burning coals flop out of a slit in it, sizzling on Jules's hair and the moss.

She starts to draw the saw along Jules's neck and Curt snaps out of it. He pile drives right into Mother —

soft foam shear

Above: Curt and Jules are attacked: pre-production art showing how the effects would be achieved.

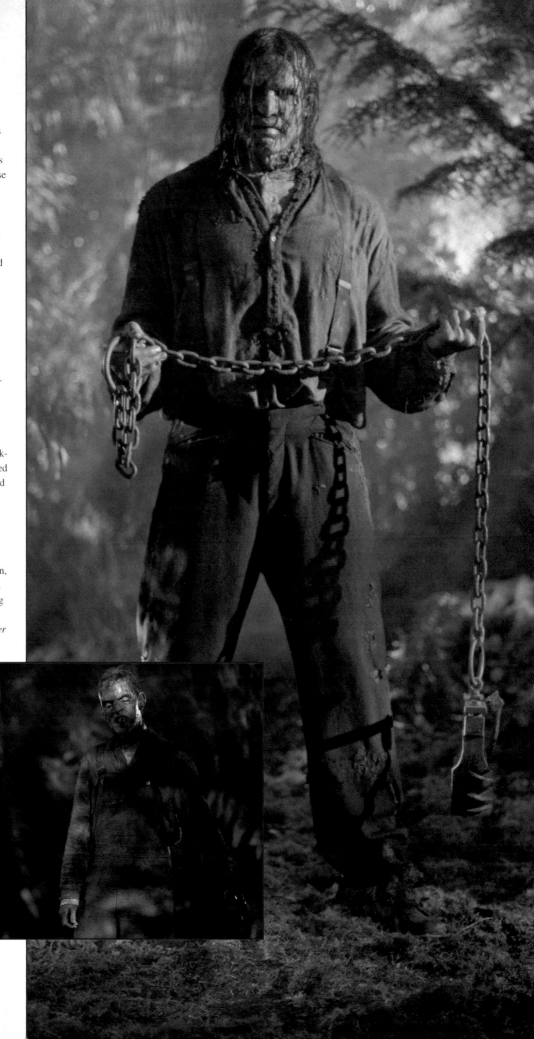

CURT
Fuck away from her!

— knocking her back on her ass. He turns
to Judah just as Judah digs the blade into
his arm. Curt howls, trying to pull it out as
Jules holds her bleeding neck, trying to rise
but weak.

Curt pulls his arm away, bringing Judah
towards him and then punches Judah hard
right in the nose. The nose breaks easily,
crumbling a bit, Judah completely unfazed
by it. Curt looks over towards the third
zombie.

Matthew stands a few feet away, leaning
slightly. Suddenly he lets a chain slide
through his fingers, all the way to the
ground, pulled by a broken bear-trap, just
a rusty metal jaw with teeth: a turn-of-the-
century mace and chain.

Matthew grins.

The trap swings with sudden speed, whack-
ing Curt's head (luckily not with the jagged
side) and knocking him back, bleeding and
dazed.

JULES
Curt!

She tries to rise and Matthew swings again,
digging the claw of the trap *into her back*.
She *SCREAMS*, arching back and flopping
face-down onto the ground, digging her
fingers into the earth as Matthew *drags her
backwards*.

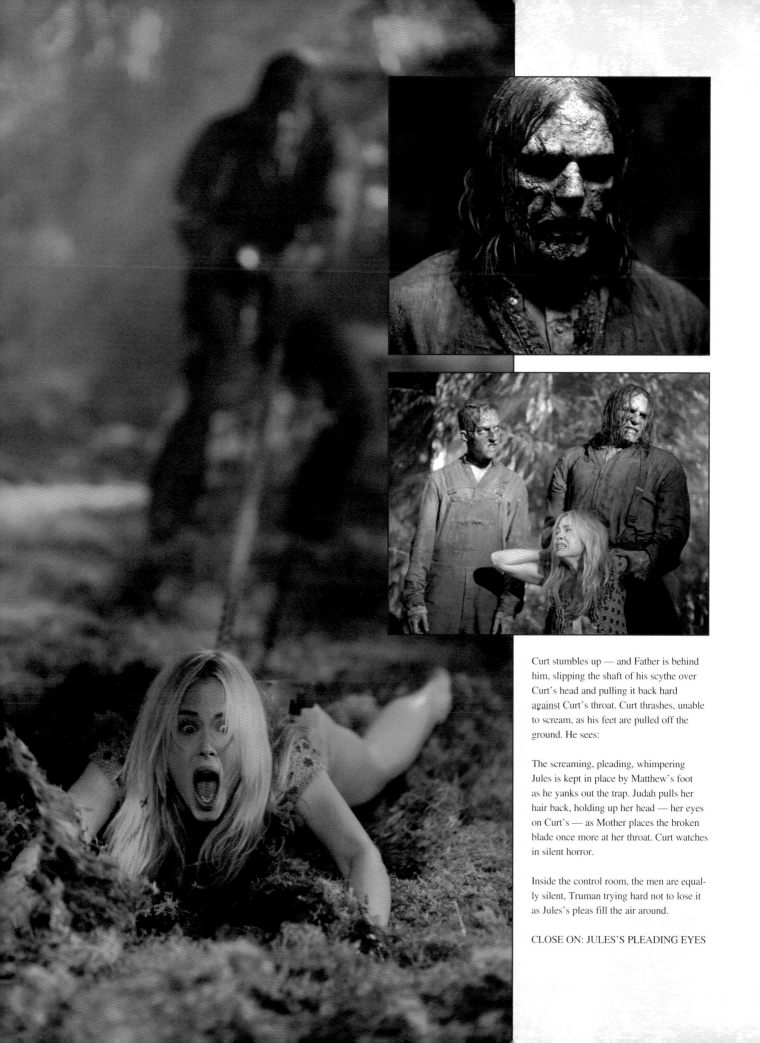

Curt stumbles up — and Father is behind him, slipping the shaft of his scythe over Curt's head and pulling it back hard against Curt's throat. Curt thrashes, unable to scream, as his feet are pulled off the ground. He sees:

The screaming, pleading, whimpering Jules is kept in place by Matthew's foot as he yanks out the trap. Judah pulls her hair back, holding up her head — her eyes on Curt's — as Mother places the broken blade once more at her throat. Curt watches in silent horror.

Inside the control room, the men are equally silent, Truman trying hard not to lose it as Jules's pleas fill the air around.

CLOSE ON: JULES'S PLEADING EYES

as we hear the horrible scrape of the saw tearing flesh.

No sound in the console at all save scraping and shuffling. Truman has his eyes closed. Hadley and Sitterson both have lowered their heads, and Sitterson quietly intones:

SITTERSON
This we offer in humility and fear, for the blessed peace of your eternal slumber. As it ever was.

HADLEY
As it ever was.

Sitterson pulls a short necklace from under his shirt. On it is a weird pagan symbol, five pointed but not a pentagram. He kisses it and replaces it under his shirt as Hadley crosses behind him to a series of five mahogany panels at the far end of the room.

He opens the first and presses an ornate brass lever down.

CLOSE ON: A MECHANISM almost like an old clock, Jules Verne-esque. A small hammer strikes a vial that cracks, dark red blood pouring out into a brass funnel that runs down a thin pipe, seemingly a very long way.

**INT. THE CHAMBER —
CONTINUOUS**

The pipe ends in the ceiling of a dark room we won't really see just yet. The blood pours out onto a leaning slab of dark marble, right into a groove at the top. The blood races down the groove as it bends and arcs different ways, forming a primitive picture of some sort — though of what, we do not yet see.

Above: Pre-production planning for filming the bear-trap in Jules's back.

Right: Mother Buckner's weapon of choice.

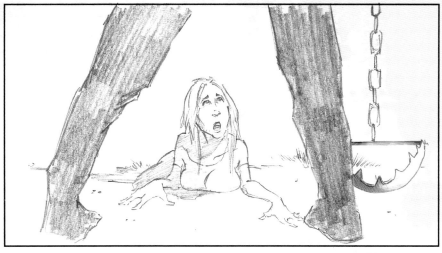

45-48

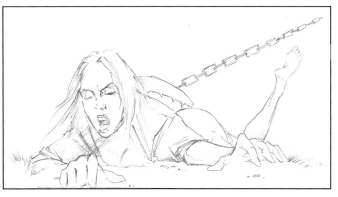

VEST RIG
WITH
CHAIN
ATTATCHED.

HARNESS RIG
SIMILAR TO
HOLDEN'S

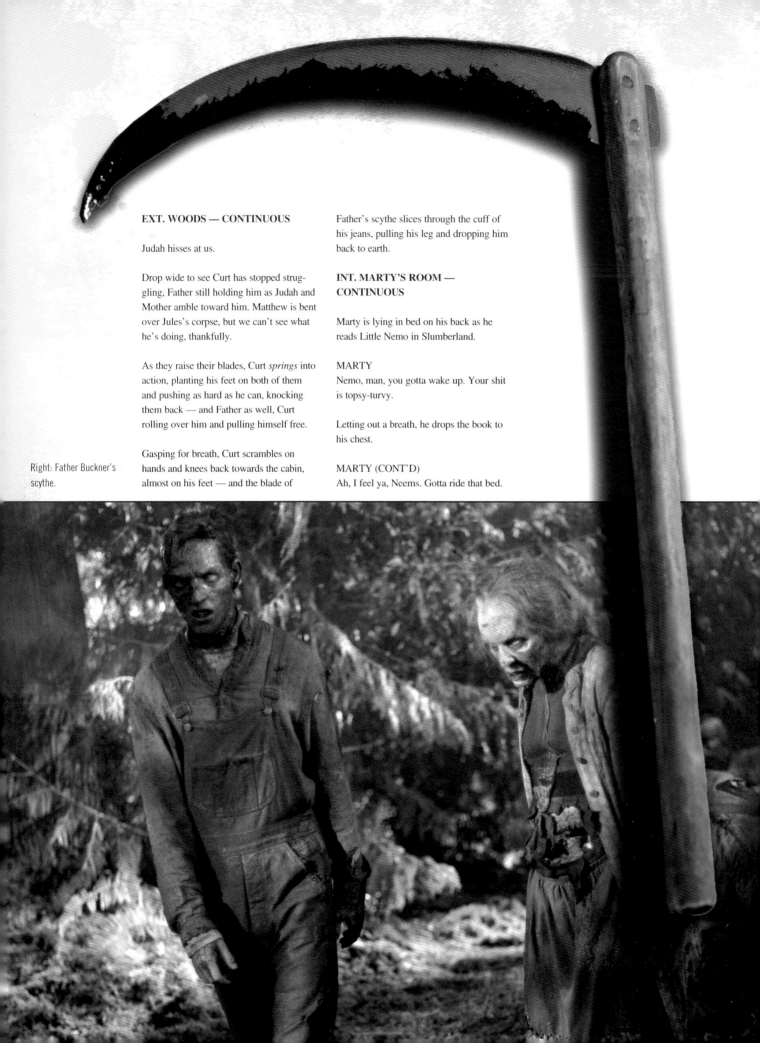

EXT. WOODS — CONTINUOUS

Judah hisses at us.

Drop wide to see Curt has stopped struggling, Father still holding him as Judah and Mother amble toward him. Matthew is bent over Jules's corpse, but we can't see what he's doing, thankfully.

As they raise their blades, Curt *springs* into action, planting his feet on both of them and pushing as hard as he can, knocking them back — and Father as well, Curt rolling over him and pulling himself free.

Gasping for breath, Curt scrambles on hands and knees back towards the cabin, almost on his feet — and the blade of

Right: Father Buckner's scythe.

Father's scythe slices through the cuff of his jeans, pulling his leg and dropping him back to earth.

INT. MARTY'S ROOM — CONTINUOUS

Marty is lying in bed on his back as he reads Little Nemo in Slumberland.

MARTY
Nemo, man, you gotta wake up. Your shit is topsy-turvy.

Letting out a breath, he drops the book to his chest.

MARTY (CONT'D)
Ah, I feel ya, Neems. Gotta ride that bed.

VOICE
I'm gonna go for a walk...

He sits right up.

MARTY
(loud, to the room)
Okay, I swear to fucking God somebody
is talking.

He runs his hands over his eyes, weary.

MARTY (CONT'D)
Or I'm pretty sure someone is...ah...

VOICE
I'm gonna go for a walk...

MARTY
(standing)
Enough! What are you saying? What do
you want? You think I'm a puppet, gonna
do a puppet dance — fuck all y'all! I'm the
boss of my brain so give it up!
(beat. Pissed:)
I'm gonna go for a walk.

**INT. LIVING ROOM —
CONTINUOUS**

Dana closes her eyes as Holden softly
kisses her. It's tender and sweet. She pulls
back.

DANA
I don't wanna... I mean I've never...
(momentarily confused)
I don't mean 'never', but...

HOLDEN
Hey. Nothing you don't want.

He leans in to kiss her again just as Marty
strides by, making them stop.

MARTY
He's got a husband bulge.

They look at each other awkwardly, the
moment broken. Marty shuts the door
behind him.

EXT. CABIN — CONTINUOUS

We walk out with Marty, leaving the house
behind. He comes out about thirty yards,
near the first trees. In medium close-up, he
looks up...

MARTY
I thought there'd be stars...
(sighs)
We are abandoned.

And he starts to take a piss. All of which is
held at this close angle, so we only hear it.

There's a noise in the woods behind. He
turns around to see a copse of trees, but no
movement. Turns back and in the BG one
of the trees turns out to be a figure — a
silhouetted girl with only one arm, holding
a hatchet.

She makes her way slowly toward him,
now lit by the side window of the house,
now lost in the dark in front of it. Marty
zips up, turns again — and *Curt attacks
him from right beside camera*, yelling and
scaring the shit out of him.

CURT
Run! Fucking run!

MARTY
What's —

CURT
GO!!!

Marty heads back, with Curt, when Anna
Patience steps out of the shadows in front of
the house. Marty rears back but Curt fuck-
ing clotheslines her, sends her flying —

CURT (CONT'D)
Dead bitch!

— and pulls Marty toward the porch.

**INT. LIVING ROOM —
CONTINUOUS**

Dana and Holden are in mid-kiss just as —

WHAM! Curt spills onto his knees in the
doorway.

DANA
Curt!

Dana and Holden race to him, gasping as
they see his bloody wounds —

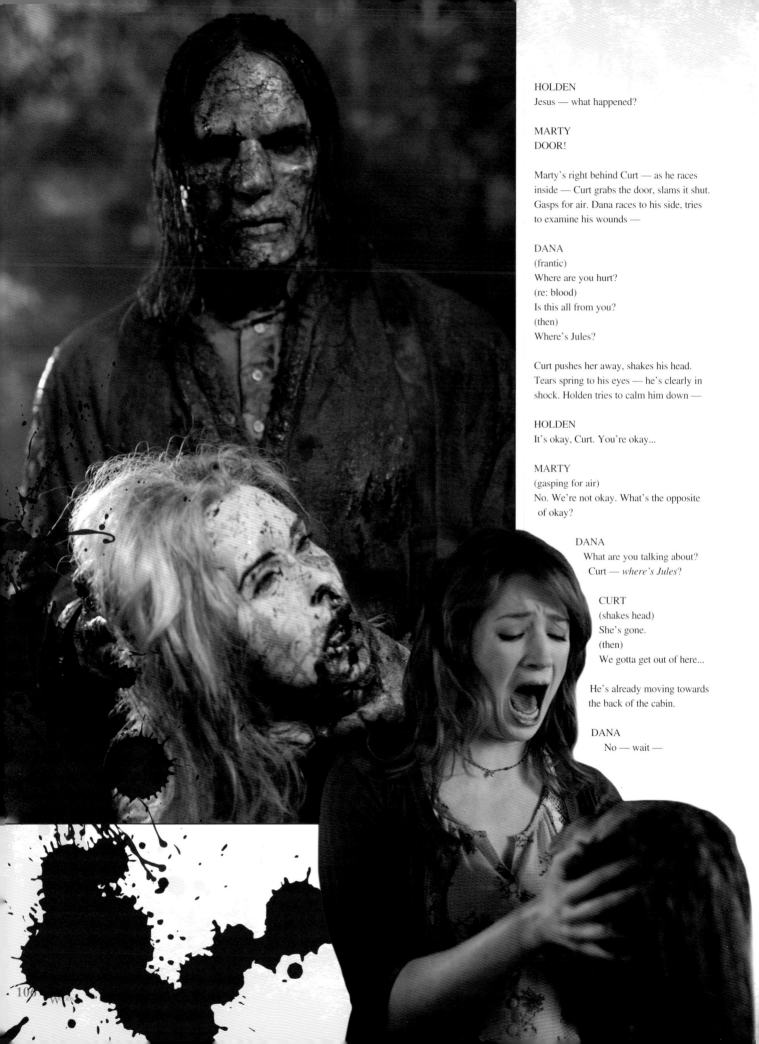

HOLDEN
Jesus — what happened?

MARTY
DOOR!

Marty's right behind Curt — as he races inside — Curt grabs the door, slams it shut. Gasps for air. Dana races to his side, tries to examine his wounds —

DANA
(frantic)
Where are you hurt?
(re: blood)
Is this all from you?
(then)
Where's Jules?

Curt pushes her away, shakes his head. Tears spring to his eyes — he's clearly in shock. Holden tries to calm him down —

HOLDEN
It's okay, Curt. You're okay...

MARTY
(gasping for air)
No. We're not okay. What's the opposite of okay?

DANA
What are you talking about?
Curt — *where's Jules?*

CURT
(shakes head)
She's gone.
(then)
We gotta get out of here...

He's already moving towards the back of the cabin.

DANA
No — wait —

Dana reaches for the front door. Starts to open it...

MARTY
Dana — *don't open that* —

DANA
I'm not leaving here without Jules.

...and she swings the door open, revealing —

MATTHEW.

He's standing on the porch, framed in the doorway. Just staring at us. Holding *something round* down by his side. He tosses it right at Dana — she gasps, catches it, looks down to see —

It's Jules' HEAD.

Dana screams her heart out. She drops Jules' head on the ground, glances up as Matthew steps up the porch. She screams and screams as Matthew approaches — Holden dives forward, slams the door shut just as —

WHAM! Matthew slams into it. The frame shakes, the wood splinters. Marty races forward, helps Holden brace the door. As they slam the deadbolt into place —

Curt flips the couch over, tries to shove it against the door. Looks up at Dana, who's still in shock —

CURT
Dana — c'mon —

Dana snaps out of it, helps Curt shove the couch under the doorknob. WHAM! The whole cabin seems to shake as Matthew slams into it —

DANA
(terrified)
What is that thing?

CURT
I don't know but there's more of them —

DANA
(glances at Marty)
More of them?

MARTY
(nods)

I saw a young girl — all zombied, like him. And "Little House on the Prairie", too, but she's missing an arm —

Dana's face falls as she realizes —

DANA
Oh god. Patience.
(glances at Holden)
The *diary* —

HOLDEN
"The pain outlives the flesh."
(thinks about it)
She must have... bound a mystical incantation into the text so someone would come along, read the diary aloud and...

DANA
(quietly)
And I did it.

CURT
(to Holden)
Look, brainiac — I don't give a limp dick WHY those things are here. We gotta lock this place down —

MARTY
(nods)
He's right.

CURT
We'll go room by room, barricade every

window and door —

Curt starts heading towards the back of the cabin. As he waves them forward —

CURT (CONT'D)
And we gotta play it safe — no matter what, *we have to stay together* —

INT. CONTROL ROOM

Hadley's slumped in his chair, shaking his head as he stares at the surveillance images of Curt and the others moving through the cabin. Sitterson's right beside him, working the console —

SITTERSON
(to Hadley)
— calm down, I got it. Watch the master work...

Clickety-clack — he hits some keys, throws a switch —

INT. CABIN

Curt's hair ripples slightly as he's hit by a gust of air from a nearby HEATING VENT. He stops in his tracks, looking slightly confused —

DANA
What's the matter?

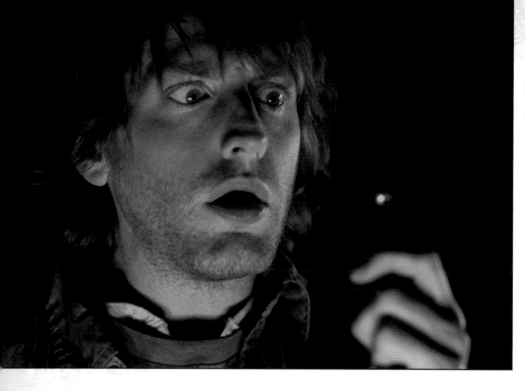

He glances around, looking slightly befuddled. Shakes his head —

CURT
(almost to himself)
This isn't right...

He looks at the others almost like he doesn't trust them.

CURT (CONT'D)
This isn't right. *We should split up.* We can cover more ground that way.

And now Dana and Holden look a little hazily paranoid as well. They think about it, nod —

HOLDEN
Yeah…
(beat)
Yeah — good idea.

MARTY
Really?

CRASH! Just then, the living room window EXPLODES INWARD. Our group cries out in surprise, looks back to see MATTHEW'S ARM now reaching through the window —

Curt turns, races back towards the living room —

CURT
I got it! You guys — *get in your rooms* —

As Curt starts shoving a bookcase up against the window, Dana and Holden share a glance. Nod.

DANA
Let's go —

They race towards the back. Marty hesitates a moment, frowning — something about this isn't quite right. But then he shakes it off, hurries after them.

INT. CONTROL ROOM

ON THE MONITORS — we see Dana, Holden, and Marty running down the hall. As Hadley and Sitterson watch —

HADLEY
Lock 'em in.

Sitterson throws a switch —

INT. CABIN — HALLWAY

— and as Dana, Holden, and Marty all split off into their separate rooms —

All the doors SLAM SHUT behind them, and: WH-CHUNK! We hear vault-worthy locks slamming home.

INT. CABIN — MARTY'S ROOM

Marty stops in his tracks. Glances back at the closed door behind him. Again, he frowns — Huh. That's weird... But before he has time to consider it fully —

WHAM! The cabin shakes again. We hear glass breaking in another room. Marty snaps out of it — *stick to the plan.* He races to the window, which is wide open —

As he dives for it, pulling it shut, he loses his balance, knocks over the end table next to his bed —

CRASH! A lamp SHATTERS on the ground. Marty glances down at the fragments. Sees something...

ON THE FLOOR — a thin black wire snakes through the shards of glass. Marty picks it up, sees there's actually a small, fiber optic CAMERA at the end of it —

INT. CONTROL ROOM

ON THE MONITOR — Marty's face fills up the entire screen as he stares directly into the camera —

SITTERSON
Uh-oh — that's not good.

HADLEY
(into mic)
Chem — I need 500 cc's of Thorazine pumped into Room Three *now* —

SITTERSON
No no no — hang on —

He points to another monitor. ON THE SCREEN — we see one of the zombies walking out of the forest, heading straight towards backside of the cabin —

SITTERSON (CONT'D)
Judah Buckner to the rescue...

INT. CABIN — MARTY'S ROOM

Marty pulls the camera wire taut, follows it up the length of the wall. Stares up at the ceiling. We see the realization hit him —

MARTY
Oh my god, I'm on a reality show.
(then)
My parents are gonna think I'm such a burnout —

CRASH! Just then, the window behind Marty EXPLODES INWARD — Judah reaches through, grabs Marty by the neck,

yanks him backward, THROUGH THE
WINDOW —

Marty screams as Judah tries to pull him
out of the cabin. Marty struggles might-
ily — he holds fast to the window frame,
desperate to get back inside —

Judah growls, yanks Marty again. As
Marty starts to lose his grip on the window,
he flails about, his free hand searching the
nearby dresser top for *anything* he can use
as a weapon —

And just as Judah yanks him one last time,
Marty's fingers close around the COFFEE
THERMOS —

EXT. CABIN — CONTINUOUS

Judah hauls Marty straight out of the cabin
window — WHAM — Marty slams into
the ground — he gasps in pain, looks up
just in time to see —

Judah plunging HIS BLADE down straight
at Marty's head. Marty rolls to the side —
THUNK — as Judah buries the blade into
the ground next to him —

Marty struggles to his feet, but Judah's
right on top of him. As Marty tries to fight
him off, he glances down at the COFFEE
THERMOS in his hand. He gives it a
shake —

CL-CLACK — and it telescopes outward
into the GIANT BONG. Marty takes the

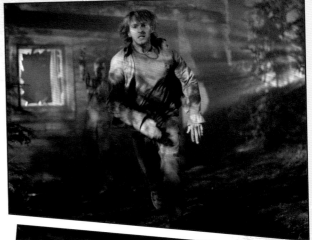

makeshift baton, swings it with all his
might —

WHAM! He hits Judah flush in the side of
the head, dropping him to the ground with
a sickening thud.

Marty stares down at Judah's crumpled
body... but Judah's only momentarily
dazed... he's already starting to get to his
feet. Marty doesn't hesitate any longer... he
bolts towards the forest —

But as Marty races away at top speed,
Judah takes the blade in hand —

And hurls it right at Marty's back.

Wh-CHUNK! Bullseye — he hits Marty
right between the shoulder blades. Marty
cries out in pain as he pitches forward,
crashes to the ground.

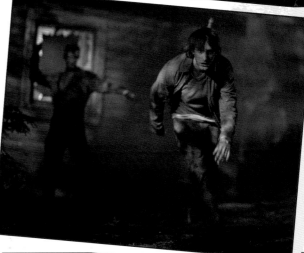

Judah slowly walks towards the fallen
Marty...

ON THE GROUND — Marty gasps in
pain, tears in his eyes as he desperately
struggles to get the blade out of his back.
He reaches behind him — his fingers
touch the hilt, but they can't find pur-
chase...

Judah grabs Marty by the leg. Starts drag-
ging him into the forest —

MARTY
No — *NOOOO* —

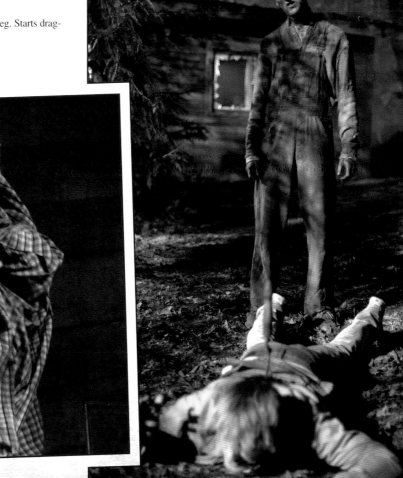

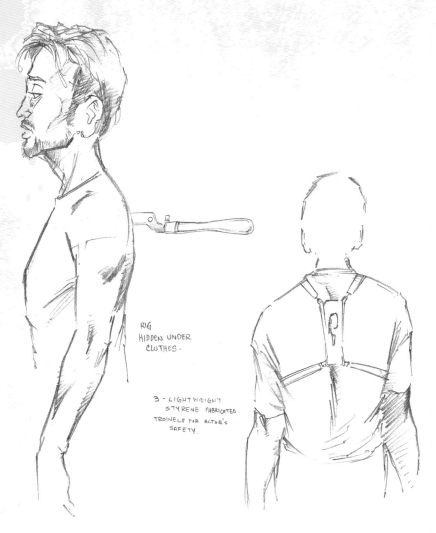

RIG HIDDEN UNDER CLOTHES.

3 - LIGHTWEIGHT STYRENE FABRICATED TROWELS FOR ACTOR'S SAFETY.

And then he's gone.

INT. CONTROL ROOM

CLOSE ON A LEVER as a hand pulls it down — CH-CHUNK —

INT. CHAMBER

— and once again, BLOOD trickles down, down, down through the carved stone etchings.

And as it flows outward we slowly PULL BACK to reveal the picture forming is of a PRIMITIVE HUMAN FIGURE. It is holding a goblet and dancing.

We hear a RUMBLING...

INT. DANA'S BEDROOM — CONTINUOUS

Dana is laboriously moving a tall dresser in front of the window, as MOTHER pounds on the frame outside. Suddenly the rumbling fills the room, which starts to shake with what feels like a decent sized *earthquake*. Dana looks around, almost exasperated in her terror —

DANA
What? No! No, come *on*!

INT. CONTROL ROOM — CONTINUOUS

Hadley, Sitterson and Truman all pause to look around as they too, are shaking. Hadley is returning from the lever he just pulled down, turns to Sitterson with shrug...

HADLEY
They're getting excited downstairs.

SITTERSON
Greatest Show on Earth...

Above: Designing the rig that would allow Fran Kranz to be 'stabbed' by Judah's broken shear (below).

EXT. FOREST — CONTINUOUS

— and we're WITH MARTY as Judah drags him through the treeline. They're heading towards a DARK HOLE in the ground (from which Judah first emerged). Marty tries to struggle — blood seeps from the wound in his back, leaving a bloody trail through the dirt.

Marty's fading fast... He coughs blood, tears stream down his face —

MARTY
No — HELP ME —

And as Judah drags him down into the hole, we STAY UPTOP — Marty struggles with everything he's got — his TERRIFIED EYES stare back at us as he screams and screams — his fingers claw trails in the dirt around him as he tries to hang on —

MARTY (CONT'D)
HELP MEEEE —

But it's no use. And with a final yank, Marty disappears from view entirely. His horrified screams echo through the forest...

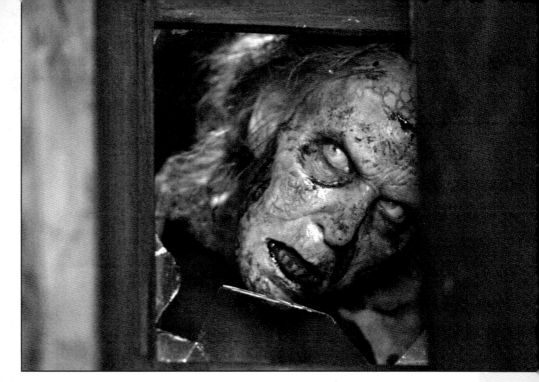

INT. DANA'S BEDROOM — CONTINUOUS

The rumbling subsides and she turns her attention back to the dresser. As she gets it in place she hears the window shatter and the chest begins to rock. She shoves the bed against it and goes for the door.

It won't open. She pulls, kicks, but it's locked solid. She's staring at it, confused — it looks so flimsy — when the chest goes over Mother starts climbing in. She hits her with a lamp but it has no effect.

She backs up against the wall — and *the picture on it goes flying*, glass shattering, making her jump.

Holden knocks out the rest of the one-way mirror. There's banging in his room but no zombies in yet.

HOLDEN
My door's stuck!

DANA
Mine too!

He looks at her sitch — worse than his own — and beckons her to come through.

HOLDEN
Come on!

She stands on the bed and wriggles through, with his help, but not without some cuts, and they both fall to the floor.

They're still rising when the furniture Holden has piled up is knocked away — By Matthew.

DANA
The bed!

They up-end it and shove it at the window, holding its metal frame against the pounding from without. Dana looks around for something else, sees:

ANGLE: UNDER THE BEDSPACE is a trapdoor.

DANA (CONT'D)
Holden.

He looks, puts his shoulder to the bed to take the weight as he indicates for her to

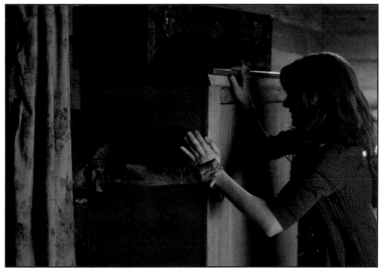

check it out. She moves to it and pulls it open — nothing but blackness below. She looks back at Holden

DANA (CONT'D)
Better or worse?

He sticks his foot out and slides a lamp to her. It's been set on the floor (during the furniture pile-up) but still plugged in. She lowers it into the dark space, lets it hang by its plug.

DANA (CONT'D)
It's empty...

Holden gives the bed one last kick in place and moves to the door, calling out:
HOLDEN

Curt! Curt!

The knob starts moving.

CURT
(from without)
Unlock your door!

HOLDEN
I can't! Get down to the basement! We got a way down!

CURT
(from without)
Okay!

Holden moves to the edge of the space, takes a quick look in and goes in head first, holding the edge and flipping himself over

to land on his feet. Dana slips down into his upstretched arms right after, disappearing into the hole.

INT. BLACK ROOM — CONTINUOUS

It's strangely quiet, as though it swallowed the noise from above. The only light is from the dangling lamp, and it throws the whole small room into a creepy half-light. And creepy seems to be the general theme.

It's a torture chamber, with a chair, chains, shackles, and a table with some truly appalling instruments rusting on it. Sweeney Todd would get squeamish in here.

They look around a bit, unwittingly fascinated.

DANA
This is the Black Room.

HOLDEN
Which?

DANA
From the diary. This is where he killed them.
(quietly)
This is where he kills *us*.

HOLDEN
What?

DANA
(she's cracking)
I brought us here. I found the room, the diary... you're all gonna die because of me.

He takes her firmly by her arms.

HOLDEN
Nobody did this. Okay, it's bad luck. Horrible fucking luck but I'm not gonna die and neither are you. We just gotta find the door.

DANA
There isn't one.

He looks — she's right.

HOLDEN
In the wall, something. Just look.

She pulls herself together — moves to the far wall, grabbing something that looks like a small crowbar, running one hand along the wall for a hidden door and tapping with the bar occasionally to test the sound of it.

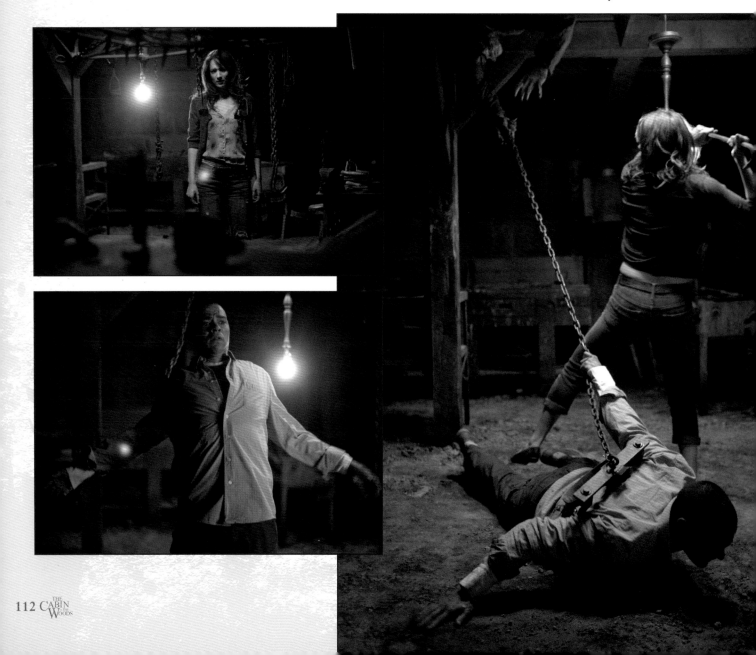

Calls out:

DANA
Curt?

Holden has moved to one wall, now crosses below the trapdoor to the other —

HOLDEN
Hidden rooms were a staple of post-civil war architecture. There's gotta be a —

— and the bear-trap swings down from the trapdoor, catching under his arm and digging into the back of his shoulder. He SCREAMS as Matthew starts hoisting him up through the trap-door.

Dana runs to him and helps him struggle, finally overbalancing Matthew, who falls forward, stuck upside down halfway through the trap-door, still grabbing at Holden on the floor.

Holden painfully pulls the trap from his shoulder — but Matthew gets a hold of him, his mouth wide in a hissing scream —

DANA
You like pain?

Dana runs the crowbar right through

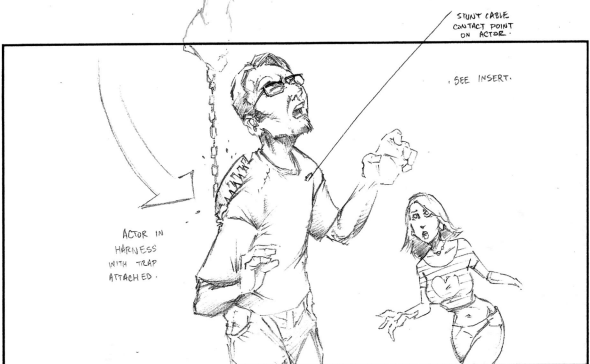

Left: Storyboards for the shot where Holden is caught by Matthew's bear-trap.

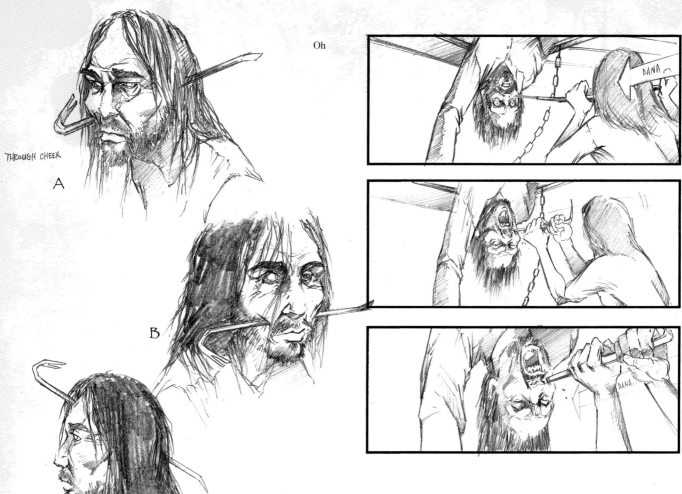

THROUGH CHEEK

A

B

C

Oh

Above: "How's that work for ya?" Options for the crowbar-in-Matthew's-face effect.

Matthew's face and into the wall behind, pinning him. Screams in his face:

DANA (CONT'D)
How's that work for ya?

Matthew grabs the bar and pulls at it — Holden getting free — and Dana finds a kitchen knife, stabs Matthew with it several times, shaking with rage. Matthew finally hangs limp. Dana stares at him, breathing hard.

INT. CONTROL ROOM — CONTINUOUS

Hadley hovers over Sitterson's shoulder, watching the action on the screen.

HADLEY

yeah. Nothing to worry about. He looks dead...

SITTERSON
And what do we do when the dead guy stops moving...?

Sitterson pushes a button —

INT. BLACK ROOM — CONTINUOUS

CLOSE ON: THE KNIFE HANDLE as a small electrical charge jolts Dana's hand.

As we drop back wider, it looks like she's dropping the knife 'cause she doesn't like holding it. She turns her back on Matthew, dragging Holden up. They move to the other side of the room — and the wall behind them opens, Curt reaching in to grab them.

DANA
AH!

CURT
Let's move let's move!

They exit into:

INT. CELLAR — CONTINUOUS

And make for the storm doors, pushing them open, Curt grabbing a handy plank to hit zombies with.

EXT. CABIN/INT. VAN — CONTINUOUS

They move as quickly as they can, both Holden and Curt being injured, not encountering any dead folk as they race to the Rambler.

DANA
What about Marty?

CURT
They got him.

They come around the Rambler, camera behind, and Curt moves to open the door.

There is dirt on the latch.

He looks at Holden, steps back with his plank as Holden readies to open the door and get out of the way. A beat, and Curt nods.

The door opens —

HARD CUT TO:
CLOSE ON: A HIDEOUS SCREAMING FACE of a Japanese floating drowned girl. It suddenly stops, a warm glow building around its now-bewildered face.

Cut wide to see:

INT. SCHOOLROOM IN JAPAN — NIGHT

The floaty girl hovers over the room, in which several Japanese schoolchildren are placing lotus flowers into a large bowl of water on the floor, all the while singing a happy song of love.

The floaty girl is consumed by light and disappears. A frog hops out the bowl.

JAPANESE SCHOOLGIRL
(subtitled)
Now Kiko's spirit will live in the happy frog!

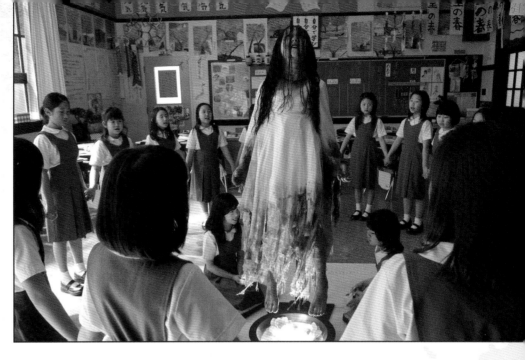

They all laugh and hug.
HARD CUT TO:

INT. CONTROL ROOM — NIGHT

Sitterson is watching this on a screen, very unhappy. Hadley is working behind him.

SITTERSON
Fuuhhhcck yooouuu...!

A com-line lights up and he switches it, eyes still on the screen and the frog and the happy song of love. WENDY LIN appears on a separate monitor.

SITTERSON (CONT'D)
(to the com, still watching)
You seeing this?

LIN
(from monitor)
Perfect record, huh?

SITTERSON
Naruto-watching, geisha-fucking, weird gameshow-having DICKS! They fucked us!

LIN
(on monitor)
Zero fatality. Total wash. Any word from

Below: Designs used as set dressing for the Japanese schoolroom scene.

downstairs?

SITTERSON
Downstairs doesn't care about Japan.
(unconvincing)
The Director trusts us...

LIN
(on monitor)
You guys better be on your game.

Hadley replies, though he's still in the BG working.

HADLEY
You just sweat the chem, Lin. While these morons are singing "What a Friend We Have in Shinto", we're bringing the *pain*.

SITTERSON
Fuck was up with that fool's *pot*, anyway? He shoulda been drooling and instead he nearly made us.

LIN
(on monitor)
We treated the shit out of it!

HADLEY
(just to Sitterson, all business)
Got 'em in the Rambler, headed for the tunnel.

LIN
(on monitor)
The Fool is toast anyway. You better not

fuck us on the report.

HADLEY
Shit.

LIN
(on monitor)
What? Shit why?

Hadley makes the hand-across-throat sign to Sitterson.

HADLEY
(calm voice)
Work to do. Gotta go.

LIN
(on monitor)
You guys are humanity's last hope, don't tell me —

And Sitterson cuts her off, looking at Hadley.

HADLEY
There's no cave-in.

SITTERSON
What?

ANGLE: SCREEN OF THE OPEN TUNNEL, light on the road beyond.

HADLEY
The fucking tunnel is open!

Sitterson rolls back to his station, hits a

com-line...

SITTERSON
This is control to demolition...
(to Hadley)
They're not even picking up!
(hits another button)
Broadcast, can you patch me in to demolition?

BROADCAST
(on com)
We're dark on their whole sector, might have been a surge in the —

But Sitterson stabs a button, cuts them off. He's on his feet heading out.

SITTERSON
See if you can bypass —

HADLEY
Fuck you think I'm doing?

SITTERSON
(to Truman)
Get the door.

TRUMAN
Mister Sitterson, you're not supposed to leave the —

SITTERSON
Open the goddamn door!

HADLEY
(working the screen)
You got family, Truman?

TRUMAN
Yeah...

HADLEY
Kids get through that tunnel alive, you won't anymore.

EXT. WOODS — NIGHT

The Rambler plows away from us at dangerous speed.

INT. HALL — MOMENTS LATER

Sitterson runs through the hall, a few workers and guards moving aside —

SITTERSON
Make a hole! Move!

EXT. WOODS — NIGHT

The Rambler careens around a curve —
and in the distance is the tunnel.

INT. CONTROL ROOM — CONTINUOUS

Hadley gets an "UNABLE TO
OVERRIDE. AUTHORIZE SYSTEMS
DIAGNOSTIC?"

He bangs the counter in frustration.

INT. DEMOLITION — CONTINUOUS

We enter with Sitterson to see the lights
blinking and sparks coming from a dark-
ened console. Three workers — more blue-
collar than Sitterson — are trying to bring
it back to life.

DEMO GUY #1
It's not the breakers!

SITTERSON
Fuck is going on in here?

DEMO GUY #2

We don't know! Electrical said there was a
glitch up top, one of the creatures?
SITTERSON
The tunnel should have been blown hours
ago!

DEMO GUY #2
We never got the order...

SITTERSON
You need me to tell you to wipe your ass?
(pushes past him)
How do we get past this?

DEMO GIRL
We're fried inside. We need a clean
connection to the detonator —

Sitterson has dropped to the ground and
pulled open the underpart of the console,
revealing wires and circuits galore. He
gets on his back, messing with ones above
him —

DEMO GUY #1
Systems Tech is trying a reboot on the —

SITTERSON

We don't have time. Talk me through.

INT. RAMBLER — CONTINUOUS

Curt is driving, Dana in the seat next to him, fear fighting despair as tears begin to line her eyes. Holden is between them, eyes on the tunnel...

HOLDEN
Don't stop for anything...

INT. DEMOLITION — CONTINUOUS

Sitterson replaces a chip in a board — some of the console lights up.

DEMO GIRL
No, that's just local; it's not linked.

SITTERSON
Shit!

INT. CONTROL ROOM — CONTINUOUS

The camera races in with Ms. Lin —

LIN
Hadley, what's going on?

He just spins and stares at her, nervous as hell. Camera continues past him to a screen showing the van speeding through the woods — the tunnel visible not far ahead.

EXT. WOODS — CONTINUOUS
The van races through frame —

INT. DEMOLITION — CONTINUOUS

Sitterson puts a wire to a contact — it sparks and he flinches — lights come back up across the board.

DEMO GUY #1
We're up!

SITTERSON
Blow it!

Demo Girl hits a big red knob.

EXT. MOUNTAIN TUNNEL/INT. RAMBLER — CONTINUOUS

And the Rambler enters the tunnel as a charge sends rocks tumbling down. The kids see them through the windshield falling up ahead before the van is pounded from above —

HOLDEN
Back up! Back up!
The whole tunnel is caving in as Curt slams on the brakes, hits reverse and tears back out, the van stopping a few yards from the din and smoke of total collapse.

The kids look at it, in shock.

INT. DEMOLITION — MOMENTS LATER

Sitterson is breathing hard, nobody saying anything. He exits, saying to #2 contemptuously:

SITTERSON
Wipe your ass.

EXT. MOUNTAIN TUNNEL — MOMENTS LATER

The kids are out, Dana looking nervously back for possible pursuing zombies, not giving in to the tears she can't stop. Curt is furious, looking over the side of the mountain at the cliff's edge on the other side, a tantalizing 20 feet away. Holden looks it over intently, working the problem.

Below: Pre-production plan for the tunnel collapse scene.

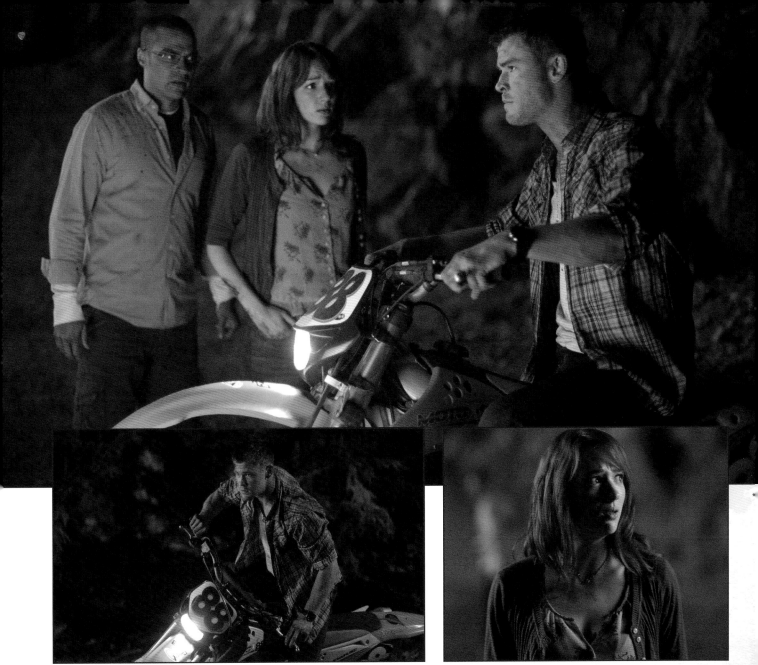

CURT
No! No fucking way! This isn't happening!
It's *right there*!

HOLDEN
You got any climbing gear, ropes?

CURT
Yeah, in my fucking dorm room!

HOLDEN
We can't climb this. This is limestone, it's slippery and it'll crumble under pressure.

DANA
(joining them)
We can't go back. There's no way across?

HOLDEN
(dismissing her)
What are we gonna do — jump?

CURT
Dude.

HOLDEN
What.

**EXT. MOUNTAIN TUNNEL —
MOMENTS LATER**

ANGLE ON: CURT'S DIRTBIKE as the wheel spins in the dirt and the bike turns, Curt revving it, getting his nerve up.

DANA

Curt, are you sure about this?

CURT
I've done bigger jumps than this.

HOLDEN
You've got a smooth run and maybe a five foot differential on the other side, which is good. But you gotta give it everything.

CURT
You know it.

DANA
Curt...

He comes down off his adrenaline kick for a moment, looks at her like the guy we

knew.

CURT
You guys stay in the Rambler. If they come, just keep driving away from 'em. I'll get help. If I wipe out I'll fuckin' *limp* for help but I'm coming back with cops and choppers and large fucking guns and those *things* are gonna pay. For Jules.

A moment. Dana kisses him on the cheek. He guns it.

HOLDEN
Don't hold back.

CURT
Never do.

He guns it and lets GO — wheels spinning as he blasts toward the edge, Dana and Holden watching in fear and hope —

Curt sails over the edge with great form, front wheel high, the arc is good —

— he *slams* into the invisible barrier and his bike *explodes* —

DANA
NOOO!

— as he plummets straight down, scraping the electrical matrix so it appears by him all the way as he falls.

DANA (CONT'D)
Oh God, oh God...

HOLDEN
(freaking)
He hit something! There's nothing! What'd he hit!

DANA
(softly, realizing)
Puppeteers...

HOLDEN
Did you see it? What'd he hit?

DANA
Marty was right. God.

HOLDEN
Get in the van.

DANA
Marty was right...

INT. THE CHAMBER — MOMENTS LATER

The blood pours, this time onto the primitive figure of a muscular man with javelin and ball.

INT. RAMBLER

Holden guns the engine, swinging the Rambler back down the dirt road, away from the tunnel. Dana is oddly calm.

DANA
You're going back.

HOLDEN
(trying to think)
I'm going *through*. We'll just drive — there's gotta be another road, another way out of here —

DANA
It won't work — something will happen, it'll collapse, or wash away —

HOLDEN
Then we'll leave the roads altogether, drive as far as we can into the forest, go on foot from there —

Dana shakes her head, really starting to get it —

DANA
You're missing the point.

Her zombie-like fatality gets to Holden.

HOLDEN
Hey — *hey*. Look at me.

She looks at him. He holds her gaze, rock-solid —

HOLDEN (CONT'D)
This isn't your fault.

She actually laughs a little, which doesn't help.

DANA
I know. It's the puppeteers.

HOLDEN
Please don't go nuts on me, Dana. You're all I got.

She stares at him, eyes softening.

DANA
I'm okay.

HOLDEN
Good. 'Cause I need you calm.
(then)
No matter what happens... We gotta stay calm.

WSSSHLICK — A SCYTHE *tears through Holden's throat from behind.*

Blood splatters the windshield — Dana SCREAMS — she glances back to see —

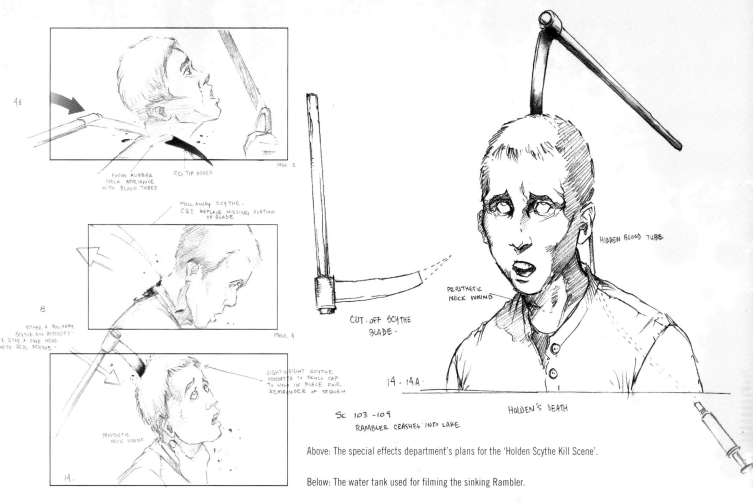

4A

FORM RUBBER
NECK APPLIANCE
WITH BLOOD TUBES

CGI TIP ADDED

PAGE 3

PULL AWAY SCYTHE.
CGI REPLACE MISSING PORTION
OF BLADE

B

EITHER A PULLAWAY
SCYTHE AND REVERSED
R STAB A FAKE HEAD
WITH REAL SCYTHE

PAGE 4

LIGHT WEIGHT SCYTHE
MOUNTED TO SKULL CAP
TO HOLD IN PLACE FOR
REMAINDER OF SEQUEN

PROSTHETIC
NECK WOUND

14

CUT-OFF SCYTHE
BLADE.

HIDDEN BLOOD TUBE

PROSTHETIC
NECK WOUND

14-14A

HOLDEN'S DEATH

SC 103-109
RAMBLER CRASHES INTO LAKE

Above: The special effects department's plans for the 'Holden Scythe Kill Scene'.

Below: The water tank used for filming the sinking Rambler.

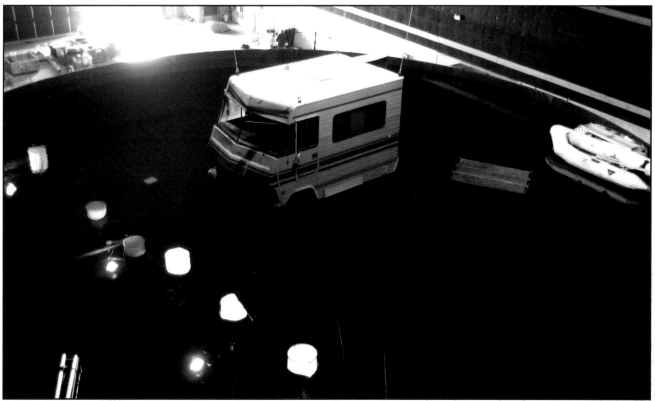

FATHER BUCKNER.
He's right behind them, having crept up from his hiding place in the Rambler.

He growls as he tries to dislodge his scythe from Holden's throat — SHLOCK — he pulls it free — arterial blood sprays everywhere, *all over Dana* —

Dana continues to scream and scream as Holden's hands instinctively clutch at his own throat — the steering wheel spins unchecked —
WH-SHLACK — Father Buckner swings the scythe again, this time lodging it in the side of Holden's head. Holden pitches forward, the Rambler careens out of control, leaps off the road and crashes —
Right into the lake.

SMASH! The front windshield SHATTERS — lake water comes rushing into the cab, blasting Dana straight back into her seat —

Beside her, Holden continues to THRASH — *he's still alive* — Father Buckner yanks the scythe free, tries to swing it again but the water blasts him back to the rear of the Rambler —

Lake water fills the cab — within a matter of seconds, they're completely submerged — we're with Dana as she screams, goes under —
And everything goes quiet.

Dana struggles underwater, panic in her eyes as she looks over and sees Holden staring back at her. He's still holding his throat — blood pours from his wounds —

Dana fights to free herself from the seatbelt — she shakes her head, CRIES OUT underwater as she holds Holden's gaze — And WE'RE CLOSE ON HOLDEN as the life drains out of him. As he stares at Dana, his hands go slack, blood gushes from his throat, clouding the water around him until he disappears entirely...

EXT. LAKE — NIGHT

WIDE ON THE LAKE as the rest of the Rambler sinks below the surface, disappearing entirely from view.

INT. RAMBLER/LAKE — NIGHT

We're WITH DANA as the Rambler continues to sink, the van now perpendicular as it plummets straight down. She tumbles upward, into the ceiling, towards the back...

Her hands reach out for anything, desperate to find purchase. Her eyes dart upward, falling on —

The CEILING HATCH.

It's small — a basic ventilation hatch, no

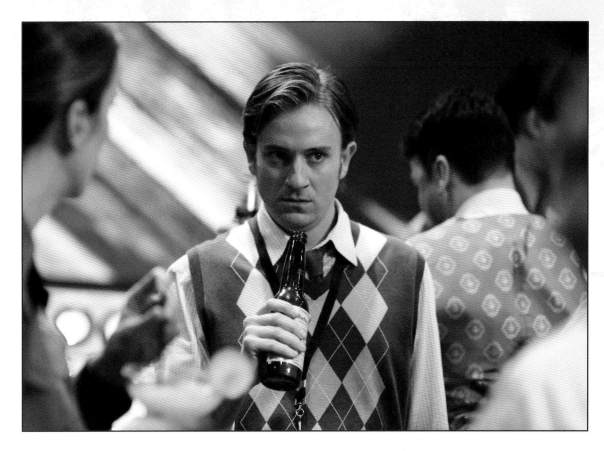

more than a foot-and-a-half square — but now's not the time to be picky.

There's a little bubble of air trapped in there, and Dana shoves her face in it, gasps it greedily. It disappears as she does and she pulls her head back, holding her breath again —

CLOSE ON: FATHER, smiling in the dark water. He doesn't need to hold his breath.

Dana reaches out, grabs the crank, spins it around. As the hatch swings open, she punches out the screen, squeezes her body through the hole. And just as she gets about halfway through —

Father Buckner grabs her ankle.

We're ON DANA as the sheer terror of it all hits her — she's stuck half-in, half-out of a sinking van with a deranged zombie yanking at her legs. She thrashes with everything she's got left — kicking him as hard as she can in the face — WHACK — knocking him back.

She breaks free, rockets upward out of the hatch, towards the surface. Beneath her, the van disappears into the inky darkness of the lake below... Dana kicks for the surface, closer, closer —

INT. CONTROL ROOM — CONTINUOUS

And a beer *breaks through the surface* of the ice-water of the little cooler the boys had stashed by the console.

Sitterson tosses it to Hadley, pulls out two more for Lin and himself.

HADLEY
God DAMN that was close.

SITTERSON
Photo fuckin' finish. But we are the champions — of the world.
(to Truman)
Tru?

He holds a beer up. Truman shakes his head.

TRUMAN
I don't understand. We're celebrating?

LIN
They're celebrating. I'm *drinking*.

He points to the BIG MONITOR, where ON THE SCREEN we see a bloodied, exhausted Dana swimming through the lake towards shore.

TRUMAN
She's still alive. How can the ritual be complete?

HADLEY
The Virgin's death is optional. As long as it's *last*.
(watches the screen)
All that really matters is that she *suffers*.

Sitterson steps up beside him. Watches Dana on the screen.

SITTERSON
(with genuine respect)
That she did.

HADLEY
(watching screen)
I'm actually rooting for her, believe it or not.
(others peek in)
The kid's got spunk, which is more than —
Hey, thank god — tequila! Get in here!

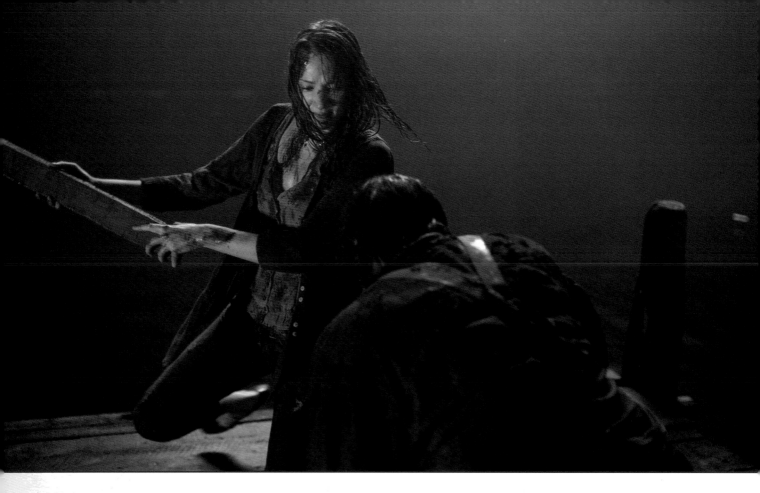

Below: The hero Matthew's bear-trap prop. Foam rubber ones were used for some shots.

As he ushers in a few workers who are, in fact, carrying a large bottle of tequila...

EXT. DOCK — NIGHT

Elegaic MUSIC starts to swell on the score. Dana grabs hold of the wooden dock — it takes every ounce of strength she's got left to pull herself up out of the lake. She rolls on her back, gasps for air.

As she lays there, staring up at the stars, the score continues to swell. She gasps and gasps... and we're CLOSE ON HER as the FULL WEIGHT of what she's been through hits her. She can't hold back the tears — *she's the only one left. All her friends are dead.*

As the haunting score echoes on the soundtrack, we HOLD ON DANA. Alone.

Overwhelmed. As her tears continue to spill over...

WHAM! MATTHEW'S BEAR TRAP splinters the dock just millimeters from her head.

Dana screams, scrambling back, sees MATTHEW looming over her, the crowbar still sticking through his head. As he bears down on her —

INT. CONTROL ROOM — CONTINUOUS

ON THE MONITORS — we see Dana fighting for her life with Matthew. But with the notable exception of Truman, nobody really seems to be watching anymore. People from other departments have trickled in, some with drinks, bags of chips — there's an office party vibe — even music playing. We cut around the room:

Hadley is talking to couple of excited co-workers, a STORY DEPT GUY and a female ACCOUNTANT...

ACCOUNTANT
I wish I could do what you guys do. It's masterful.

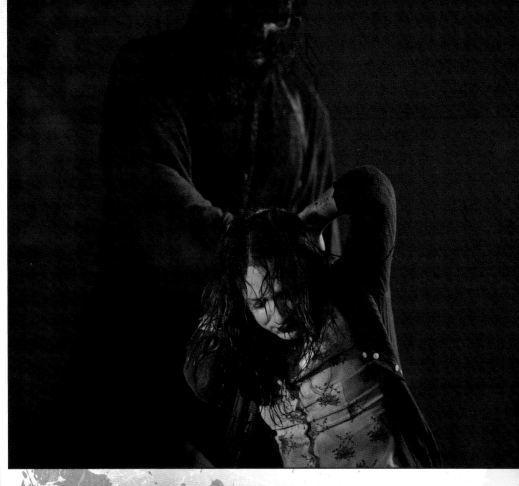

HADLEY
(not as excited)
It was good. It was solid...

STORY DEPT GUY
Are you kidding? Classic denouement.
When the van hit the lake?

ACCOUNTANT
I screamed!

STORY DEPT GUY
Right?

ACCOUNTANT
The zombie, the water rushing in...

STORY DEPT GUY
That's *primal* terror.

HADLEY
(wistful)
Woulda been cooler with a merman...

A MILITARY LIAISON, A
WEREWOLF WRANGLER, and
Ronald the Intern are casually drinking
in a group. While they talk, we can see
DANA GETTING PUMMELED BY
MATTHEW on the viewscreens behind
them.

MILITARY LIAISON
Do you know if we made the overtime
bonus on this one?

WEREWOLF WRANGLER
Accounting's right over there — ask them.

MILITARY LIAISON
(shoulders slump)
I don't need to ask them — I already know
the answer.

WEREWOLF WRANGLER
"We're accountants and we're full of
hate?"

MILITARY LIAISON
Exactly.

RONALD
I'm an intern.
(beat; off their looks)
So. I don't qualify for OT.

The Chem Dept Guy from before is try-
ing to talk to PRETTY LABWORKER.
His eyes are somewhat bloodshot. It's

unclear whether she's listening to him or
not.
CHEM DEPT GUY
Don't worry about my eyes — that's why
we have eye washes, right? And they say
baking soda is good for your complexion.
(beat)
 Anyway... it's funny that you like the
 ballet, because I happened to get two
 tickets to...

 She walks away.

 CHEM DEPT GUY (CONT'D)
 ...your favorite...

 He trails off. And hopes nobody
 saw that.

 Sitterson heads towards the
 Demolition guys.

 SITTERSON
 You! Yoouuuu! Knuckleheads
 almost gave me a heart-attack
 with that tunnel!

DEMO GUY #2
(in no mood)
That wasn't our fault.

SITTERSON
I'm just giving you a hard time.
(to Demo #2)
C'mere you — let's have a hug —

But Demo Guy #2 blows right past him,
the others chiming in:

DEMO GUY#1
No. *Seriously*. That wasn't on us.

DEMO GIRL
There was an unauthorized power re-route
from upstairs.

Sitterson stops mid-drink, frowns. Wait —

SITTERSON
What do you mean, "upstairs"?

BRRRRING.

Just then, a piercing RING fills the air.
Sitterson's face falls — his eyes dart
towards the back of the room where —

A single RED TELEPHONE sits on the
wall. *BRRRING.* As one, the crowd goes

QUIET. Sitterson looks to Hadley — they
lock eyes, color draining from their faces
— Oh. Shit. Hadley swallows, moves
towards the phone —

HADLEY
(dead serious)
Turn that fucking music off.

Someone stops the music. The workers
glance at each other, tense. *BRRRING.*
Hadley grabs hold of the phone, takes a
deep breath, then answers it —

HADLEY (CONT'D)
(into phone)
Hello.
(listens, then)
That's impossible — everything was within
guidelines and the Virgin is the only —
(winces)
No no — of course I'm not doubting you,
it's just —

Hadley's face falls as his eyes dart up to
the VIEWSCREENS.

HADLEY (CONT'D)

(into phone, quietly)
Which one?
EXT. DOCKS — NIGHT

WHAM! Dana's body hits the dock hard.
Matthew's bear trap shatters the wood
beside her — the dock's now in splinters.

Dana looks terrible — she's sopping wet,
battered and bloody. Clearly, Matthew's
been kicking the hell out of her. Dana can't
even stand — tears in her eyes, she tries
to crawl away — she sees a broken dock
plank beside her — maybe it can be used
as weapon — she reaches out for it —

And Matthew steps down on her arm. Dana
CRIES OUT... As she tries to struggle,
Matthew bears down... We're with Dana
as she realizes there's nothing she can do...
she's as good as dead...

CHING... CHING... CHING... Matthew
starts to swing the chain... He grabs the
handle with both hands, swinging the chain
behind his back and overhead... and just as
he's bringing it down for the deathblow —

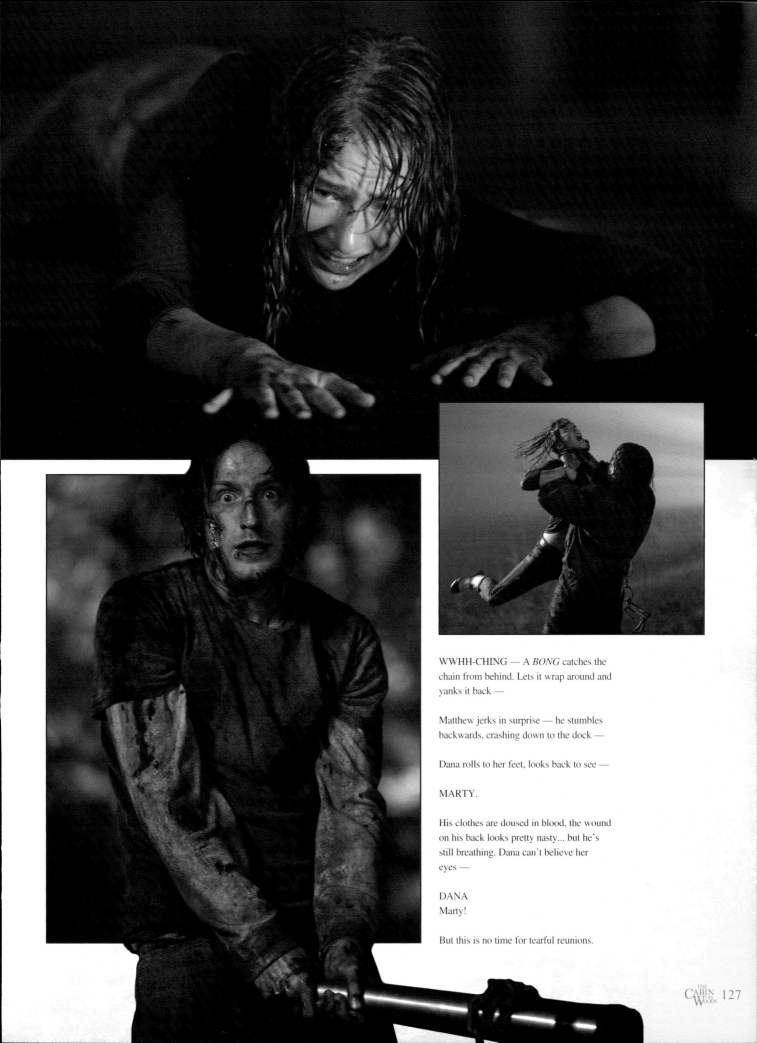

WWHH-CHING — A *BONG* catches the chain from behind. Lets it wrap around and yanks it back —

Matthew jerks in surprise — he stumbles backwards, crashing down to the dock —

Dana rolls to her feet, looks back to see —

MARTY.

His clothes are doused in blood, the wound on his back looks pretty nasty... but he's still breathing. Dana can't believe her eyes —

DANA
Marty!

But this is no time for tearful reunions.

Matthew's already struggling to his feet beside them —

MARTY
Dana — get away!

But she doesn't run. As Matthew yanks his chain from Marty's grasp, Dana grabs hold of the dock plank beside her. She swings it with all her might right at Matthew —

CRACK! It hits him square in the face — he pitches backwards right off the dock — SPLASH — into the lake.

Dana joins Marty and they are at a dead run.

SPLOOSH! Matthew re-emerges from the lake. Starts moving through the water. Right towards them.

MARTY (CONT'D)
C'mon —

EXT. CABIN — NIGHT

Dana and Marty race towards the cabin. Behind them, we can see Matthew emerge from the lake, following them —

DANA
Where are we going?

WHAM! UP AHEAD, the front door of the cabin flies open. Framed in the doorway is MOTHER BUCKNER.

Dana and Marty both jump, scared. As Mother Buckner steps out onto the porch, Marty pulls Dana to the side —

MARTY
This way —

They bolt around the side of the house, heading towards the back. Mother Buckner follows...

EXT. CABIN/FOREST — NIGHT

— Marty and Dana race around the corner of the cabin. Marty heads straight for the tree-line. UP AHEAD — we see the edge of the 'grave' Judah dragged Marty into earlier.

DANA
Marty — *wait* —

Scccrrr... Dana looks over, sees Mother Buckner round the corner of the cabin. Dragging her saw by her side...

MARTY
Dana, *c'mon* —

DANA
(to Marty)
We're going in *there*?

Shlop... Shlop... the sound of Matthew's wet footsteps ring out as he comes around the other side of the cabin.

MARTY
I need you to keep the faith right now, sister —

Fwish — in the forest UP AHEAD, Anna Patience Buckner breaks through the tree-line.

ON DANA — as she sees Mother, Matthew, and Anna Patience all closing in on her. She's trapped. She knows it. So it takes her all of one second to make the decision —

Marty kneels by the hole in the ground and opens it further like a storm door. On top, sod and leaves. Underneath, smooth, clean metal.

Looking apprehensive, Dana slides in and Marty SLAMS the door shut on top of them.

We stay outside, looking down, holding on the door in the earth for a beat. And then —

Anna Patience Buckner slides down the embankment. She awkwardly tries to paw at the metal door with her one hand. And as she scratches at the metal, she lets out a chilling cry of zombie frustration —

PATIENCE
Mwwrrrooraarrr —

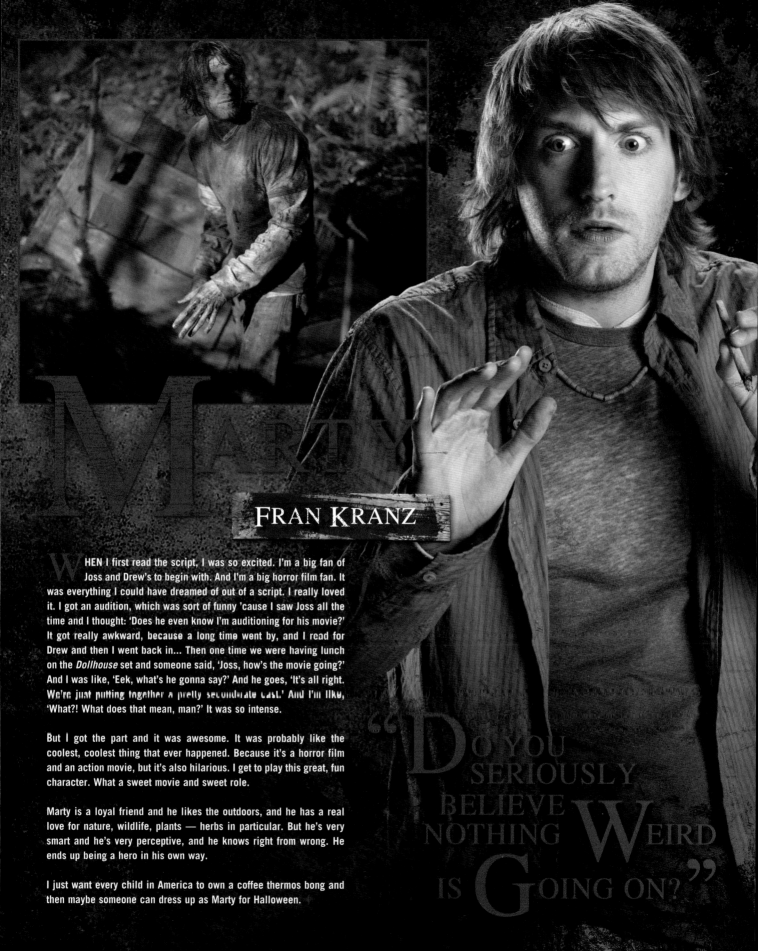

MARTY

FRAN KRANZ

WHEN I first read the script, I was so excited. I'm a big fan of Joss and Drew's to begin with. And I'm a big horror film fan. It was everything I could have dreamed of out of a script. I really loved it. I got an audition, which was sort of funny 'cause I saw Joss all the time and I thought: 'Does he even know I'm auditioning for his movie?' It got really awkward, because a long time went by, and I read for Drew and then I went back in... Then one time we were having lunch on the *Dollhouse* set and someone said, 'Joss, how's the movie going?' And I was like, 'Eek, what's he gonna say?' And he goes, 'It's all right. We're just putting together a pretty secondrate cast.' And I'm like, 'What?! What does that mean, man?' It was so intense.

But I got the part and it was awesome. It was probably like the coolest, coolest thing that ever happened. Because it's a horror film and an action movie, but it's also hilarious. I get to play this great, fun character. What a sweet movie and sweet role.

Marty is a loyal friend and he likes the outdoors, and he has a real love for nature, wildlife, plants — herbs in particular. But he's very smart and he's very perceptive, and he knows right from wrong. He ends up being a hero in his own way.

I just want every child in America to own a coffee thermos bong and then maybe someone can dress up as Marty for Halloween.

"DO YOU SERIOUSLY BELIEVE NOTHING WEIRD IS GOING ON?"

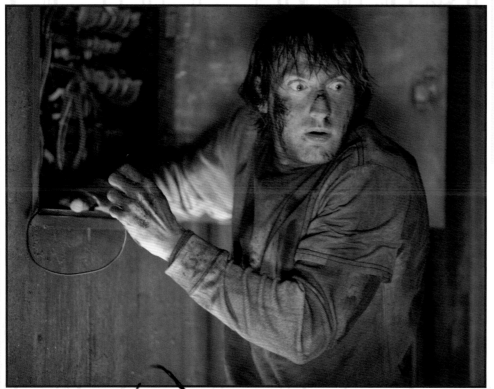

INT. UNDERGROUND SPACE — CONTINUOUS

The sound of Dana's breath echoes off the metal walls of this small, dark chamber. It's only tall enough to crouch in, but a good twelve feet by twelve feet, with a square metal door in the middle of the floor. The light in the room comes from a panel in the metal that's been popped out, a few glowing cables behind, including a couple that have been messed with. As Dana looks more closely...

DANA
What is this place?

She steps on something soft, jerks back as she realizes it's Judah's mewling face. He's been completely dismembered and piled up in the corner, but his bits still twitch.

MARTY
Yeah, I hadda dismember that guy with a trowel. What've you been up to?

Right: Production designs for the dismembered Judah, and the on-screen result (opposite).

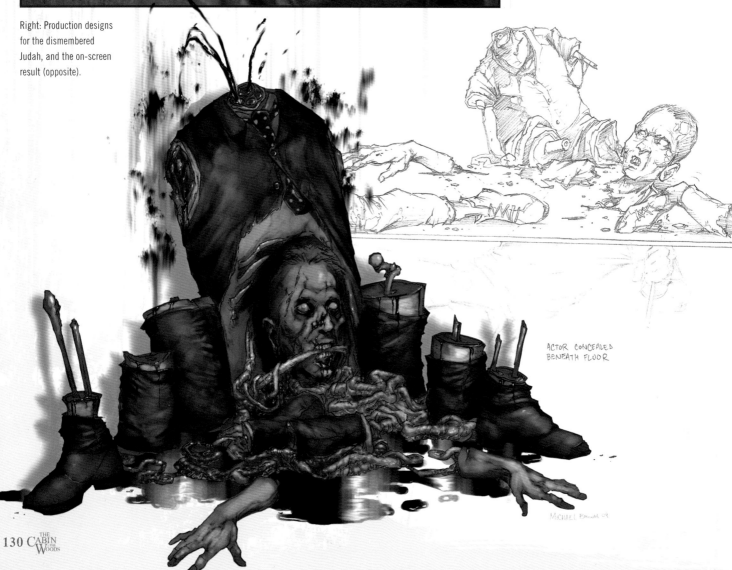

ACTOR CONCEALED BENEATH FLOOR

MICHAEL BROOM 09

She looks at him, bewildered and despairing.

MARTY (CONT'D)
Nobody else, huh?

She shakes her head.

MARTY (CONT'D)
I figured.

DANA
You figured everything.

MARTY
Not even close, but I do know some stuff. As in:

He goes to the door in the floor and slides it open. She looks down: it's a small metal elevator. Two sides are thick glass, but they are up against the metal shaft so tight you might not even tell.

MARTY (CONT'D)
It's an elevator. Somebody sent these dead fucks up to get us. There's no controls inside but there's maintenance overrides in there. I been playing around. I think I can make it go down.

DANA
Do we *wanna* go down?

MARTY
Where else we gonna go?

A beat, and she scrambles down into it as he moves to the open panel.

MARTY (CONT'D)
Get ready — the timing on this might be pretty tight.

INT. ELEVATOR — CONTINUOUS

She moves against the wall, looking up. Marty flicks a switch and slides right into the hole as the elevator whirs to life and the door starts sliding shut. He barely makes it — and one of Judah's arms falls in with him, the two of them doing the get-away-from-it dance even as they brace themselves against the sudden plummet.

MARTY
(kicking it to the side)
Ah! Fuckin' zombie arm!

The elevator starts down — not too fast — and it is shaken by another *tremor.*

EXT. WOODS — CONTINUOUS

The tremor rocks Anna Patience as well. At its height, we hear metal scraping and *the hatch grinds open* a sliver. Anna Patience looks at it, her head cocked curiously.

INT. ELEVATOR — CONTINUOUS

It seems to go down a good long while — then joltingly stops. They look at each other — nothing opens — then it starts moving again...

MARTY
Are we moving *sideways*?

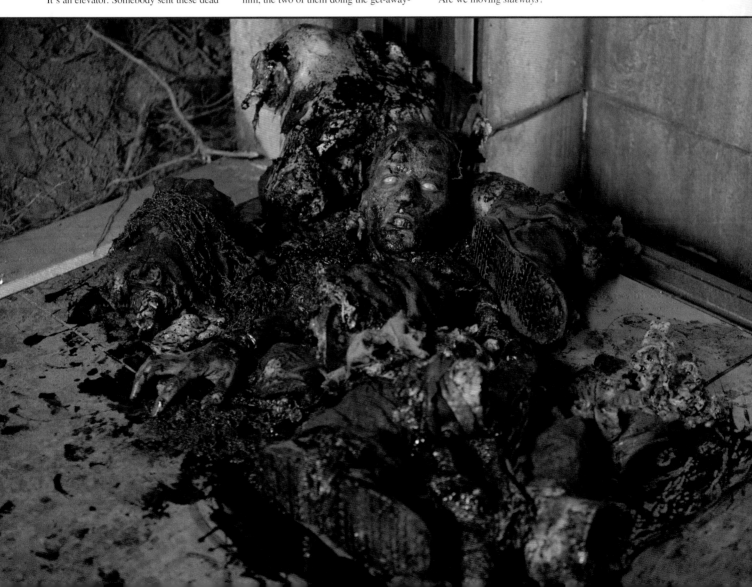

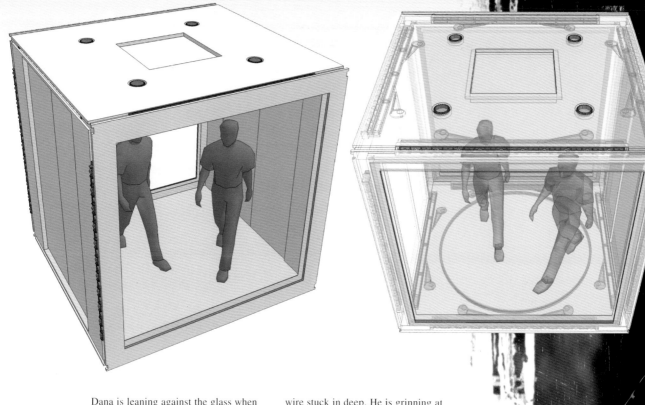

Dana is leaning against the glass when the elevator suddenly comes abreast of *another elevator*, also with a thick glass wall, and stops —

— a ravenous WEREWOLF leaps at her as she turns — she jumps back as it hits the glass, clawing at it and drooling. Marty stares in incomprehension.

MARTY (CONT'D)
So, *no...*

Both of them press up against the opposite wall — and the elevator moves sideways again, revealing an ALIEN hanging from the ceiling behind them. It jumps onto the glass and sticks there, freaking them out again, making them move to the middle of the small space, looking around for the next horror.

The elevator is jerked down — then sideways, revealing this time one on each side. Marty sees:

A little girl in a ragged ballerina outfit (not a tutu, but a limp, torn skirt). She has no face, just a circle-mouth with a ring of teeth.

Dana sees:

A staring man in a long, leather, futuristic coat. He's dead white, has no hair and buzzsaws stuck in his head in a neat row. His arms are ringed with barbed

wire stuck in deep. He is grinning at Dana and holding a glowing sphere almost exactly the same as the one in the cellar.

DANA
(realizing)
We chose...

MARTY
(looking over at hers)
What?

The elevator moves back down into darkness.

DANA
In the cellar. All that shit we were playing with... They made us choose.
(beat)
They made us choose how we die.

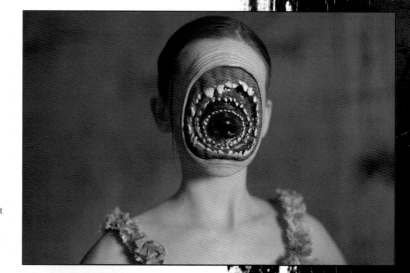

Above: Designs for the glass elevators.

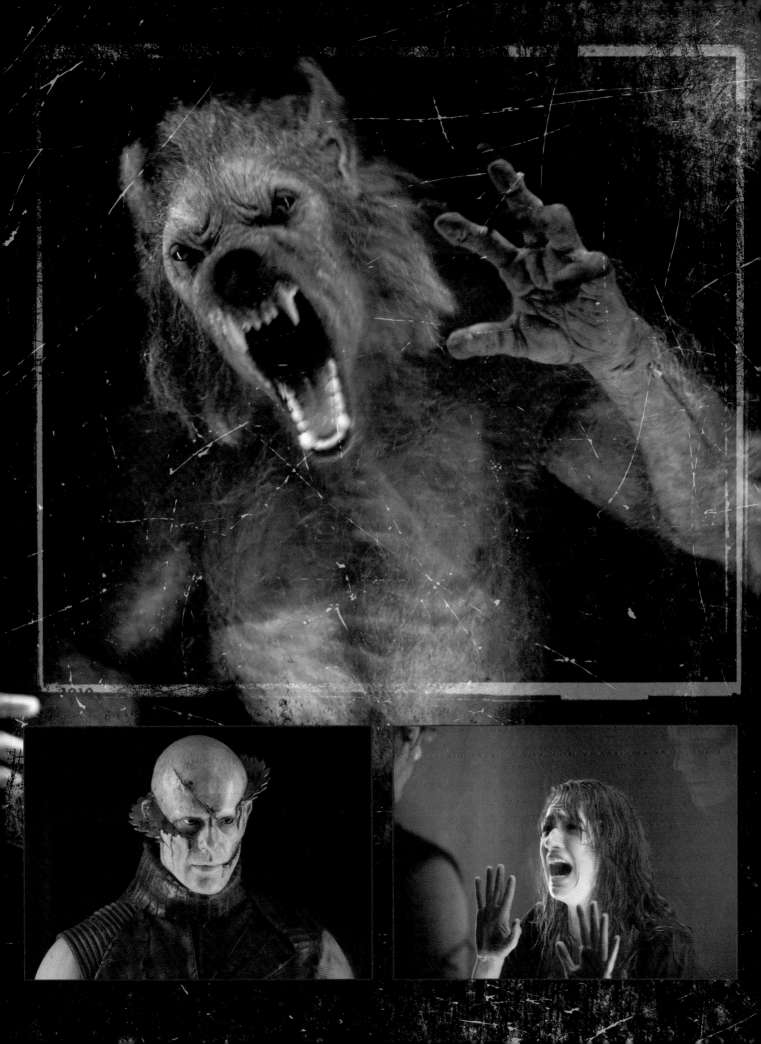

THE ELEVATORS

MARTIN Whist on the elevators and the lobby: "I wanted them to basically be without any controls, which is obviously not the traditional way of approaching an elevator, and I wanted it to almost feel like a glamorized freight elevator. There was a certain amount of aging in there that I wanted, just the residue of who or what had been in there the time before. We ended up making three or four different sizes of elevator: we made a little miniature one so we could put a bug in it and shoot it as though it's an enormous bug. The same technique with the giant. It wasn't a giant — we had about a sixty-percent-sized elevator that this person got into, and obviously it looked like he was crammed into the space.

"The lobby I wanted to look slightly utilitarian, contemporary, and institutional. I wanted it to look sharp and almost characterless. Kubrick is the best reference or inspiration for what I wanted that moment to feel like. It was very austere and dispassionate, in contrast to where we just came from, which was dense, dark woods." ✛

Above: Pre-production visualization of the elevator lobby.

The incomprehension builds in her and she punches the glass. It doesn't make a crack but she keeps going, pounding away with both fists like a prize-fighter going for body blows — Marty tries to hold her and she screams, thrashing as we drop back wide to see:

An endless array of elevators. Moving around like a 3-D puzzle. Monsters (many of them like the ones we've seen) in every single one. It's the Costco of death.

INT. CONTROL ROOM — CONTINUOUS

Everyone has cleared out except Wendy and our hero three. She's in the lower part, on console, earpiece in. The men are going through every part of the building on their screens, moving fast and frightened.

Sitterson watches nine constantly changing views of monsters in elevators, looking for the kids.

SITTERSON
(into com)

We saw them go down the access drop, they have to be in one of these! Internal security should be able to — I don't care if that's not protocol! Are you fucking high?

Hadley, over this, is looking at halls and stairwells, (many of them being swept by security teams), also talking on an earpiece:

HADLEY
It's the fool! No! You can't touch the girl — If he outlives her all this goes to hell! *Take him out first.*

LIN
(to the guys)
Clean-up says the prep team missed one of the kid's stashes. Whatever he's been smoking has been immunizing him to all our shit.

HADLEY
How does that help us right now?
(into com)
What? Yes. If you have a confirmed kill you can take her out too.

TRUMAN
There!

He's looking at the elevator screens. Sitterson freezes them from changing, then puts their screen on all nine.

SITTERSON
Thirty six oh six. Gotcha.

HADLEY
Bring 'em down.

And we PUSH THROUGH the monitor, to FIND:

INT. ELEVATOR / LOBBY — CONTINUOUS

Marty is holding Dana, who's breathing hard but calm, as the elevator goes down. The elevator stops and the door opens into a sort of lobby. Instantly a GUARD is stepping one foot in, gun at their heads. Dana is a little in front of Marty, standing exhausted, haunted, her knuckles — and much else of her — bloody.

GUARD
Out of the elevator!
(beat)
Step out of the elevator!

DANA
Why are you trying to kill us?

GUARD
Step out! Just the girl!

DANA
Just me?

GUARD
Do it!

He moves forward — fully into the elevator now — as *Judah's arm grabs his foot.* He wigs, shooting at it.

Dana takes the moment to rush him, driving her shoulder into his chest. CRACK! His head slams into the wall, knocking him unconscious.

Marty grabs the Guard's sidearm, picks up Judah's blade from the floor.

MARTY
(à la "Lassie":)
Good work, zombie arm!

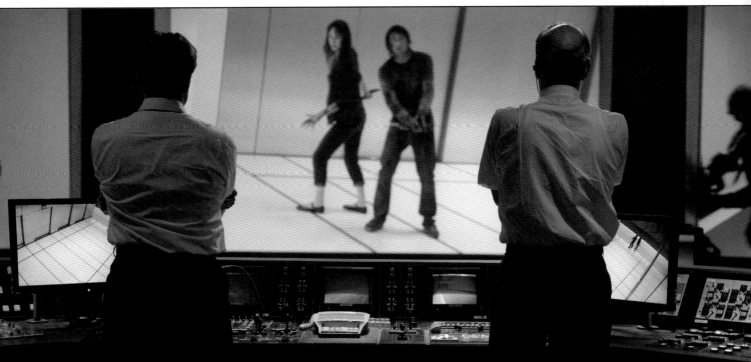

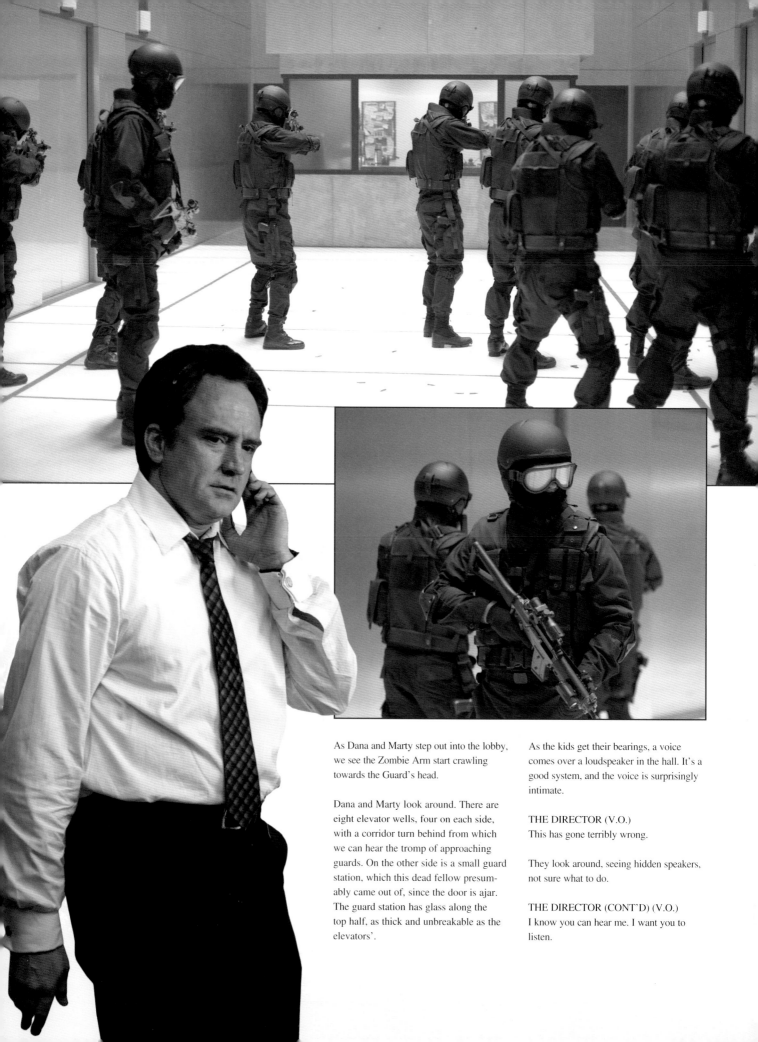

As Dana and Marty step out into the lobby, we see the Zombie Arm start crawling towards the Guard's head.

Dana and Marty look around. There are eight elevator wells, four on each side, with a corridor turn behind from which we can hear the tromp of approaching guards. On the other side is a small guard station, which this dead fellow presumably came out of, since the door is ajar. The guard station has glass along the top half, as thick and unbreakable as the elevators'.

As the kids get their bearings, a voice comes over a loudspeaker in the hall. It's a good system, and the voice is surprisingly intimate.

THE DIRECTOR (V.O.)
This has gone terribly wrong.

They look around, seeing hidden speakers, not sure what to do.

THE DIRECTOR (CONT'D) (V.O.)
I know you can hear me. I want you to listen.

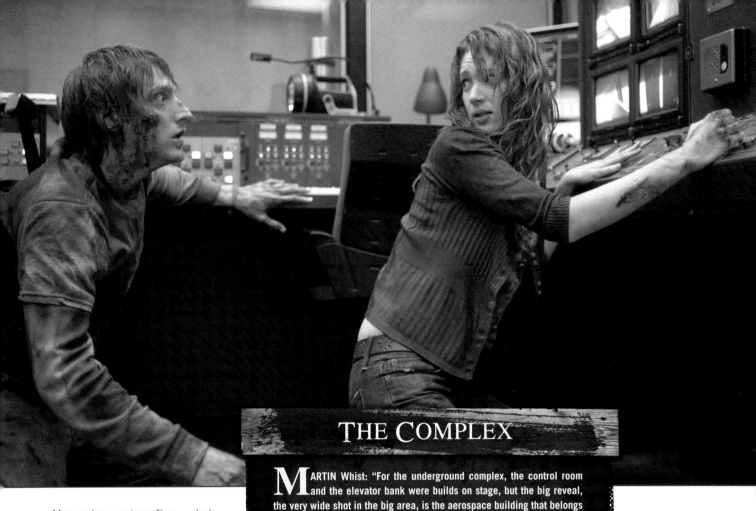

THE COMPLEX

MARTIN Whist: "For the underground complex, the control room and the elevator bank were builds on stage, but the big reveal, the very wide shot in the big area, is the aerospace building that belongs to the British Columbia Institute of Technology. It's very high-tech industrial, and it's a brand-new building, never been shot in before. We had looked at dozens of places up to that point, and luckily, it came up on the radar and we went there and it was just fantastic." ✦

Marty makes a motion to Dana — don't speak.

THE DIRECTOR (CONT'D) (V.O.)
You won't get out of this complex alive. What I want you to understand is that you *mustn't try*. Because your deaths will avert countless others.

**INT. CONTROL ROOM —
CONTINUOUS**

Hadley and Sitterson listen as well. On their screens, we see Marty and Dana in a corridor — and a SWAT-lookin' team creeping down another.

THE DIRECTOR (V.O.)
You've seen horrible things: an army of nightmare creatures. And they are real.

**INT. GUARD STATION/LOBBY —
CONTINUOUS**

THE DIRECTOR (V.O.)
But they are nothing compared to... to the alternative.

The kids see the shadows of the approaching guards — look around for escape.

THE DIRECTOR (CONT'D) (V.O.)
You've been chosen to be sacrificed for the greater good. Look, it's an *honor*. So forgive us... and let us get on with it.

Marty pulls at Dana, handing her the blade as they head to the empty guard station.

**INT. GUARD STATION/LOBBY —
CONTINUOUS**

They are closing the door behind them when it is peppered with gunfire. They slam it shut and lock it, keeping low even though the glass isn't even cracking yet.

Marty looks up: the lobby is full of approaching guards — SWAT-looking guys who keep a steady pound of bullets coming.

Dana looks at the console, realization dawning on her:

ANGLE: THE CONSOLE controls all the elevators. ON THE MONITORS, we can see images of monsters in their cells. Beneath each, there's a bevy of switches. And at the far end of the console, there's a button that says "PURGE".

DANA
An army of nightmares, huh?

She looks at the guards, at Marty. Back at the console. As she begins flipping switches —

DANA (CONT'D)
Let's get this party started.

She hits "purge".

In the hall, the sound of the elevators is audible. The lead guard holds his fist up.

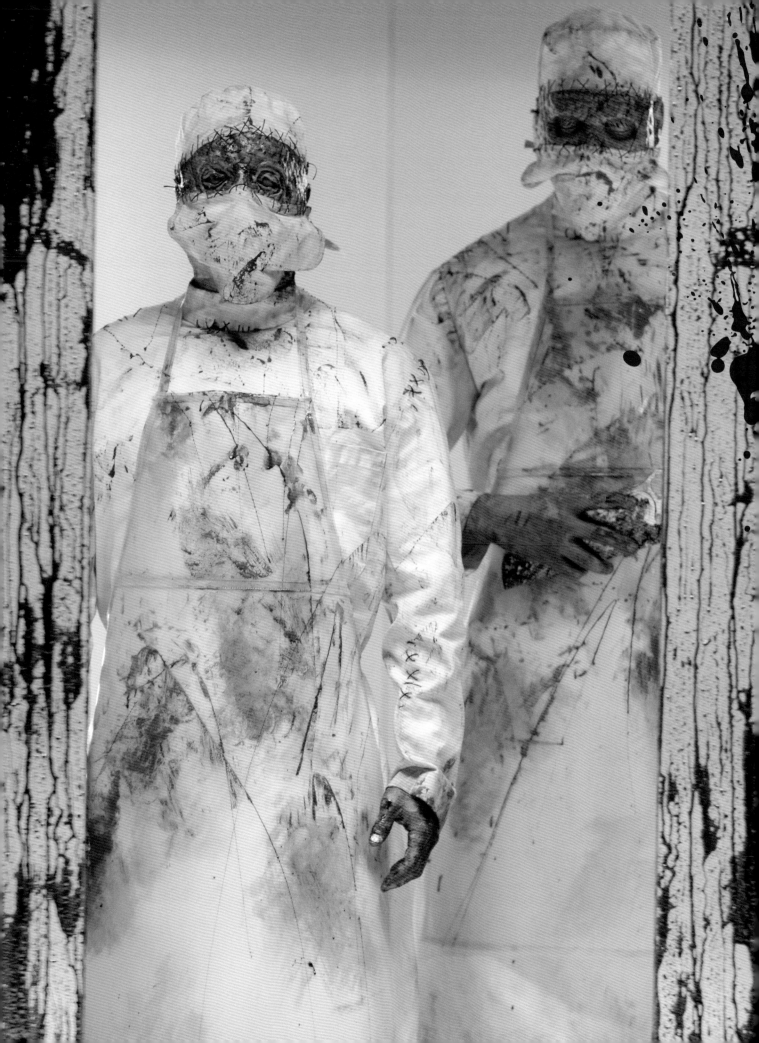

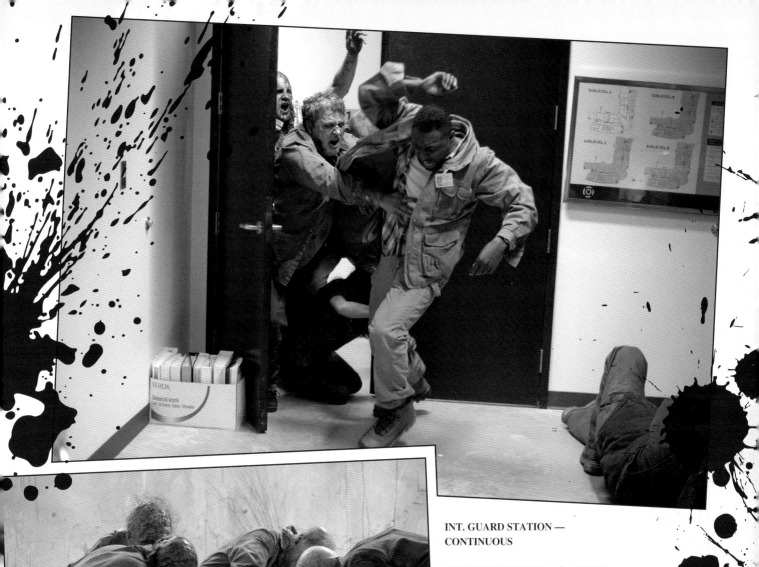

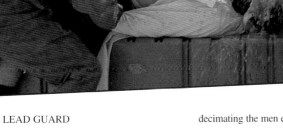

LEAD GUARD
Hold fire! Hold fire!

They finally do, and there's a moment of quiet.
ANGLE: DOWN THE HALL.

We can see every elevator door open, but not what's inside. Another moment as the men between turn to look.

Werewolves, Aliens, Mutants and Robots pour out of the elevators at crazy speed, decimating the men even as they begin to fire. It's a warzone in a second.

ANGLE: RUNNING DOWN THE ADJOINING HALL with the next group of guards, they turn the corner to see the horrible aftermath of the slaughter we just witnessed. The lobby is coated in blood. Several zombies are feasting on what remains of a guard. And as they turn their attention to the second wave of guards... DING! The elevators LIGHT UP AGAIN and we CUT:

**INT. GUARD STATION —
CONTINUOUS**

INSIDE THE STATION to find DANA AND MARTY sitting with their backs against the walls, listening to all manner of screams and weird sounds and things bumping or smearing against the window above.

INT. VARIOUS:

As the carnage continues:

INT. HALLWAYS — CONTINUOUS

We hear a chorus of SCREAMS erupt as terrified LABWORKERS, TECHNICIANS, and WHITE-COLLAR WORKERS come racing around the corner towards us, followed by what looks like an ARMY OF MUTANTS, ZOMBIES, and other VARIOUS HORRIBLE CREATURES.

ANGLE: One of the scientists is tackled to the ground by a MUTANT. We're close on him as the mutant VOMITS TOXIC WASTE all over him.

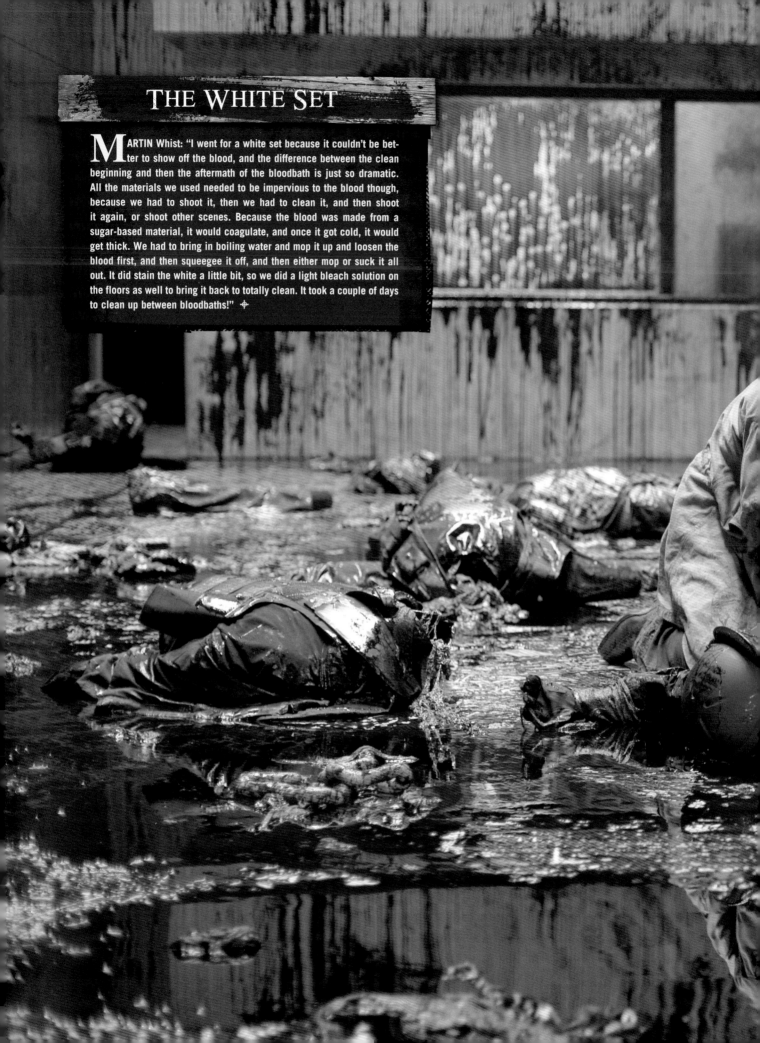

THE WHITE SET

MARTIN Whist: "I went for a white set because it couldn't be better to show off the blood, and the difference between the clean beginning and then the aftermath of the bloodbath is just so dramatic. All the materials we used needed to be impervious to the blood though, because we had to shoot it, then we had to clean it, and then shoot it again, or shoot other scenes. Because the blood was made from a sugar-based material, it would coagulate, and once it got cold, it would get thick. We had to bring in boiling water and mop it up and loosen the blood first, and then squeegee it off, and then either mop or suck it all out. It did stain the white a little bit, so we did a light bleach solution on the floors as well to bring it back to totally clean. It took a couple of days to clean up between bloodbaths!" ✦

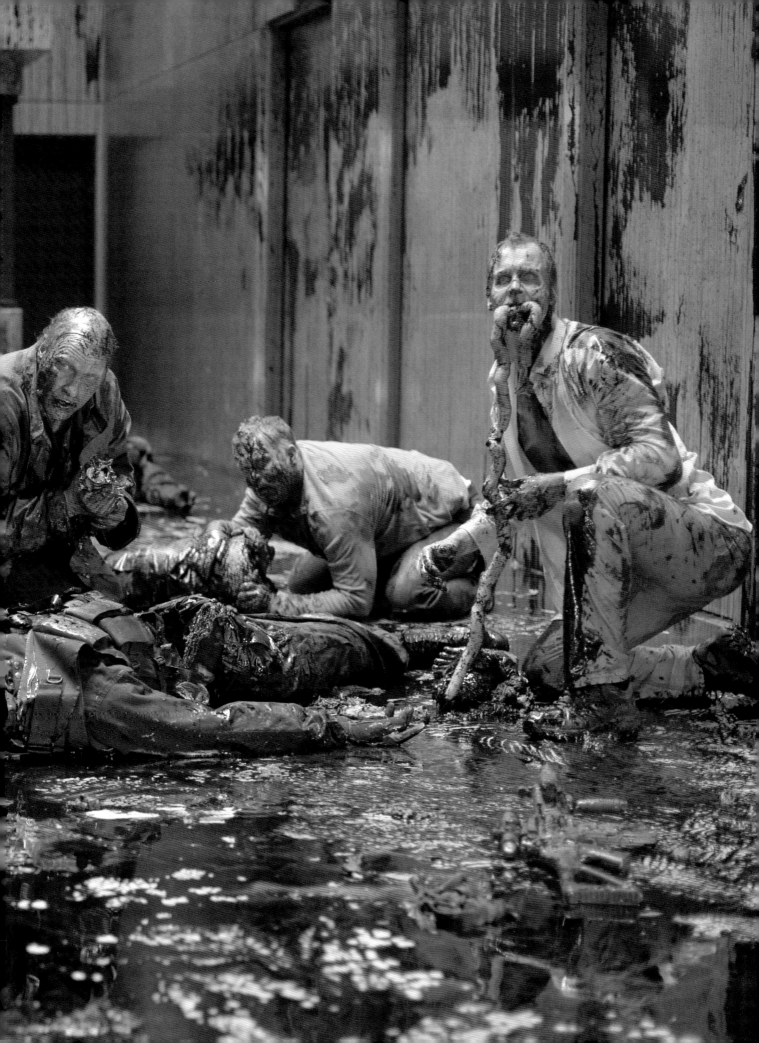

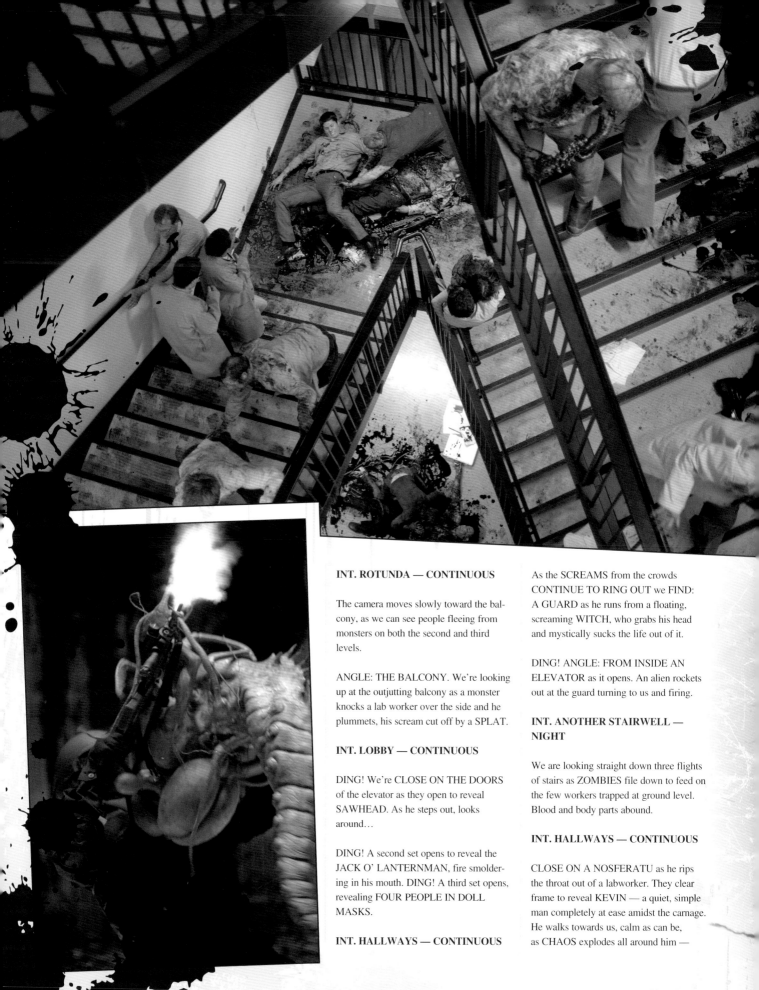

INT. ROTUNDA — CONTINUOUS

The camera moves slowly toward the balcony, as we can see people fleeing from monsters on both the second and third levels.

ANGLE: THE BALCONY. We're looking up at the outjutting balcony as a monster knocks a lab worker over the side and he plummets, his scream cut off by a SPLAT.

INT. LOBBY — CONTINUOUS

DING! We're CLOSE ON THE DOORS of the elevator as they open to reveal SAWHEAD. As he steps out, looks around…

DING! A second set opens to reveal the JACK O' LANTERNMAN, fire smoldering in his mouth. DING! A third set opens, revealing FOUR PEOPLE IN DOLL MASKS.

INT. HALLWAYS — CONTINUOUS

As the SCREAMS from the crowds CONTINUE TO RING OUT we FIND: A GUARD as he runs from a floating, screaming WITCH, who grabs his head and mystically sucks the life out of it.

DING! ANGLE: FROM INSIDE AN ELEVATOR as it opens. An alien rockets out at the guard turning to us and firing.

INT. ANOTHER STAIRWELL — NIGHT

We are looking straight down three flights of stairs as ZOMBIES file down to feed on the few workers trapped at ground level. Blood and body parts abound.

INT. HALLWAYS — CONTINUOUS

CLOSE ON A NOSFERATU as he rips the throat out of a labworker. They clear frame to reveal KEVIN — a quiet, simple man completely at ease amidst the carnage. He walks towards us, calm as can be, as CHAOS explodes all around him —

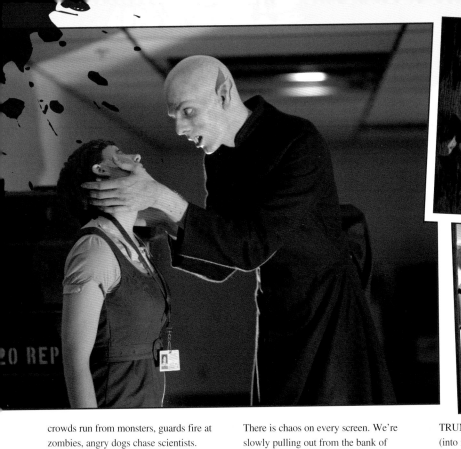

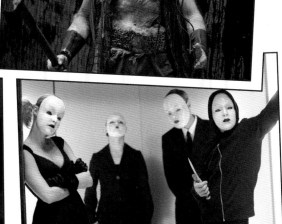

crowds run from monsters, guards fire at zombies, angry dogs chase scientists.

Kevin might as well be walking through the park. But then an injured GUARD on the ground catches his attention, so Kevin stops, kneels down next to him... and exsanguinates the guard in a most unpleasant fashion.

INT. CONTROL ROOM — A BIT LATER

There is chaos on every screen. We're slowly pulling out from the bank of monitors — everywhere we look, we see surveillance footage of MONSTERS doing horrific things to people who work at the complex.

We angle around to FIND WENDY — she's silent and near tears as she stares at the screens. We continue moving to find Truman — as he keys the console at his station, he pulls his sidearm, checks the clip.

TRUMAN
(into intercom)
Lead Officer Truman to Sec Command, requesting immediate reinforcement. Code Black. Repeat: Code Black. *Where the hell are you guys?*

We continue moving to find Hadley and Sitterson, still working feverishly at their station.

SITTERSON
Why aren't the defenses working? Where's the fucking *gas*?

HADLEY
Something chewed through the connections, in the utility shaft.

SITTERSON
Something which?

HADLEY
Something scary!

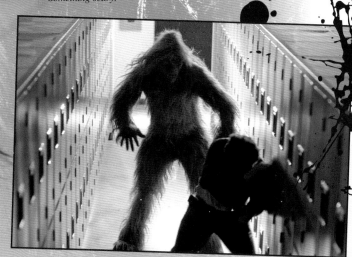

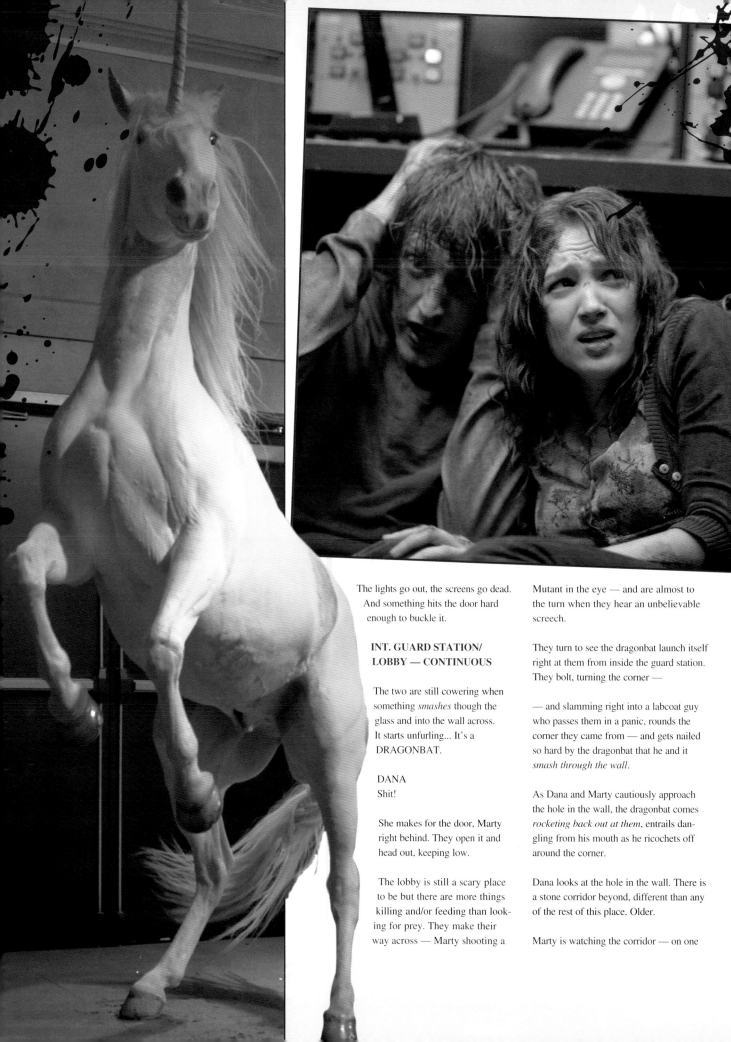

The lights go out, the screens go dead. And something hits the door hard enough to buckle it.

INT. GUARD STATION/ LOBBY — CONTINUOUS

The two are still cowering when something *smashes* though the glass and into the wall across. It starts unfurling... It's a DRAGONBAT.

DANA
Shit!

She makes for the door, Marty right behind. They open it and head out, keeping low.

The lobby is still a scary place to be but there are more things killing and/or feeding than looking for prey. They make their way across — Marty shooting a

Mutant in the eye — and are almost to the turn when they hear an unbelievable screech.

They turn to see the dragonbat launch itself right at them from inside the guard station. They bolt, turning the corner —

— and slamming right into a labcoat guy who passes them in a panic, rounds the corner they came from — and gets nailed so hard by the dragonbat that he and it *smash through the wall*.

As Dana and Marty cautiously approach the hole in the wall, the dragonbat comes *rocketing back out at them*, entrails dangling from his mouth as he ricochets off around the corner.

Dana looks at the hole in the wall. There is a stone corridor beyond, different than any of the rest of this place. Older.

Marty is watching the corridor — on one

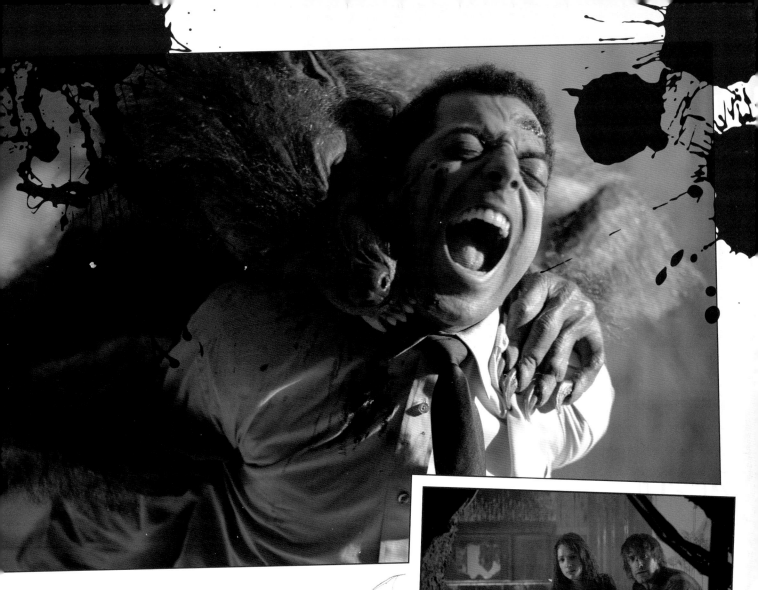

side, a couple of flesh-eating zombies are slowly coming toward them. On the other, a large fireball accompanies a set of agonizing screams. They have no choice — Dana grabs Marty's arm, pulls him into the stone corridor.

INT. VARIOUS

And more carnage:

ANGLE: A CLOWN taking bullet hit after bullet hit as it lumbers forward, knife in hand.

ANGLE: A SCIENTIST runs screaming from a UNICORN. The unicorn gores him into a wall... again and again and AGAIN, blood spurting all over its lovely unicorn mane.

ANGLE: THE WEREWOLF tackles a worker from behind, clearing frame to reveal THE GOBLINS as they mow a

scientist down with a golf cart. As they speed away, the werewolf rears back into frame with a viscera-soaked HOWL.

INT. LOBBY — CONTINUOUS

DING! The doors open yet again to reveal...

ANNA PATIENCE BUCKNER. As she steps out into the lobby, she glances around at all the violent aftermath. Huh.

INT. CONTROL ROOM ⌐ CONTINUOUS

Left: Pre-production art of a goblin attack (see also the photo on page 38).

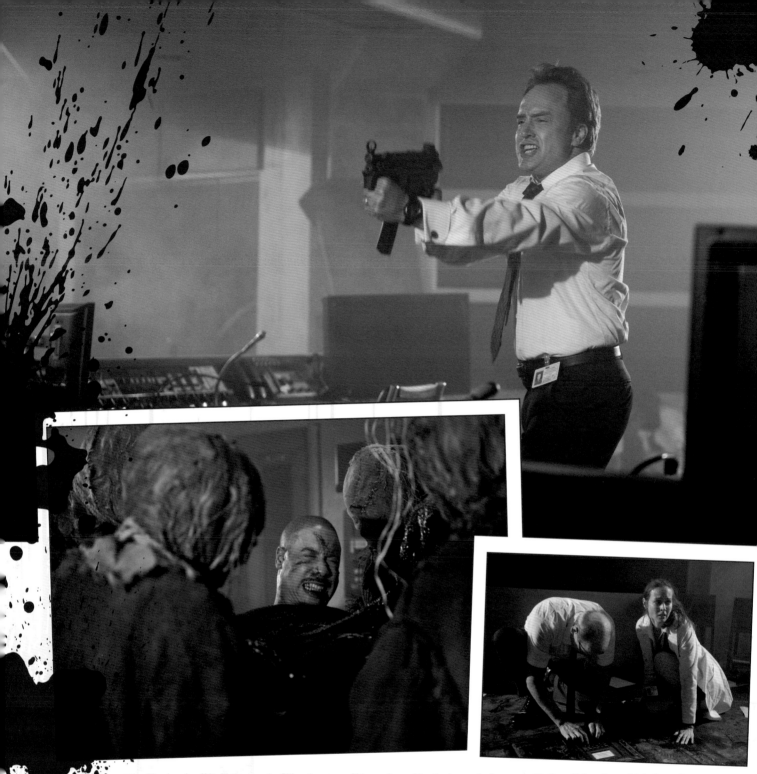

The door is off its hinges, smoke filling the dark room.

The SCARECROW FOLK have almost overpowered Truman, their knife-fingers twitching as he shoots them to no avail. He pulls out a grenade...

Hadley has a submachine gun from a sliding drawer of weapons under his console. He's looking down into the space and firing cover shots into the smoky room

as Sitterson is working the key-pad of a secure trapdoor hidden under the carpet. Wendy Lin stands over him, terrified.

HADLEY
Running out of time!

SITTERSON
It's on emergency lockdown! I'm bypassing...

Truman's grenade explosion knocks

Hadley off the edge and into the main space, lost in the smoke.

LIN
Hadley!

SITTERSON
I'm close I'm close I'm close —

ANGLE: HADLEY is on his back, dazed, when he hears something slurping toward him in the smoke. He looks to see the

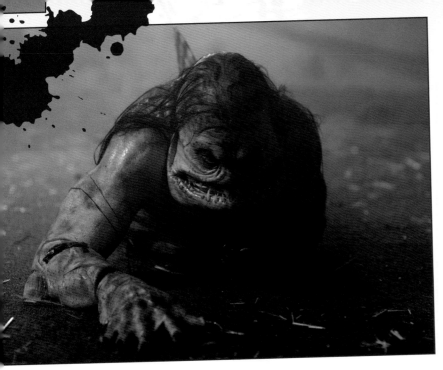

MERMAN, black fin and dorsal like a whale, black soaking hair, black eyes — everything else as white as his razor-sharp teeth. He puts a webbed hand on Hadley's throat as Hadley realizes he's about to be killed by a merman —

HADLEY
Oh, *come on*!

And it bites his face off.

ANGLE: SITTERSON AND LIN are concentrating on the trapdoor, we hear a 'ping' —

SITTERSON
Got it!

Sitterson swings the heavy stone door up as a tentacle wraps around Lin and whips her up out of frame. Sitterson dives into the hole and pulls the door shut over him.

INT. HIDDEN CORRIDOR — CONTINUOUS

Sitterson races down a ladder and around the corner — and right into Dana's blade. He looks at her, confused by the blade in his chest. She looks stricken.

He sees Marty coming up behind her, turns to her as he sinks...

SITTERSON
Please... kill him...

And dies at her feet, blade still in him.

MARTY
Come on. We have to find a way out before everything else finds a way in.

She's looking down at Sitterson.

MARTY (CONT'D)
Dana!

She looks up at him. He holds out the gun.

MARTY (CONT'D)
Here. It's easier with this.

She takes the gun and does seem to gain some measure of calm from it. Starts down the hall — and down a long stone staircase, taking point, gun held out.

INT. THE CHAMBER — CONTINUOUS

Marty and Dana enter quickly, Dana holding the gun, the camera circling them as they turn, looking at the five stone slabs, then arming up to see they're standing on a mosaic of the symbol Sitterson wore.

Except at the stairs, the edges of the stone don't reach the wall. The two of them look over the edge to see a space of maybe four feet across that goes *all the way down into darkness*. But there is the sense of something moving in that darkness. The kids draw back from it.

MARTY
No way out.

DANA
Look at these.
(turning slowly)
Five of them.

MARTY
What are they?

DANA
Us.
(to Marty)
I should've seen it like you did. All of this: the old guy at the gas station, the out of control behavior, the monsters... this is part of a ritual.

MARTY
A ritual sacrifice? Great! You tie someone to a stone, get a fancy dagger and a bunch

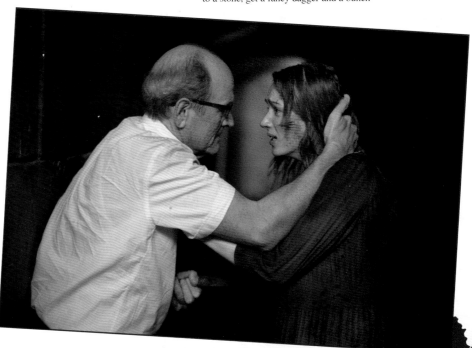

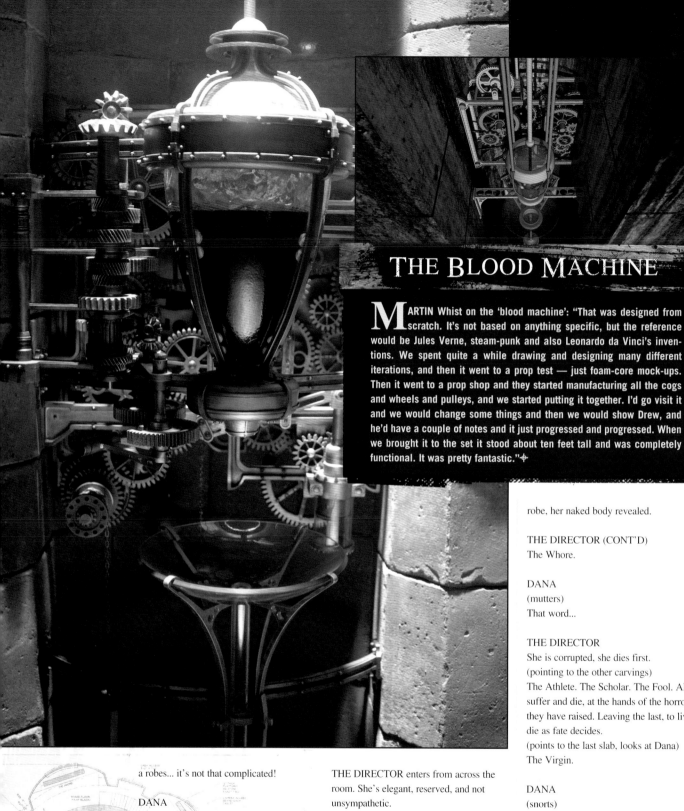

THE BLOOD MACHINE

MARTIN Whist on the 'blood machine': "That was designed from scratch. It's not based on anything specific, but the reference would be Jules Verne, steam-punk and also Leonardo da Vinci's inventions. We spent quite a while drawing and designing many different iterations, and then it went to a prop test — just foam-core mock-ups. Then it went to a prop shop and they started manufacturing all the cogs and wheels and pulleys, and we started putting it together. I'd go visit it and we would change some things and then we would show Drew, and he'd have a couple of notes and it just progressed and progressed. When we brought it to the set it stood about ten feet tall and was completely functional. It was pretty fantastic."

a robes... it's not that complicated!

DANA
No, it's simple. They don't just wanna see us killed. They want to see us *punished*.

MARTY
Punished for what?

THE DIRECTOR (O.S.)
For being young?

THE DIRECTOR enters from across the room. She's elegant, reserved, and not unsympathetic.

THE DIRECTOR (CONT'D)
It's different for every culture. And it changes over the years, but it's very specific. There must be at least five.

She points to one of the carvings: it's a woman standing erect, holding open her robe, her naked body revealed.

THE DIRECTOR (CONT'D)
The Whore.

DANA
(mutters)
That word...

THE DIRECTOR
She is corrupted, she dies first.
(pointing to the other carvings)
The Athlete. The Scholar. The Fool. All suffer and die, at the hands of the horror they have raised. Leaving the last, to live or die as fate decides.
(points to the last slab, looks at Dana)
The Virgin.

DANA
(snorts)
Me? Virgin?

MARTY
Dude, she's a homewrecker!

THE DIRECTOR
We work with what we have.

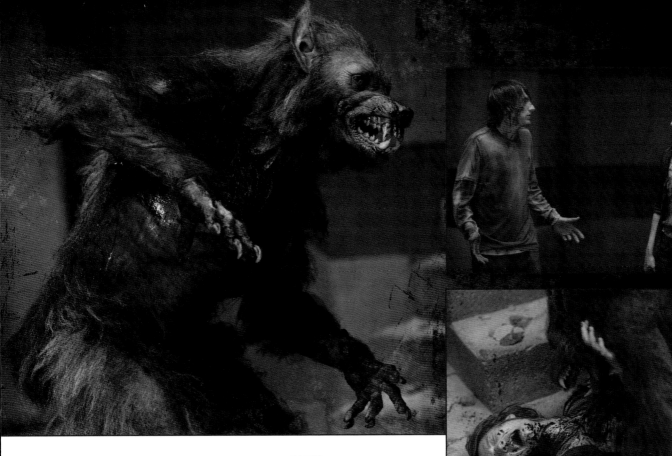

MARTY
What happens if you don't pull it off?

THE DIRECTOR
They awaken.

DANA
Who does? What's beneath us?

THE DIRECTOR
The gods. The sleeping gods; the giants that live in the earth, that used to rule it. They fought for a billion years and now they sleep. In every country, for every culture, there is a god to appease. As long as one sleeps, they all do. But the other rituals have all failed.

There is a great rumbling — they all stagger a bit, and silt sifts down from the ceiling. As it subsides...

THE DIRECTOR (CONT'D)
The sun will rise in eight minutes.
(to Marty)
If you live to see it, the world will end.

Neither of them questions the truth of it. They stare at her a moment.

MARTY
Maybe that's the way it ought to be. Maybe it's time for a change.

THE DIRECTOR
We're not talking about change. We're talking about the agonizing death of every human soul on the planet.
(to Marty)
Including you. You can die with them. Or you can die *for* them.

MARTY
Gosh, they're both so enticing...

He looks over to Dana to see that *she is pointing the gun at him.*

MARTY (CONT'D)
Wow.

DANA
Marty... The whole world...

THE DIRECTOR
Is in your hands.

Dana glances at The Director, shaken, as the weight of the world bears down on her slender shoulders.

THE DIRECTOR (CONT'D)
(to Dana)
There is no other way. You have to be strong.

MARTY
Yeah, Dana. You feeling strong?

DANA
I'm sorry.

MARTY
So am I.

A WEREWOLF leaps at her from the stairs and tears into her! The gun goes flying as she falls to the ground, trying to pull the beast off her.

The Director and Marty both move for the gun, and struggle themselves, but Marty finally gets hold of it — knocking The Director to the floor — and without hesitation puts three bullets into the werewolf, sending it screeching back up the stairs.

Dana rolls over, eyes wild, blood everywhere. The Director rises and tackles Marty. They wrestle on the floor, the gun just out of reach, the edge of the abyss by their heads.

As they fight, Dana breathes heavily by the stairs, unable to rise. She looks over as

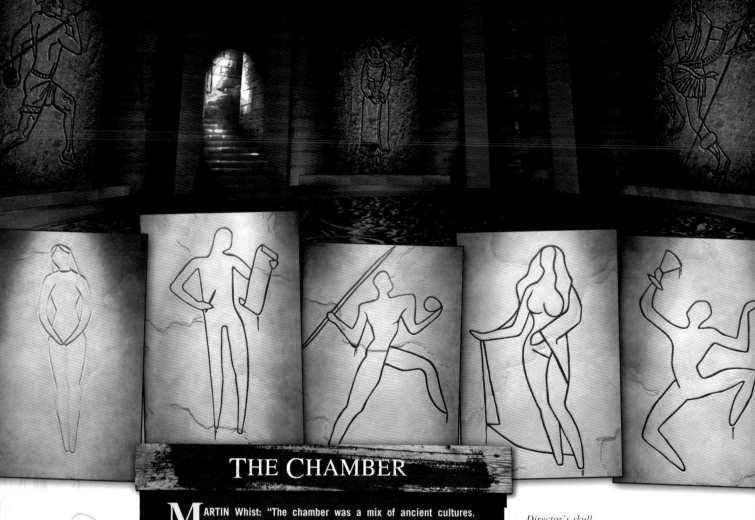

THE CHAMBER

MARTIN Whist: "The chamber was a mix of ancient cultures. For the wall carving figures, it kind of got back to the Venus of Willendorf time, where images were just starting to be carved. The figures needed to be as simple as possible but still immediately read very clearly what their identities are, so we chose not to adorn them with anything, any kind of tell-tale design on them, just to make it in a very broad term, 'ancient,' but not ancient in relationship to any particular society. They were big wooden blocks, covered with about two inches of foam that then was carved and textured, and then the images themselves were hand-carved out of the foam. Then the whole thing was given a painted scenic treatment, so that it looked like stone and was good and old-looking." ✦

two small feet shamble by her, in old, dirty shoes, the edge of a tattered gingham dress swinging above the ankles.

Marty gets on top of The Director and pushes his forearm against her windpipe. His back is to the girl.

DANA
Marty...

He turns — The Director grabs the gun — and Marty spins The Director on top of him just as Anna Patience *swings her hatchet, burying it in the back of the*

Director's skull.

Another tremor and Marty kicks The Director over the edge of the circle. Anna Patience, unwilling to let go her hatchet, goes over with her.

Marty watches them a moment, then limps over to the stairs.
Another, bigger tremor makes him pause, but it subsides and he slumps in the corner next to Dana. She's breathing shallow, tears streaming from her eyes, but she's pretty alert.

MARTY
Hey.

DANA
You know... I don't think... Curt even has a cousin.

MARTY
Huh. How are you?

DANA
Going away...

MARTY
I'm sorry.

DANA
I'm so sorry I almost shot you... I probably wouldn't have...

MARTY
Hey, shh, no... I totally get it.

As he continues, he lights up a joint.

MARTY (CONT'D)
I'm sorry I let you get attacked by a werewolf and then ended the world.

He takes a drag and holds it out to her. With a shakey hand, she takes it and drags on it herself.

DANA
Nahh, you were right. Humanity...
(blows out smoke in a cynical 'Pfft')
It's time to give someone else a chance.

MARTY
Giant evil gods.

DANA
Wish I coulda seen 'em.

MARTY
I know! *That* would be a fun weekend.

Biggest rumble yet. The floor starts bulging, cracking, as dust and debris cloud the screen.

Dana holds out her hand. Marty puts his in it. Squeezes it. They hold a moment.

An explosion of debris from below obliterates the chamber.

EXT. CABIN — DAWN

We are wide on the cabin as a gnarled hand, bigger than the house and on an arm a hundred feet long, shoots up from the crust of the earth.

BLACK OUT.

THE END

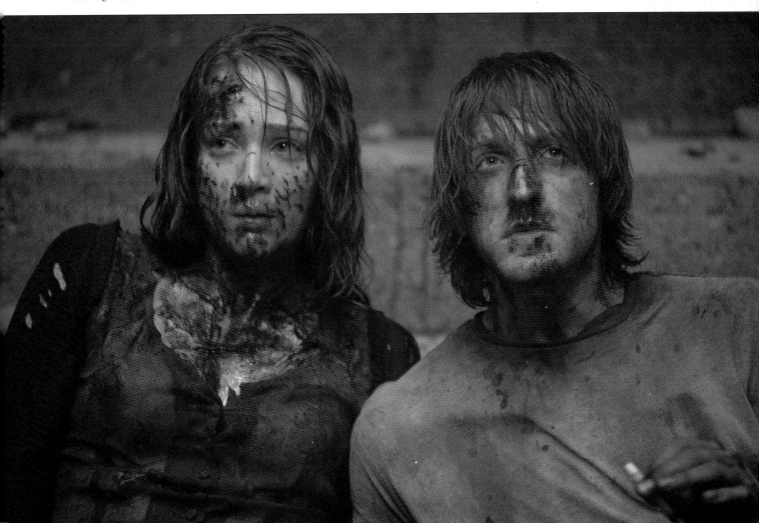

DAVID LEROY ANDERSON: I've never been in a crew that was trying to make so many creatures for a single film, never been involved in something that was so all-encompassing. I have no way of even calculating how many zombies or mutants we did, because once we were in the thick of things, it came down to as many as we could possibly make in a day! I think the hard number for types of creatures was somewhere around sixty, but it was well into the hundreds, probably close to a thousand, in individual people turned into various things.

HEATHER LANGENKAMP ANDERSON: When David saw how complex this job would be, the first call he made was to his dad, Lance Anderson, who took care of the design of the unicorn and Mother Buckner's belly of coals.

D.L. ANDERSON: AFX Studio is the building where he opened his company in the Seventies, Lance Anderson Makeup Designs. I came in and started working for him, and then he retired and now it's *mine* [laughs].

H.L. ANDERSON: One of the challenges was that we have a small shop in Van Nuys, so we knew that straight away we had to double or triple our space to do this job. We rented a facility next to the Burbank Airport, the Bat Cave, because we immediately had a crew of sixty people that had to go somewhere.

D.L. ANDERSON: *Cabin* happened at the perfect time, because there was nothing else going on in town. There are a handful of makeup effects shops in Los Angeles, full of these incredible artists. None

CREATURE
MAKING THE MONSTERS

of them were working. So I was able to hire a lot of them, and put together a crew of people that I never thought I'd get a chance to work with. The best of the best were working on it.

H.L. ANDERSON: David hired several Canadians who are crack makeup artists. He had guys taking pieces that we thought were for a background zombie but they'd turn them into the Elephant Man. They would take household items and make these incredible things overnight. There was one guy who pulls his face off and underneath is a skeleton man! The whole process really caused people to come out of their comfort zone and be extremely creative on the spot. Basically, the producers said 'Go' on December 15th 2008, but January 1st was our real start date. It was panic to meet the March 9th production start date. There were five major creature suits, and our suit fabricators, Laurel Taylor, Fred Fraleigh and Kerry Deco,

had to manage them. 'Okay, we'll put the zipper in on this day…' Our shop coordinator was Shaun Smith. They got it all done on time.

D.L. ANDERSON: The only reason it happened in time was because everybody gave and gave and gave, like for example mold supervisor Jim McLoughlin. Everybody multi-tasked. We had nearly seventy people at peak, but in effect, we had a hundred and forty people, because everybody had at least two jobs. The feedback I'm getting is that it was crazy, but that people had an incredible time. The greatest thing that happened on *The Cabin in the Woods* was that this particular group of people got to make a monster movie together and I'm forever grateful, because none of us are ever going to forget it, and we're never all going to be in the same room again. But the planets aligned and allowed us to take this trip together.

FEATURE

AN INTERVIEW WITH AFX STUDIO'S DAVID LeRoy ANDERSON AND HEATHER LANGENKAMP ANDERSON

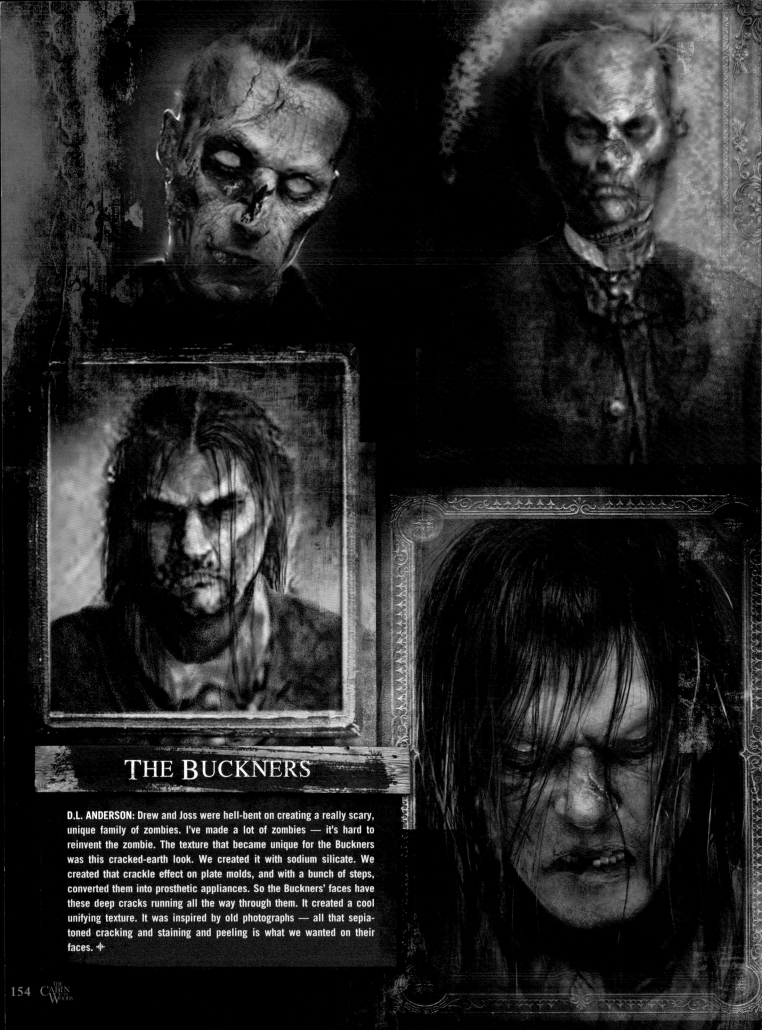

THE BUCKNERS

D.L. ANDERSON: Drew and Joss were hell-bent on creating a really scary, unique family of zombies. I've made a lot of zombies — it's hard to reinvent the zombie. The texture that became unique for the Buckners was this cracked-earth look. We created it with sodium silicate. We created that crackle effect on plate molds, and with a bunch of steps, converted them into prosthetic appliances. So the Buckners' faces have these deep cracks running all the way through them. It created a cool unifying texture. It was inspired by old photographs — all that sepia-toned cracking and staining and peeling is what we wanted on their faces. ⊕

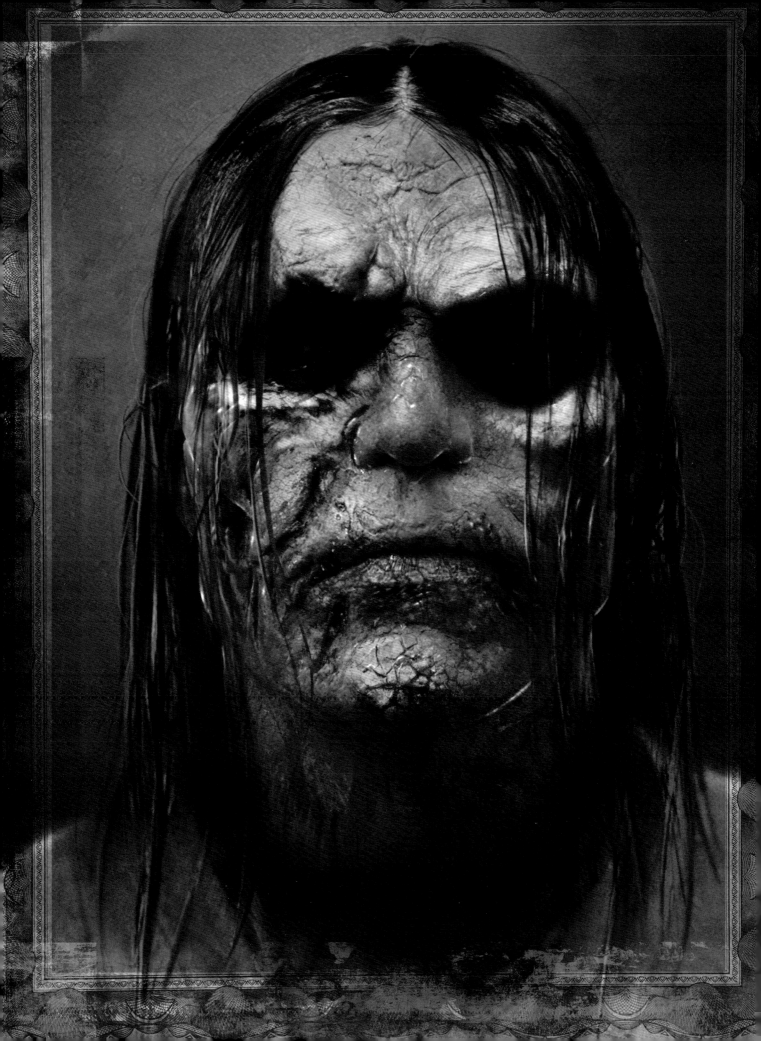

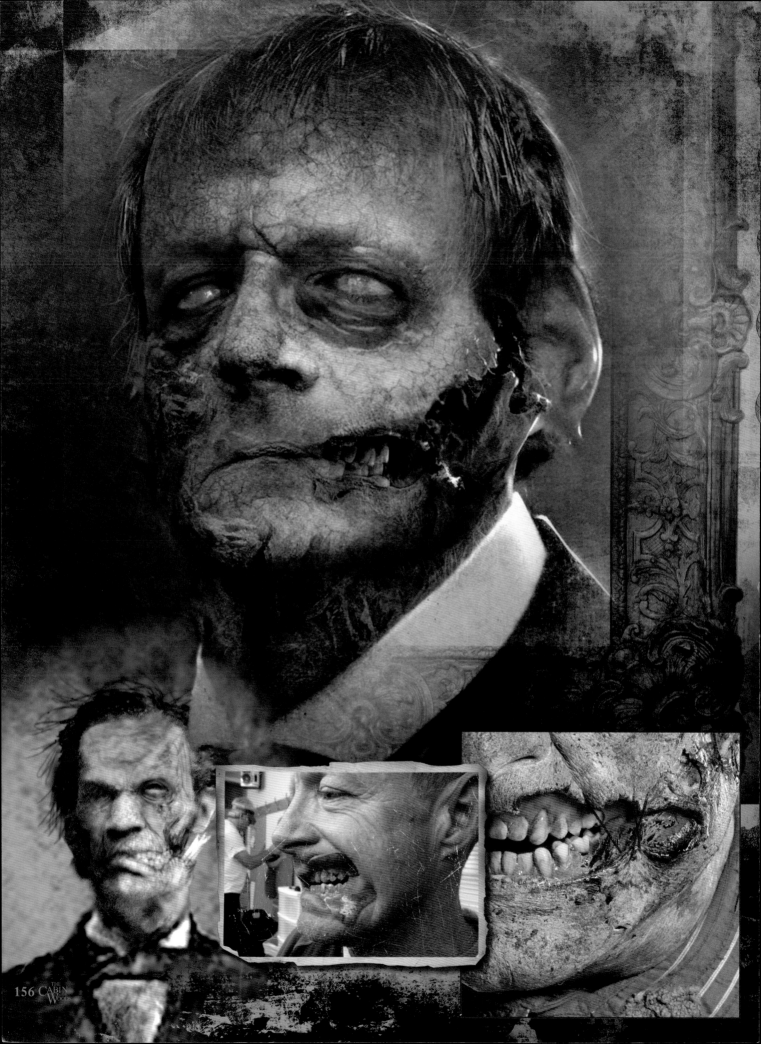

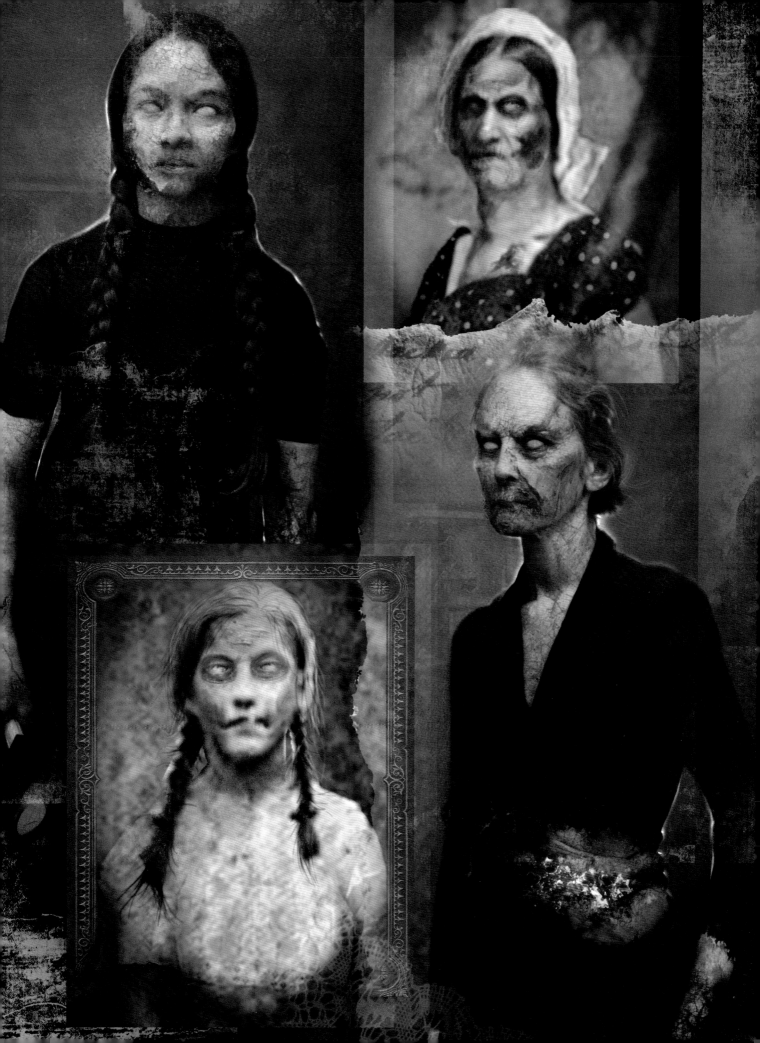

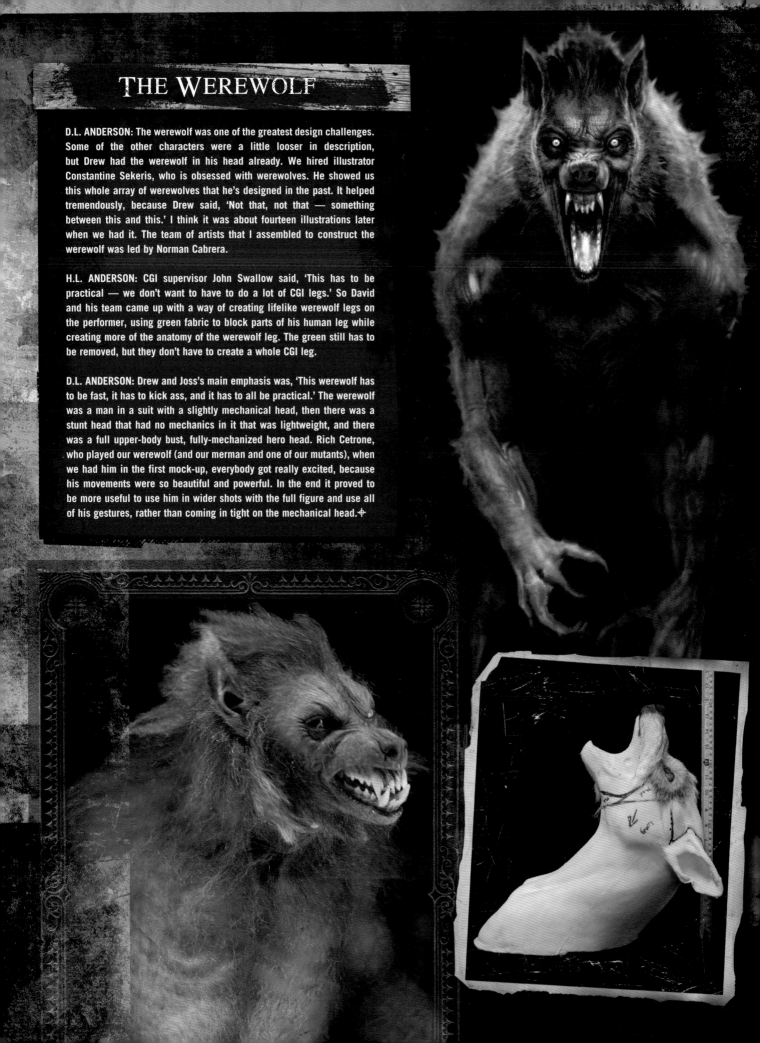

THE WEREWOLF

D.L. ANDERSON: The werewolf was one of the greatest design challenges. Some of the other characters were a little looser in description, but Drew had the werewolf in his head already. We hired illustrator Constantine Sekeris, who is obsessed with werewolves. He showed us this whole array of werewolves that he's designed in the past. It helped tremendously, because Drew said, 'Not that, not that — something between this and this.' I think it was about fourteen illustrations later when we had it. The team of artists that I assembled to construct the werewolf was led by Norman Cabrera.

H.L. ANDERSON: CGI supervisor John Swallow said, 'This has to be practical — we don't want to have to do a lot of CGI legs.' So David and his team came up with a way of creating lifelike werewolf legs on the performer, using green fabric to block parts of his human leg while creating more of the anatomy of the werewolf leg. The green still has to be removed, but they don't have to create a whole CGI leg.

D.L. ANDERSON: Drew and Joss's main emphasis was, 'This werewolf has to be fast, it has to kick ass, and it has to all be practical.' The werewolf was a man in a suit with a slightly mechanical head, then there was a stunt head that had no mechanics in it that was lightweight, and there was a full upper-body bust, fully-mechanized hero head. Rich Cetrone, who played our werewolf (and our merman and one of our mutants), when we had him in the first mock-up, everybody got really excited, because his movements were so beautiful and powerful. In the end it proved to be more useful to use him in wider shots with the full figure and use all of his gestures, rather than coming in tight on the mechanical head. ⚜

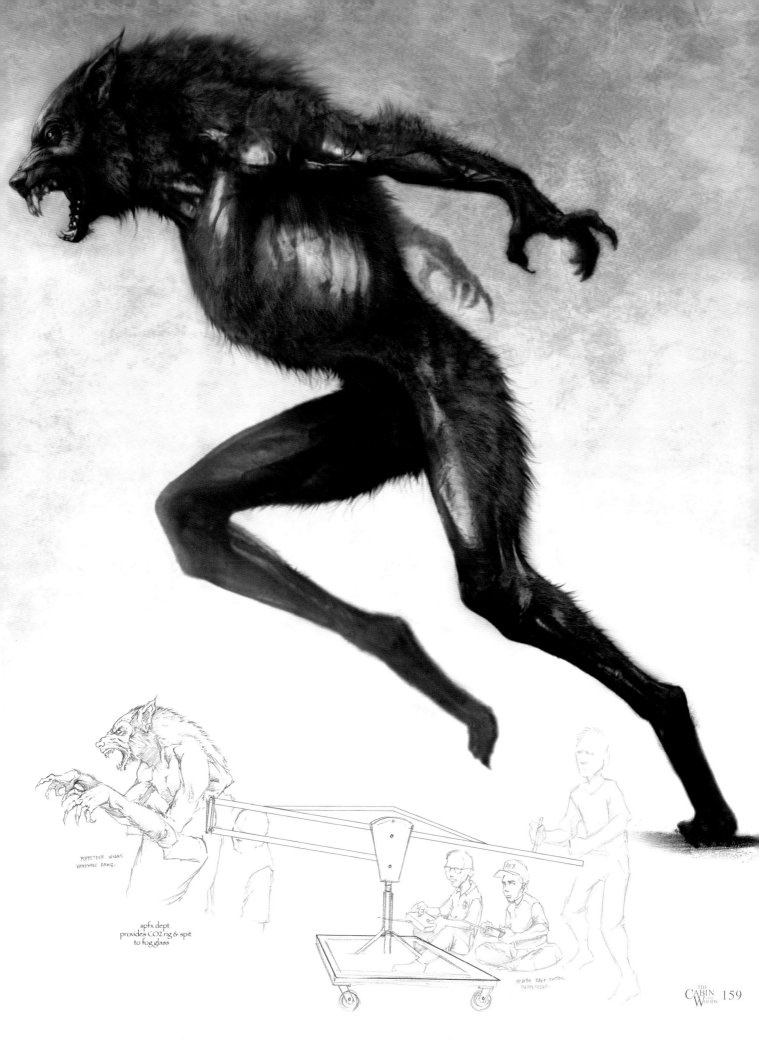

PUPPETEER WEARS
WEREWOLF ARMS.

spfx dept
provides CO2 rig & spit
to fog glass

AFX

HIDDEN RADIO-CONTROL
PUPPETEERS.

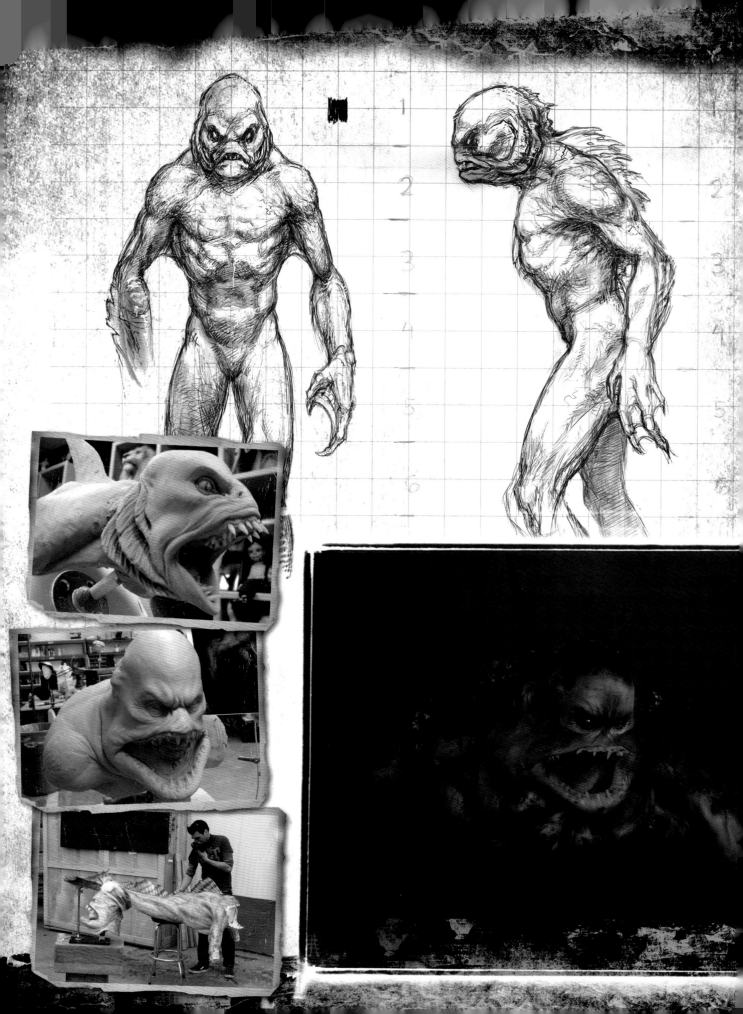

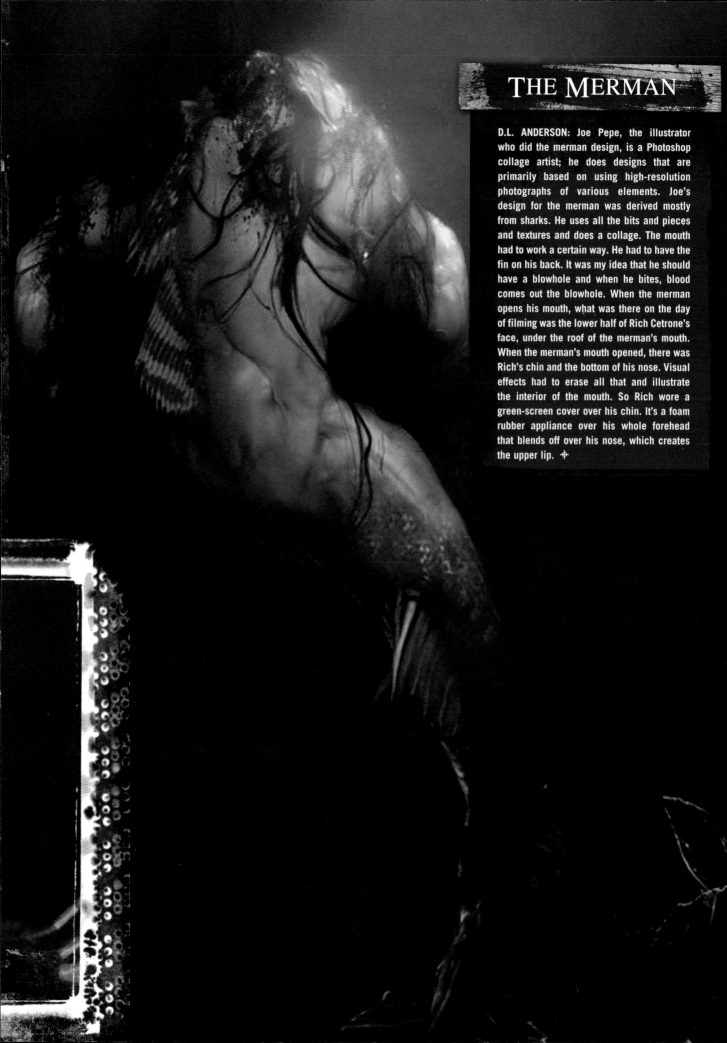

THE MERMAN

D.L. ANDERSON: Joe Pepe, the illustrator who did the merman design, is a Photoshop collage artist; he does designs that are primarily based on using high-resolution photographs of various elements. Joe's design for the merman was derived mostly from sharks. He uses all the bits and pieces and textures and does a collage. The mouth had to work a certain way. He had to have the fin on his back. It was my idea that he should have a blowhole and when he bites, blood comes out the blowhole. When the merman opens his mouth, what was there on the day of filming was the lower half of Rich Cetrone's face, under the roof of the merman's mouth. When the merman's mouth opened, there was Rich's chin and the bottom of his nose. Visual effects had to erase all that and illustrate the interior of the mouth. So Rich wore a green-screen cover over his chin. It's a foam rubber appliance over his whole forehead that blends off over his nose, which creates the upper lip. ✦

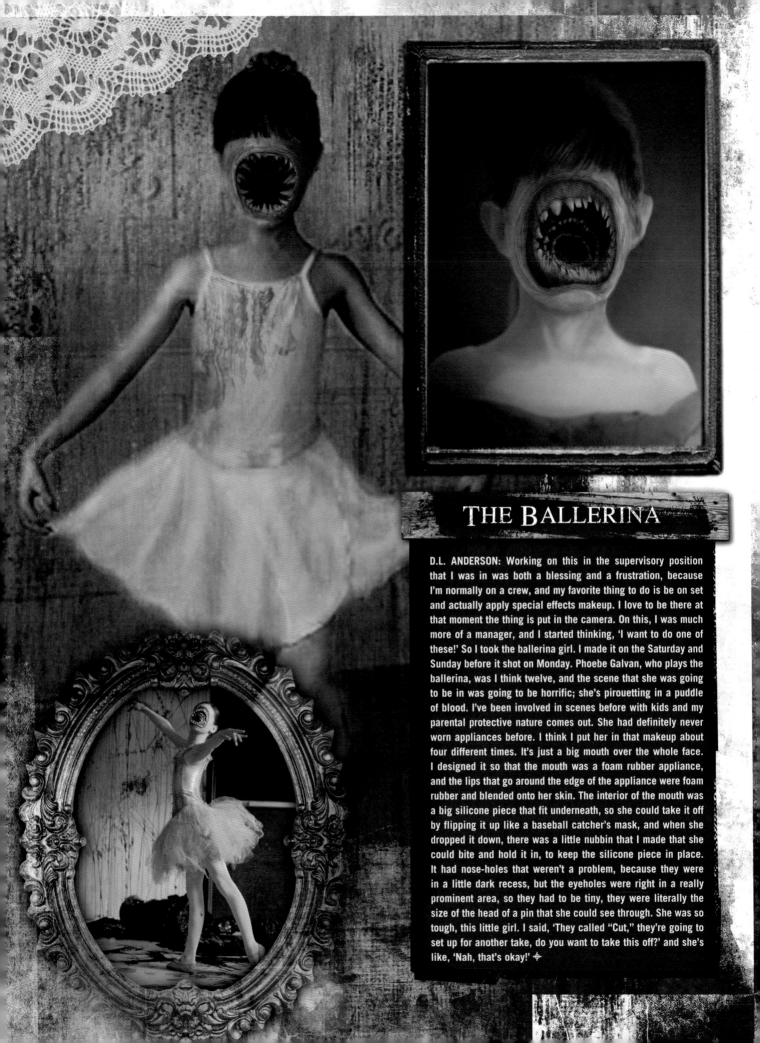

THE BALLERINA

D.L. ANDERSON: Working on this in the supervisory position that I was in was both a blessing and a frustration, because I'm normally on a crew, and my favorite thing to do is be on set and actually apply special effects makeup. I love to be there at that moment the thing is put in the camera. On this, I was much more of a manager, and I started thinking, 'I want to do one of these!' So I took the ballerina girl. I made it on the Saturday and Sunday before it shot on Monday. Phoebe Galvan, who plays the ballerina, was I think twelve, and the scene that she was going to be in was going to be horrific; she's pirouetting in a puddle of blood. I've been involved in scenes before with kids and my parental protective nature comes out. She had definitely never worn appliances before. I think I put her in that makeup about four different times. It's just a big mouth over the whole face. I designed it so that the mouth was a foam rubber appliance, and the lips that go around the edge of the appliance were foam rubber and blended onto her skin. The interior of the mouth was a big silicone piece that fit underneath, so she could take it off by flipping it up like a baseball catcher's mask, and when she dropped it down, there was a little nubbin that I made that she could bite and hold it in, to keep the silicone piece in place. It had nose-holes that weren't a problem, because they were in a little dark recess, but the eyeholes were right in a really prominent area, so they had to be tiny, they were literally the size of the head of a pin that she could see through. She was so tough, this little girl. I said, 'They called "Cut," they're going to set up for another take, do you want to take this off?' and she's like, 'Nah, that's okay!' ✚

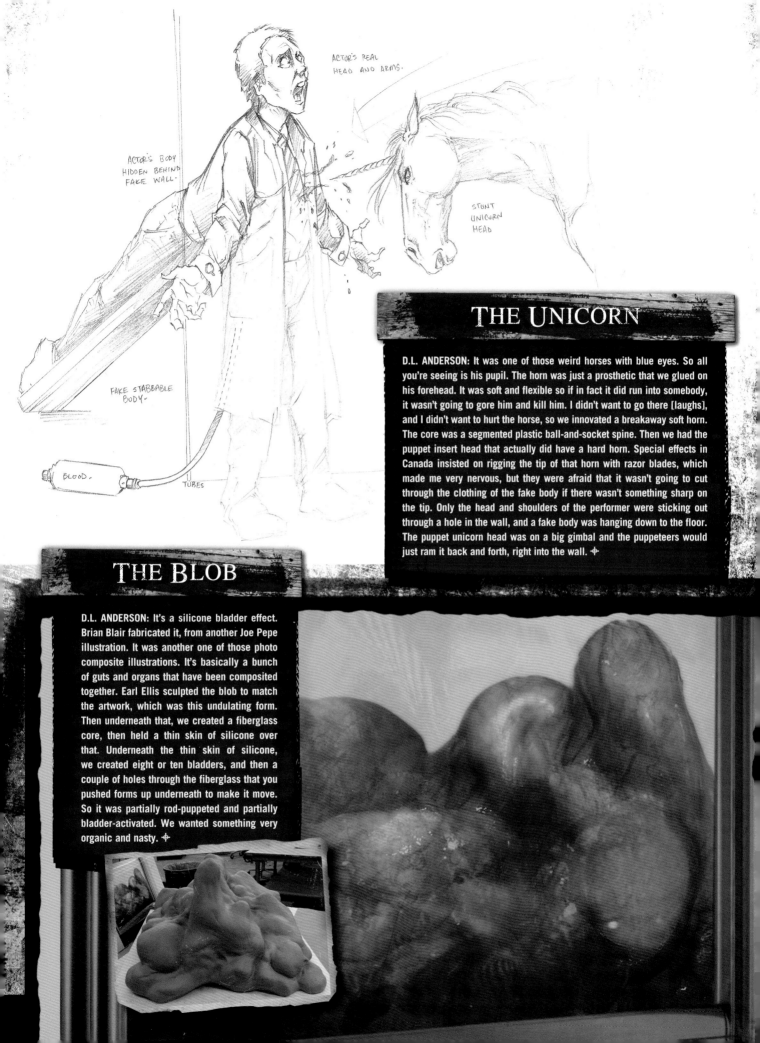

Labels on illustration:

ACTOR'S BODY HIDDEN BEHIND FAKE WALL.

ACTOR'S REAL HEAD AND ARMS.

STUNT UNICORN HEAD

FAKE STABBABLE BODY.

BLOOD.

TUBES

THE UNICORN

D.L. ANDERSON: It was one of those weird horses with blue eyes. So all you're seeing is his pupil. The horn was just a prosthetic that we glued on his forehead. It was soft and flexible so if in fact it did run into somebody, it wasn't going to gore him and kill him. I didn't want to go there [laughs], and I didn't want to hurt the horse, so we innovated a breakaway soft horn. The core was a segmented plastic ball-and-socket spine. Then we had the puppet insert head that actually did have a hard horn. Special effects in Canada insisted on rigging the tip of that horn with razor blades, which made me very nervous, but they were afraid that it wasn't going to cut through the clothing of the fake body if there wasn't something sharp on the tip. Only the head and shoulders of the performer were sticking out through a hole in the wall, and a fake body was hanging down to the floor. The puppet unicorn head was on a big gimbal and the puppeteers would just ram it back and forth, right into the wall. ✛

THE BLOB

D.L. ANDERSON: It's a silicone bladder effect. Brian Blair fabricated it, from another Joe Pepe illustration. It was another one of those photo composite illustrations. It's basically a bunch of guts and organs that have been composited together. Earl Ellis sculpted the blob to match the artwork, which was this undulating form. Then underneath that, we created a fiberglass core, then held a thin skin of silicone over that. Underneath the thin skin of silicone, we created eight or ten bladders, and then a couple of holes through the fiberglass that you pushed forms up underneath to make it move. So it was partially rod-puppeted and partially bladder-activated. We wanted something very organic and nasty. ✛

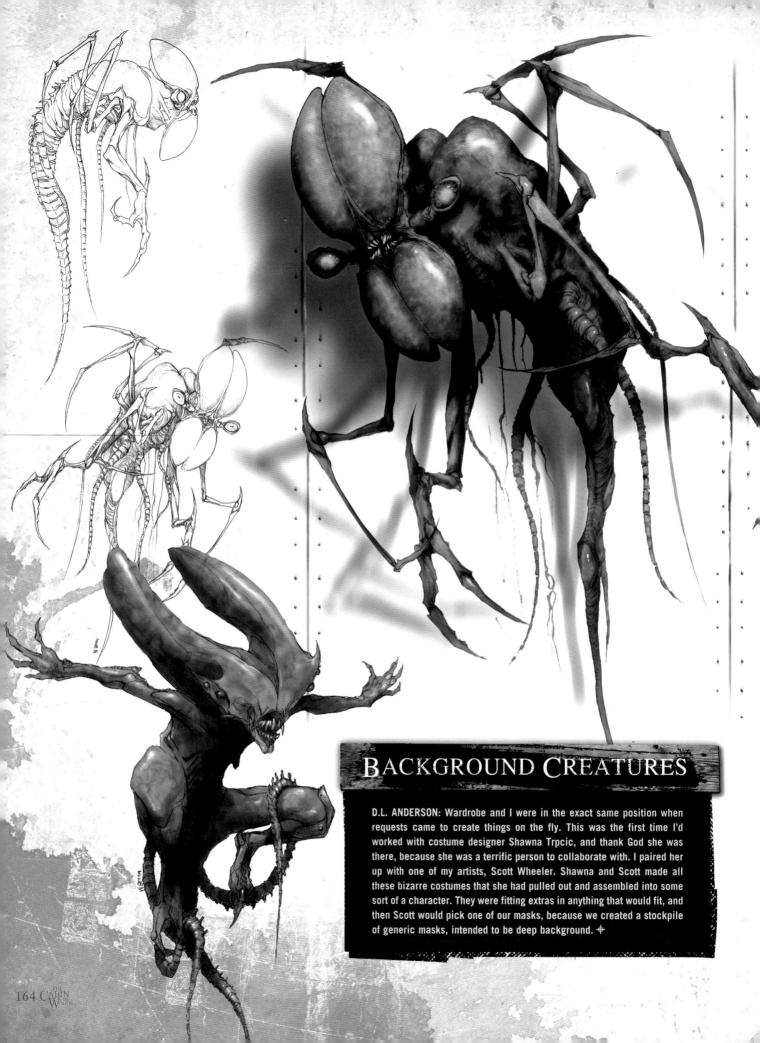

BACKGROUND CREATURES

D.L. ANDERSON: Wardrobe and I were in the exact same position when requests came to create things on the fly. This was the first time I'd worked with costume designer Shawna Trpcic, and thank God she was there, because she was a terrific person to collaborate with. I paired her up with one of my artists, Scott Wheeler. Shawna and Scott made all these bizarre costumes that she had pulled out and assembled into some sort of a character. They were fitting extras in anything that would fit, and then Scott would pick one of our masks, because we created a stockpile of generic masks, intended to be deep background. ✦

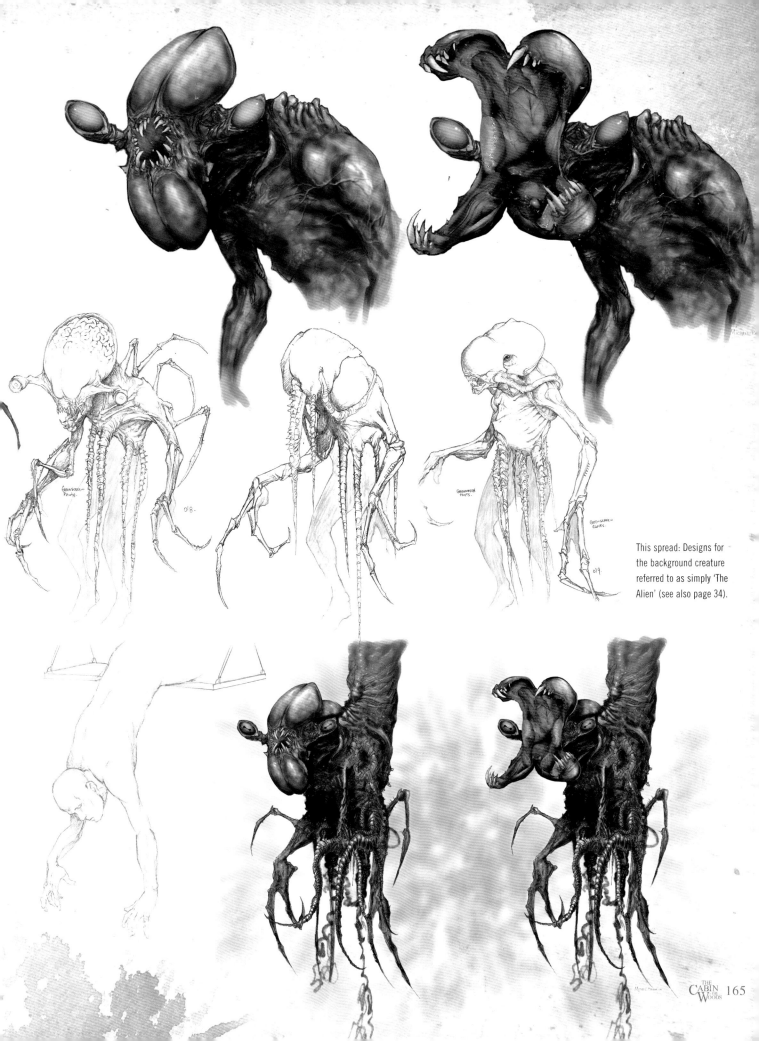

This spread: Designs for the background creature referred to as simply 'The Alien' (see also page 34).

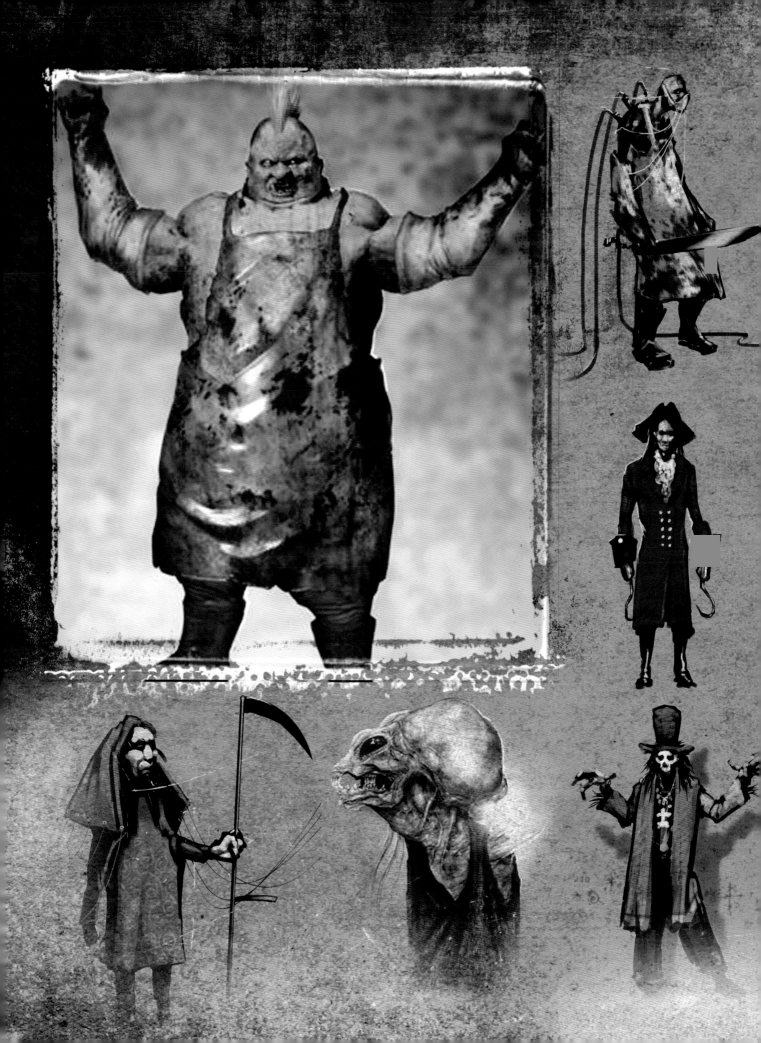

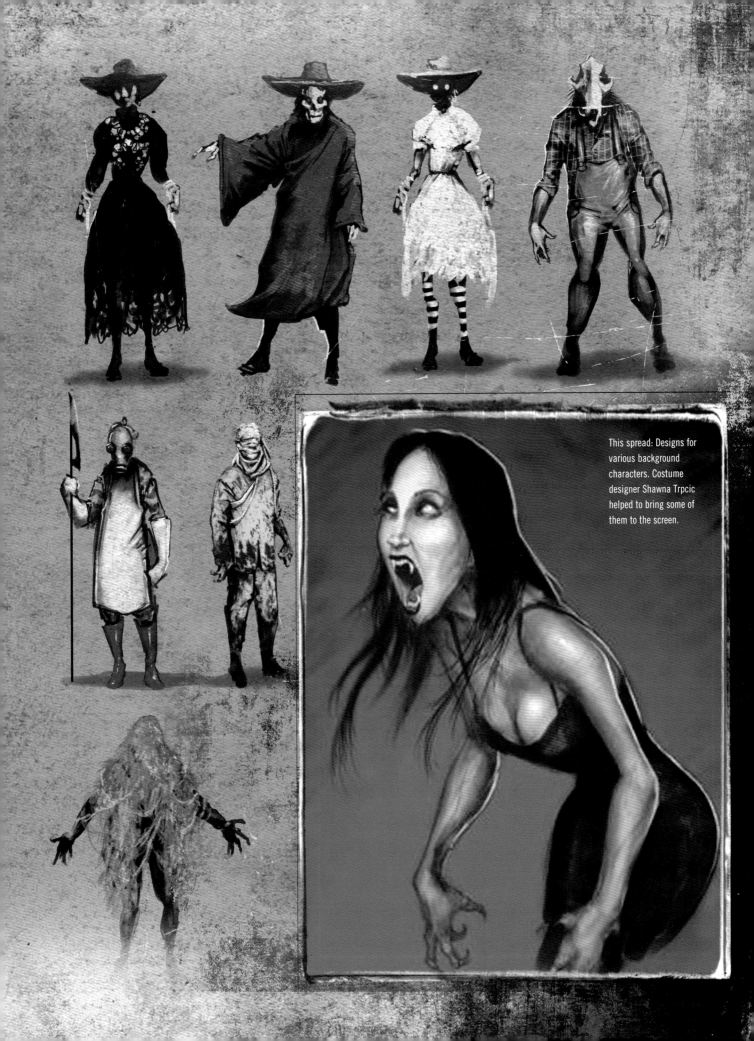

This spread: Designs for various background characters. Costume designer Shawna Trpcic helped to bring some of them to the screen.

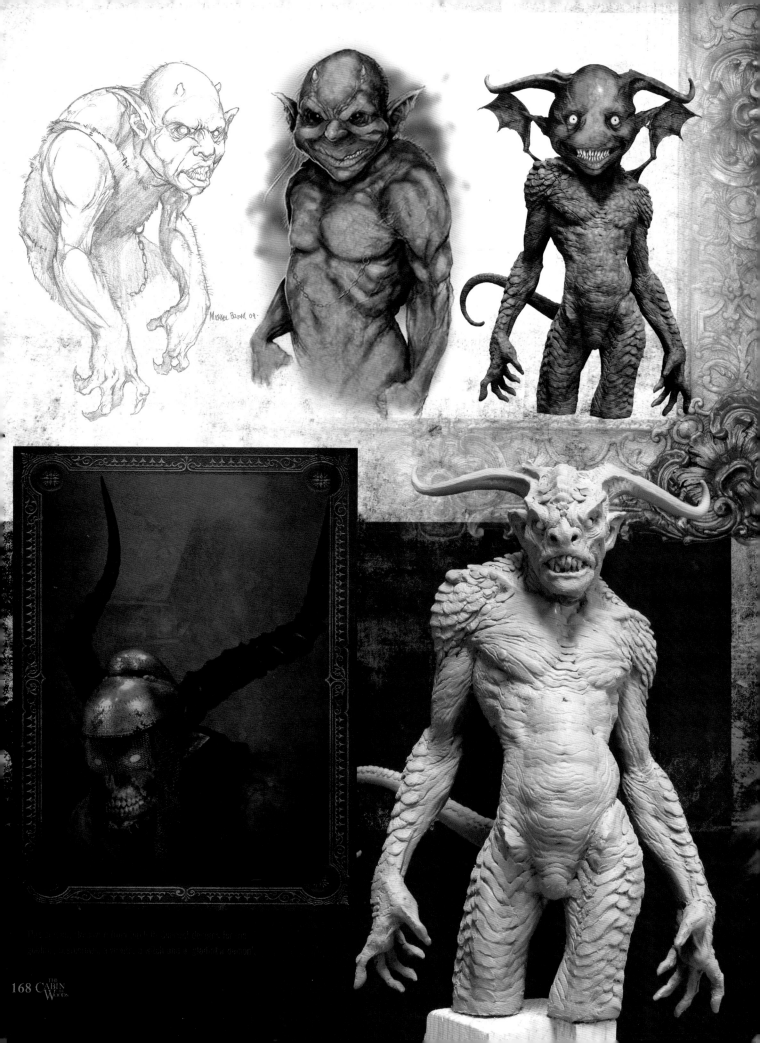

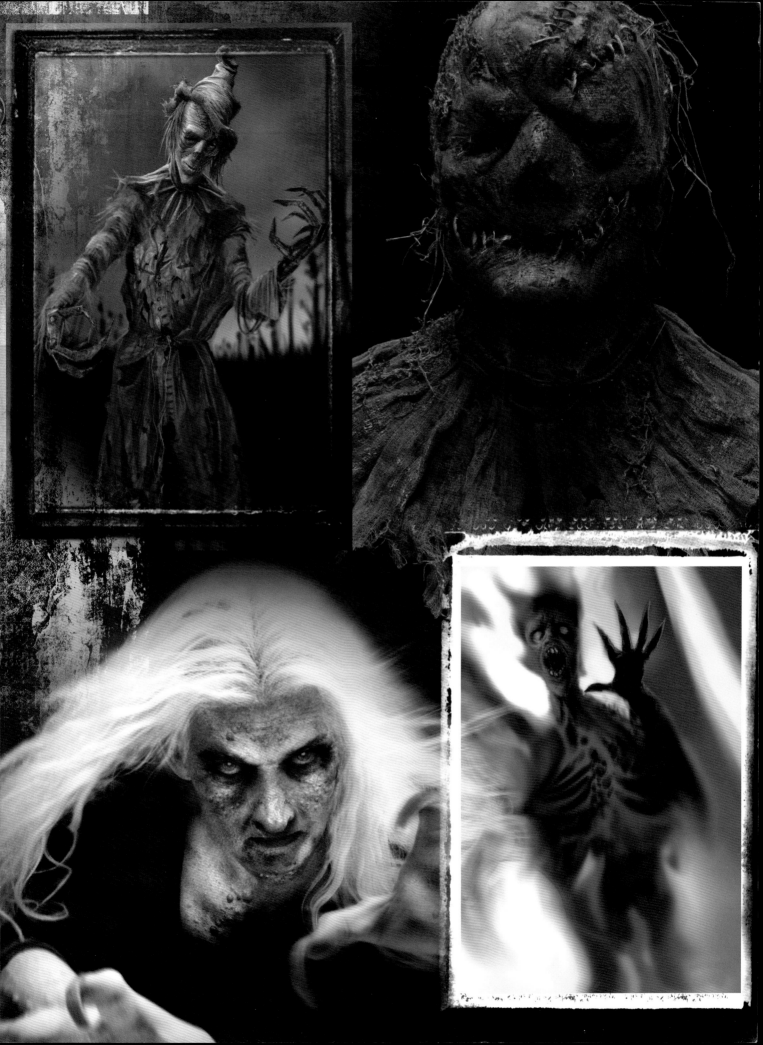

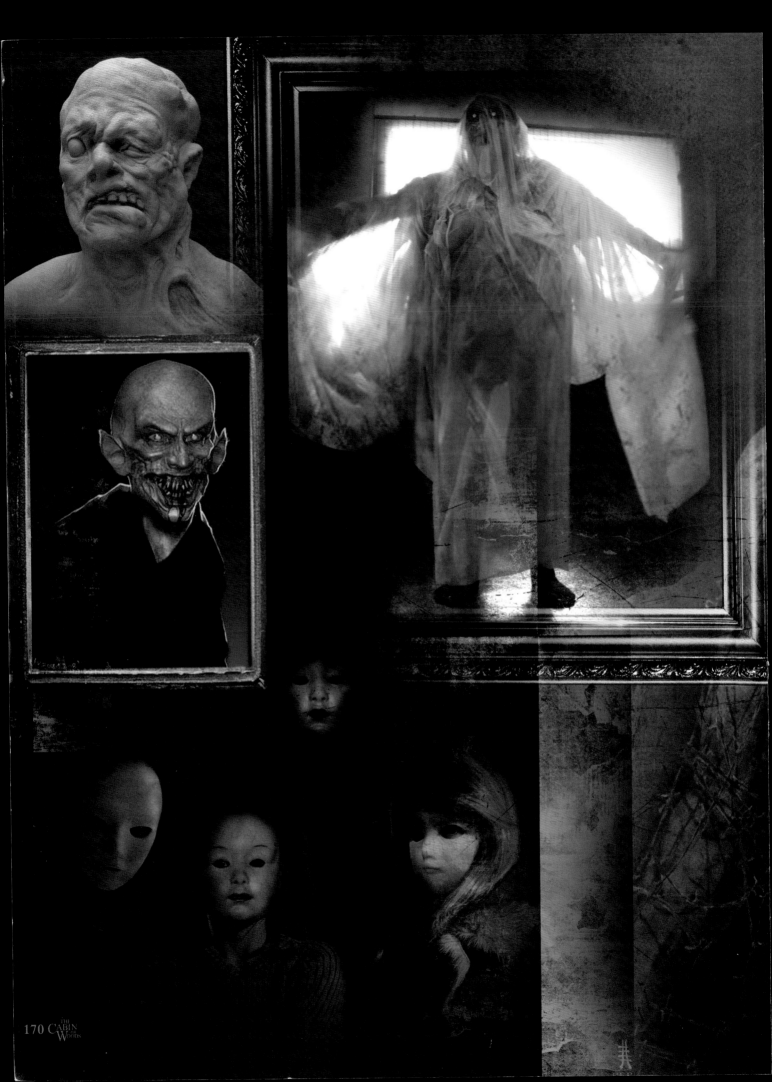

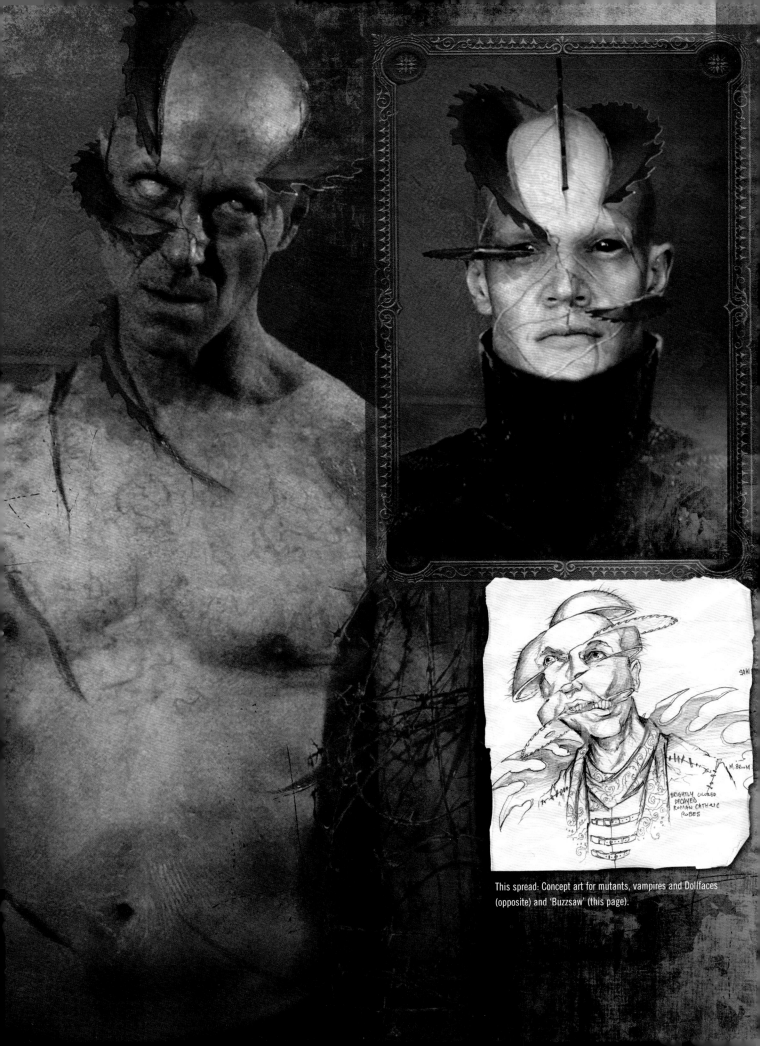

This spread: Concept art for mutants, vampires and Dollfaces (opposite) and 'Buzzsaw' (this page).

BRIGHTLY COLORED DECAYED ROMAN CATHOLIC ROBES

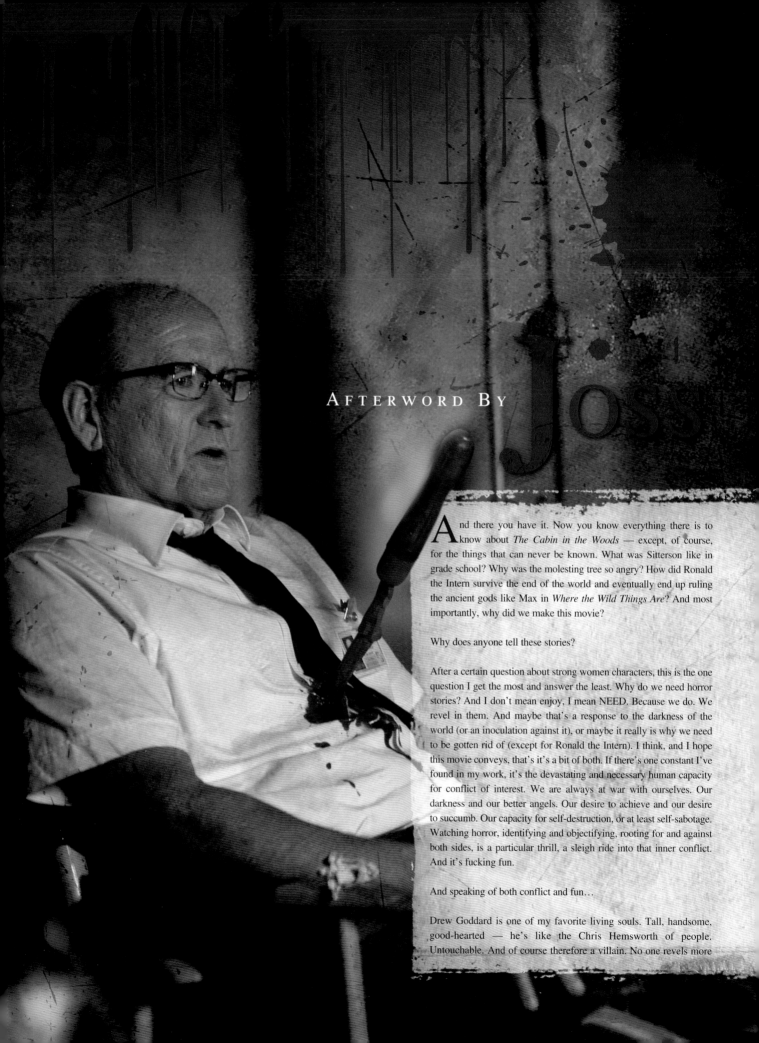

And there you have it. Now you know everything there is to know about *The Cabin in the Woods* — except, of course, for the things that can never be known. What was Sitterson like in grade school? Why was the molesting tree so angry? How did Ronald the Intern survive the end of the world and eventually end up ruling the ancient gods like Max in *Where the Wild Things Are*? And most importantly, why did we make this movie?

Why does anyone tell these stories?

After a certain question about strong women characters, this is the one question I get the most and answer the least. Why do we need horror stories? And I don't mean enjoy, I mean NEED. Because we do. We revel in them. And maybe that's a response to the darkness of the world (or an inoculation against it), or maybe it really is why we need to be gotten rid of (except for Ronald the Intern). I think, and I hope this movie conveys, that's it's a bit of both. If there's one constant I've found in my work, it's the devastating and necessary human capacity for conflict of interest. We are always at war with ourselves. Our darkness and our better angels. Our desire to achieve and our desire to succumb. Our capacity for self-destruction, or at least self-sabotage. Watching horror, identifying and objectifying, rooting for and against both sides, is a particular thrill, a sleigh ride into that inner conflict. And it's fucking fun.

And speaking of both conflict and fun…

Drew Goddard is one of my favorite living souls. Tall, handsome, good-hearted — he's like the Chris Hemsworth of people. Untouchable. And of course therefore a villain. No one revels more

in evil, in destruction, in chaos. Yet on the sly, this guy is more decent, conflicted, self-abnegating and just plain neurotic than, well, me. You want to make a horror movie, you call Drew Goddard. You want to make a horror movie that contains a meditation on the human condition asking questions about our darkest selves that you know going in cannot be answered… You call Drew Goddard. To talk about yourself as an artist while promoting a horror film is like begging people not to see it. You may as well put those little festival laurel leaves on the poster. But that's how we approached the film. We may not have said it. We may have been too busy having the most fun you can have with an insane idea, a truly great ensemble and forty thousand gallons of blood, but that's what we went for. A study of horror, our need for it, our degradation and our transcendence — with a vengeful unicorn, bitches. Try to have more fun. Really, try.

Writing this movie was pure joy. Making it, intermittent joy with a boatload of logistical issues. Getting it into theaters… Well, did you ever read *The Odyssey*? (Full disclosure: I actually haven't.) (But their shit is arduous, right?) This book comes out the day Drew's vision is finally shared with the world. Hopefully an enormous portion of the world, but I'll settle for a decent opening weekend. For me, this book was a little, bendy time-machine, that took me back through the pain, and the necessary distance I put between myself and the work (Have I said enough great things about Lionsgate? Can I possibly?), to the joy that began, that suffused this flick. I'm glad to be back.

Here's to the end of the world.

JOSS WHEDON

"HUMANITY...
PFFT.
IT'S TIME TO
GIVE
SOMEONE ELSE
A CHANCE."